Praise for
We Need to Talk

"Refreshingly honest. . . . In the era of the lost art of conversation, Headlee helps us find our voice."

—*Henry Bass,* Essence

"The perfect pre-Thanksgiving read to head off family squabbles and turn the holiday meal into a feast of ideas instead of a political fracas."

—*Karin Gillespie,* Augusta Chronicle

"This book is necessary. . . . Headlee's treatise on creating space for valuable mutual reciprocity is one that should become a handbook in any school, business, or even a doctor's office where the everyday person visits."

—*George Elerick, Buzzfeed*

"Civil discourse is one of humanity's founding institutions and it faces an existential threat: We, the people, need to talk about how we talk to one another. Celeste Headlee shows us how."

—*Ron Fournier,* New York Times *bestselling author of* Love That Boy *and former publisher of* Crain's Detroit Business

"*We Need to Talk* is an important read for a conversationally challenged, disconnected age. Headlee is a talented, honest storyteller, and her advice has helped me become a better spouse, friend, and mother."

—*Jessica Lahey, author of the* New York Times *bestseller* The Gift of Failure

"A well-researched and careful analysis of how and why we talk with one another—our strengths and (myriad) weaknesses. . . . A thoughtful discussion and sometimes-passionate plea for civility and consideration in conversation."

—Kirkus Reviews

"This powerful debut offers ten strategies for improving conversational skills. Tidbits from sociological studies and anecdotes from history, including from civil rights activist Xernona Clayton's groundbreaking conversations with KKK leader Calvin Craig, round out a book that takes its own advice and has much to communicate."

—Publishers Weekly

"In the course of her career, Headlee has interviewed thousands of people from all walks of life and learned that sparking a great conversation is really a matter of a few simple habits that anyone can learn."

—*Jessica Stillman, Inc.com*

Praise for
Do Nothing

"Through deep research and evocative storytelling, Celeste Headlee shows us how to break free from constant pressure and live the life we truly want."

—*Arianna Huffington, founder and CEO of Thrive Global*

"Despite working harder than ever, people have never been more depressed, anxious, and unhappy. Without a doubt, our modern way of life is not working. In fact, it's killing us. But what is to be done? With intelligence and compassion, Headlee presents realistic solutions for how we can reclaim our health and our humanity from a technological revolution that seems hell-bent on destroying both. I'm so grateful to have read this book. It delivers on its promise of a better life."

—*Elizabeth Gilbert, author of* Big Magic *and* Eat Pray Love

"Celeste Headlee makes a powerful case that productivity is not an inherent virtue—if you're not careful, it can become a vice. If you've ever felt compelled to work harder, this book is a clarion call to work smarter instead. Sometimes you accomplish more by doing less."

—*Adam Grant,* New York Times *bestselling author of* Originals *and* Give and Take *and host of the chart-topping TED podcast* WorkLife

For my grandfather William Grant Still, whom I still love fiercely and who would be so proud of me

SPEAKING OF RACE

WHY EVERYBODY NEEDS
TO TALK ABOUT RACISM—
AND HOW TO DO IT

CELESTE HEADLEE

HARPER WAVE
An Imprint of HarperCollins*Publishers*

SPEAKING OF RACE. Copyright © 2021 by Celeste Headlee. All rights reserved. Printed in the United States of America. No part of this book may be used or reproduced in any manner whatsoever without written permission except in the case of brief quotations embodied in critical articles and reviews. For information, address HarperCollins Publishers, 195 Broadway, New York, NY 10007.

HarperCollins books may be purchased for educational, business, or sales promotional use. For information, please email the Special Markets Department at SPsales@harpercollins.com.

Illustration in chapter 5 courtesy of the author.

FIRST EDITION

Library of Congress Cataloging-in-Publication Data has been applied for.

ISBN 978-0-06-309815-2

21 22 23 24 25 LSC 10 9 8 7 6 5 4 3 2 1

SPEAKING OF RACE

ALSO BY CELESTE HEADLEE

We Need to Talk

Do Nothing

"At a time when so many people are feeling overworked, overwhelmed, and addicted to busyness, work, and ever-present technology, Celeste Headlee offers a pathway out. Drawing on extensive research and her own experience, *Do Nothing* is a powerful reminder that taking the time to stop, connect with others, and forge real bonds is vital for building community, fostering empathy, and ultimately leads to joy."

—*Brigid Schulte, author of the* New York Times *bestseller* Overwhelmed *and director of The Better Life Lab at New America*

"I needed this book. And chances are you need it, too. Celeste Headlee does something amazing in *Do Nothing*. She battles this hectic, stressful time and highlights the things that makes our lives better. Connection. Experience. Self-care. And, above all, she reminds us to get busy living."

—*Jared Yates Sexton, author of* The Man They Wanted Me to Be

"In this thought-provoking, well-researched book, Celeste invites readers to push back against the I'm-too-busy narrative and discover what it means to be truly successful."

—*Laura Vanderkam, author of* Off the Clock *and* I Know How She Does It

"This book is honest, heartbreaking, and hopeful. It's that kind of gem that you read and know you need to hear, know you need to embrace, even if it's challenging. Incredibly well-researched and yet never preachy or dull, this book will help us all reclaim a bit of our humanness if we allow it."

—*Nataly Kogan, author of* Happier Now

"[*Do Nothing*'s] conversational tone draws readers in, and it will appeal to those looking beyond self-help to something more meaningful."

—Booklist

"This is neither a self-help book nor a how-to for people looking for a guide for different working habits. Rather, Headlee systematically deconstructs the toxicity of hustle culture with historical and scientific research to help readers question their habits and impulses surrounding overwork."

—*Shelf Awareness*

CONTENTS

Introduction . 1

PART I THE CONTEXT

Chapter 1	WHO IS RACIST? .	21
Chapter 2	THE SCIENCE .	39
Chapter 3	THE STAKES .	53
Chapter 4	WHEN IT HAS WORKED .	67

PART II THE CONVERSATION

Chapter 5	FIRST, GET YOUR HEAD STRAIGHT	85
Chapter 6	RESPECT AND ACCEPTANCE	109
Chapter 7	TAKE TURNS AND BE SPECIFIC	127
Chapter 8	LOCATION AND LANGUAGE	143
Chapter 9	COMMON GROUND AND GOOD QUESTIONS	159
Chapter 10	KEEP IT PERSONAL AND DON'T RUSH	179
Chapter 11	I SCREWED UP. WHAT NOW?	195
Chapter 12	TALKING ABOUT RACISM IN THE WORKPLACE	209
In Closing	GOOD LUCK .	229

Acknowledgments . *237*

Reading List . *241*

Notes . *245*

SPEAKING OF RACE

INTRODUCTION

> Systemic racism is like a disease. Some of us are infected. Some of us have no side effects, some of us are asymptomatic, but one way or another, all of us are affected.
>
> —DENISE HORN, DIRECTOR OF INCLUSION MARKETING
> AND COMMUNICATIONS AT WARNER MEDIA

Stop for a moment, take a breath, and pay close to attention to what I'm about to tell you: you are biased. Whether you enjoy talking to highly attractive people more than to less attractive people, or take advice more seriously when it's dispensed by someone who is educated, or assume dog owners are nicer than people who don't own dogs, you are biased.

If you grew up in the United States, you're probably sexist, too. That's because sexism is codified in our government's policies and our social structures. It is an entrenched part of our culture. Both men and women in this country make assumptions based on sex. I'm sure it comes as no surprise that the same is true of race. It is, after all, our original sin.

All of this is to say: If someone suggests that you are prejudiced, the most accurate response is "Yes, you're right. I am." Because the truth is that everyone is biased. Everyone. We all make assumptions about people based on superficial observations: the books they read,

the clothes they wear, the neighborhoods they live in, the type of work they do, the kind of car they drive.

I have thought about bias and race nearly every day of my life, and I have come to realize that the majority of people believe they are *not* biased, that they're mostly fair and just in their dealings with others. I've also come to understand how wrong that assumption is, how our understanding of bias is hampered because of our insistence that the problem lies in other people's attitudes, and not our own.

I spent many years worrying about whether I was allowed to call myself Black, and if I didn't, whether it would be an insult to my ancestors to let others believe I am white. I've been lectured about color by both Blacks and whites. I've devoured as much material on the subject as I could. Had I devoted this much time to the study of any other topic, I would call myself an expert, but I don't claim that title in this area. There is still so much for me to learn.

While there are many brilliant scholars of race theory and racial history, no one is an authority on all aspects of racism and diversity. Consequently, there are two things I want to establish immediately. First, everyone is a work in progress when it comes to prejudice and human diversity, with room for education and enlightenment. Second, racism has wasted enough of our time. Action need wait no longer for further information. We know enough about racism to know that it must end.

We've already given too many lives and endured too much suffering for the sake of something that doesn't exist, scientifically speaking. Racism is real, but race is not.[1] Cultural differences exist, as do disparities caused by inequities in education, environment, housing, opportunity, and health care, but no DNA test can really tell you what imagined "race" you belong to,[2] only what general area on the map your ancestors migrated from. As Vivian Chou of Harvard University wrote in 2019, "In the biological and social sciences, the consensus is clear: race is a social construct, not a biological attribute."[3]

It boggles my mind that we've squandered so much on perceived racial difference. What if we had never fallen prey to racism and prejudice in the first place? Can you imagine what more Martin Luther King Jr. might have achieved if he hadn't felt an urgent need to battle racism? Obviously, he accomplished a great deal, but what might he have done if his civil rights work was unnecessary because Blacks were not disadvantaged and targeted? What more might he have been able to achieve in the area of poverty had he not been killed? Would his life have been cut short in the absence of racism? What about Harriet Tubman or Frederick Douglass? What might they have accomplished? What might James Baldwin have written about? What might Angela Davis have done?

If we are to finally put this woeful history behind us, we must talk about it with honesty and authenticity, open our mental doors and air out the musty cupboards of our prejudice, lift the rocks and send the creepy-crawlies of racism scrambling. As Baldwin wrote, "Not everything that is faced can be changed, but nothing can be changed until it is faced. . . . Most of us are about as eager to change as we were to be born, and go through our changes in a similar state of shock."[4]

If you want to learn about racism, you can. If your goal is to become educated so that you understand the history of segregation, the causes of inequity in the criminal justice system, and the exact meaning of the term "white privilege," there are many thoughtful and enlightening books that will help you achieve that aim. I strongly support that kind of research, but this is not one of those books.

This is also not a book that will teach you how to have the kind of ineffectual discussion of race that so many of us have had. Too often when people say they want to talk about race, they mean they want to talk with someone who holds mostly the same opinions they do or, if they're willing to speak to someone who disagrees, it's because they hope to change their mind, rather than to learn something.

That's all right. We are, after all, human. We don't like changing our minds or being told we're wrong.

A 2017 study published in the *Journal of Experimental Social Psychology* revealed that both those who considered themselves politically conservative and those who identified as liberal were equally averse to hearing opposing viewpoints.[5] And a meta-analysis of fifty-one different studies on the Social Science Research Network, an online repository of scholarly research in the social sciences and humanities, showed that regardless of political party or affiliation, everyone is equally susceptible to confirmation bias when it comes to politics.[6] That is, we're all as likely to discount the information that proves us wrong and give extra weight to the evidence that bolsters our existing views.

Every time we hear something that confirms our opinions, our brains get a little boost of dopamine.[7] Dopamine is sometimes called the addiction hormone; it's the same neurotransmitter activated when you take certain drugs or pull the arm on a slot machine.[8] You see the problem, right? You might enter a conversation with someone you think is racist, hoping to enlighten them and open their eyes, while they are equally determined to convince you they're not racist at all, that you're wrong and not seeing the issue clearly. No one wins in these conversations, and no progress is made by reinforcing the opinions of a racist.

Even worse is the kind of shouted exchange that occurs between anti-racist activists and counterprotestors screaming at them from the other side of the street. As the psychologists Craig Foster and Steven Samuels wrote in the *Skeptical Inquirer*, "Yelling at white supremacists seems unlikely to make them less racist. Indeed, it might do more harm than good. . . . Plus, the conflict between white supremacists and protestors might serve to invigorate the white supremacist community. It gives them a sense of purpose—together

they stand against the brainwashed liberals who are taking their country from them."[9]

This may be why some have urged Americans to reach out to those who hold abhorrent beliefs, and to avoid shaming them or scolding them. In 2017 in *The Forward*, a publication aimed at a Jewish American audience, Bethany Mandel wrote a column titled "We Need to Start Befriending Neo Nazis."[10] She noted that, while she's not sure she herself could do it, some people have had success in changing the minds of even unrepentant racists "through the power of listening, and treating these people with their heinous views as humans first and foremost." Not surprisingly, Mandel's piece was called divisive, and the arguments refuting it came swiftly and decisively.

I don't blame you if you don't want to sit down for a heart-to-heart with a neo-Nazi, but that's not the kind of conversation about race I'd expect you to be having anyway. In truth, few of us engage in casual chats about race with strangers; it's much more likely that we discuss these issues with people we know and love, like family members. Part of what often makes these encounters so fraught is the sense of betrayal we feel when a family member argues with us on a matter of fairness and equality. "We all need to experience a sense of belonging with others," says Suzanne Degges-White, chair of the Department of Counseling and Higher Education at Northern Illinois University, "and when we feel that our families do not understand or agree with our perspective, it can be emotionally distressing. We may try even harder to convince family members to share our own beliefs than we would acquaintances or strangers."[11] In the end, we can choose friends based on shared perspectives and we can end friendships when our values don't align, but we're mostly stuck with our family members. That can make us even more desperate to change their minds.

Sadly, that desperation tends to lead us down the wrong path, away from the techniques and strategies that might actually prove useful in shifting someone's perspective and toward the types of arguments, full of heightened emotions, that lead people to cling more stubbornly to their existing views. The latter accomplish nothing. They are frustrating and sometimes hurtful for both parties, and it's no surprise we often choose to avoid them. As the Yale social psychologist Michael Kraus says, "We want to move past issues of race all the time because they are difficult to talk about, because they bring up really painful pasts that we have lived in this country. It's much more comfortable for us to avoid those thoughts."[12]

I can't teach you how to persuade someone who doesn't agree with you or how to dunk on them by making them look stupid. I can, however, help you recognize that you can disagree with someone strongly and yet have the conversation *anyway*. Debates have changed very few minds, but conversations have the power to change hearts.

I asked one of my friends recently if he was avoiding a conversation about race with anyone in his life. He said his sister was a Trump supporter and a racist who believes Black people want handouts instead of working for what they get. "I don't think there's any chance that I will persuade her to think differently," he said.

"So," I asked, "what will you do? Will you stop talking to her? Do you exclude her from the family? Do you just tolerate her on Thanksgiving and Christmas and avoid her otherwise?"

He was silent for a moment, considering. "I don't know what to do," he finally said. "She's my sister and I don't want to break all ties with her. I just don't know what to say to her."

That's where this book lives: in the awkward and painful space many of us know too well and have been trying to navigate for years. It's a space that makes us uncomfortable, gets us upset, and leaves us struggling to find the right words. But in that space it's possible

to build connections among people who will seemingly never agree and therefore believe there is nothing to be said.

My hope is that you will turn to this book when there is someone in your life with whom every conversation threatens to become an argument, when your option is to tell them they're wrong or just shake your head and stop talking altogether. I have lived in this space all my life. Because I am a light-skinned Black Jew, sometimes called "racially ambiguous," I've been talking about race for as long as I can remember. So, in this book about conversation, let me begin by addressing one of the worst questions you can ask another human being: "What *are* you?"

Mostly, I'm Black. My grandfather was William Grant Still, known widely as the dean of African American composers. His skin was the color of brown mahogany. Mine is the color of sugar pine. My grandfather suffered countless indignities and injustices because of his color. I remember them to this day, almost viscerally. They still feel personal to me.

In 1947, when Oberlin College awarded him an honorary doctorate, he drove with his family from Los Angeles to Oberlin, Ohio, southwest of Cleveland, for the ceremony. He couldn't stay at the white hotels because he was Black; he couldn't say at the Black hotels because his wife was white. So he drove about 2,300 miles without stopping. In photos of the ceremony at Oberlin, he's stooping; he looks exhausted. That story is part of our family history. I've heard it dozens of times, and yet my chest burns with indignation every time I see the photos. It still makes me angry.

My grandparents had to get married in Tijuana, Mexico, because marriage between a Black man and a Jewish woman was illegal in California, where they lived. That's personal.

He had to build a six-foot fence around his home to protect his children—my mother and her brother—from violence. At that time, people were dragging mixed-race families out of their beds

and beating them, or even setting their homes on fire. I look at my mother sometimes and think about how lucky I am that she survived.

I have roughly the same amount of Black ancestry as Sally Hemings, slave to Thomas Jefferson and mother to at least six of his children.[13] (Side note: Three of those children lived their adult lives as white. They "passed.")[14]

Kids at my elementary school called me a "nigger" sometimes. I punched one of them in the eye and was sent to the principal's office. This would have been the late 1970s and my progressive principal told me that if anyone else called me that name again, I should punch them, too.

I spent a good part of my childhood at my grandparents' home in Los Angeles. They lived in the Oxford Square area, near the corner of Pico and Crenshaw, one of the first Black middle-class neighborhoods in the city. Whenever I was staying with them, which was often, I was surrounded by Black people.

I remember going to the National Center for Civil and Human Rights in Atlanta and reading through the Jim Crow laws from various states, all of which would have legally applied to me and to my son. Regardless of how I see myself, I am not far removed from a time when I would have had no option to think of myself as anything other than Black. As the deeply racist lawyer and politician Thomas Dixon Jr. wrote in his bestselling novel *The Leopard's Spots*, "One drop of Negro blood makes a Negro" and "puts out the light of intellect."[15]

I'm also white. My mother's side of the family was born of the rape of young female slaves by their owners. That means I share DNA with the man who owned my great-grandmother.

My mother was fair skinned, while her brother was chocolate brown. My mother married a tall white guy with Texas roots, so my paternal grandparents are white, as are my cousins.

People don't always look at me and think I'm part Black. Once when I interviewed the actress Mo'Nique, she called me a "white lady." I was raised in an upper-middle-class town in California where I was surrounded by white people. Almost all my childhood friends were white; there were hardly any Black kids to hang out with in my neighborhood.

So what am I? What race do you think I should claim on my census forms?

When I was in elementary school in Mission Viejo, California, I was the second-darkest kid in the school. Only Shawna, with her glowing walnut-toned skin and colorful barrettes in her perfectly pigtailed hair, was darker than me.

One day, a classmate came to me at recess while I was playing tetherball. "My grandpa told me you can tell if someone's Black because their skin is darker than a lunch bag," she said. She was holding a wrinkled paper bag in her hand.

"I am part Black," I said. (I don't say "part" anymore.)

"Let's see," she answered, and pressed the lunch bag up against my forearm. My arm was at least a shade darker than the bag. "So you're Black."

"Look at Karen's arm," I said, gesturing to the friend I'd been playing with. "Her arm is darker than mine."

"Yeah," replied the girl, "but she just has a tan. She'll go back to normal. You won't."

I hope you can see, as I lay out this "evidence," how absurd this debate really is. As the geneticist Adam Rutherford has written, "You are descended from multitudes, from all around the world, from people you think you know, and from more you know nothing about. You will have no meaningful genetic link to many of them. These are the facts of biology."[16] Rutherford reminds us, as we struggle to place one another into categories, that "for humans, there are no purebloods, only mongrels enriched by the blood of multitudes."[17]

My situation is hardly unique. It is not only the descendants of Africa who are often forced in the United States to choose between one race or another; this is common whenever someone's ancestors hail from somewhere other than Europe. The nineteenth-century Cherokee chief Guwisguwi, called "the Moses of his people" by white supporters, was just one-eighth Cherokee, with the rest of his ancestors mostly Scottish. Yet he led the Cherokee Nation for nearly four decades.[18]

The science of race has been available to us for decades, but most people still operate under the false ideas that a person's race is knowable, that having that knowledge helps us understand them, and that racial identity can be granted or denied. Some people have screamed in my face that I'm not Black (for instance, when I tried to join the Black Student Union in college), and others have dismissed my opinions on issues by saying, "Well, you're Black, so it makes sense that you'd think that." Yet I am neither Black nor white.

When I was young and trying to find an identity, I was obsessed with stories of mixed-race people. At some point in college, I found Walter Francis White's memoir, *A Man Called White*. The civil rights activist was at the helm of the NAACP from 1929 until his death in 1955.

White was so, well, white, that he had fair skin, blond hair, and blue eyes. He was so Caucasian in appearance that he nearly joined the Ku Klux Klan (KKK) as an undercover investigator. In his memoir, he describes sitting in fear as a child during a race riot in Atlanta, when his family's home was nearly burned to the ground. "In the flickering light the mob swayed, paused, and began to flow toward us," he wrote. "In that instant there opened up within me a great awareness; I knew then who I was. I was a Negro."[19]

Today, the one-drop rule may have been struck from state laws, but it lives on in the nation's subconscious. I remember reading a piece by Henry Louis Gates Jr. in a 1996 issue of the *New Yorker*

and feeling every word vibrate in my chest. Gates was reviewing a memoir by Anatole Broyard, the respected literary columnist who was Black but chose to live as a white man. As Gates put it, Broyard was "born black and became white." I can still remember how I felt when I read these words: "Racial recusal is a forlorn hope. In a system where whiteness is the default, racelessness is never a possibility. You cannot opt out; you can only opt in."[20] That's so true that reading it squeezed my heart.

My heritage and my non-race-specific features have allowed me to see the racial underpinnings of our society in a way that most can't, or don't. On the one hand, I hear things I'm not meant to hear; people say things they wouldn't if they knew my background, and I've seen prejudice in both blue eyes and dark brown. On the other hand, my light skin has protected me; there is no denying that. Going back generations, my family members chose light-skinned mates, partly because light skin is associated with higher rank, better opportunities, more safety. I look at myself in the mirror, see my café-au-lait skin, and think about how my racially ambiguous appearance was not an accident, but the result of intentional, racist choices made by my ancestors. Choices with which I can empathize but still deplore.

I've never been followed through a store by a suspicious clerk; I've never feared for my life when pulled over by a police officer; I doubt I've ever made people nervous or fearful just by walking into a room. In order to understand how those experiences feel and how they impact a person's life, I've had to ask questions of my darker-skinned friends and thank them for sharing such painful memories with candor.

In general, I tell people who ask that I'm Black and Jewish. Why? Because that's how I was raised. My grandmother was Jewish but her family cut ties with her almost completely when she married a Black man. It was my African American relatives who never blinked

or hesitated after their wedding. I grew up with her, my Black grandfather, and their daughter, my mother.

Yes, I'm the descendant of slave owners as well as slaves, but there was never any question about which side would care for my family when the Civil War ended. My great-great-grandmother's children were born of rapes she suffered while enslaved. Most of her children were taken from her, sold to other plantations and masters. When emancipation came, do you think she would hand her remaining daughters over to the people who'd kept her in chains? Do you think the white family would take them in? No, there was never a question about what side of town my family would live on, or who would love and nurture those babies.

I'm roughly 25 percent Black, more than enough to banish me from the homes of my white forebears. In years past, I would have been called a "quadroon." (That label and others like it are offensive, of course, and no longer acceptable to use.) About nine million people in the United States identify as multiracial, as I do. Our histories are part of America's racial story.

If I am brown enough to have been called "nigger" in school, to be denied promotions at work, and to be labeled "angry"; if I'm brown enough to inherit no property from my ancestors because racial inequity and discrimination left them nothing to hand down; if I'm brown enough to feel indignation and shame when I think about what my family has endured—then I'm brown enough.

And here's why this argument matters in a book about conversation: If I stopped talking to everyone who didn't understand my racial background and experience, I would have few people to talk to.

This is a book for people like me, who have tried to debate and educate and argue, gained no ground, but are not ready to give up. This is a book for optimists, those who believe we don't have to exclude people who see things differently. We don't have to accept the

racists' view of the world or allow their ideas to govern policy, but we also don't have to ostracize them.

A conversation, it should be noted, is not a debate. A debate will not change someone's opinions, no matter how devastating your statistics or eye-opening your data. And yet we often enter exchanges about race armed with our anger and our facts. In doing so, we engage in a practice that the Harvard Negotiation Project, a division of the school founded in 1979 to address issues of conflict resolution, calls "wrong-spotting."[21] We already know how we feel about a person, we're confident that we're right, and we watch like a hawk for what they get wrong. When you are wrong-spotting, you will always feel vindicated because everyone makes mistakes or says things that seem wrong from your perspective.

For example, people will say this book has flaws, that it doesn't ring true to everyone, that it doesn't fully capture the struggles all people face—and those critics will be right. No book can be all things to all people, and that's especially true with the subject of race.

Although, when I inevitably get something wrong, it won't be because I haven't done my homework. I've read the books, not just the recent ones, but going back more than 230 years to the slave narratives of Olaudah Equiano and Frederick Douglass and Harriet Jacobs. I read Ida B. Wells and Booker T. Washington and W. E. B. Du Bois. I read Malcolm and Zora and Toni and Maya and James Baldwin.

If I get something wrong, it's a matter not of ignorance, but of different understanding. That's what I'm trying to say here: there is always something to be learned about how racial identity manifests in the lives of others. None of us can ever fully know what others have suffered, and so we must always listen, always stretch our empathy to embrace more stories and experiences and ideas.

Even civil rights activists make mistakes. For example, Harold Washington, the first Black mayor of Chicago, said that if someone is living in America, they must learn how to speak English. The political science professor María de los Angeles Torres recalled fighting with Washington over that issue. "Even he didn't understand that language was part of identity," she said. "It's like asking an African-American to straighten his hair because that's the way Americans do it."[22]

It is impossible for one book to tell you everything you need to know about the lived experience of people who have survived as a different race in a different culture and perhaps a different era. That's why I want not to teach you about race, but how to *learn* about race. I want to teach you how to ask questions and, most important, how to listen to the responses. I want you to master the skills necessary to be changed by what you hear.

If your goal is to have an honest discussion, rather than to prove someone wrong and create a viral video of your victory, then you must let go of the temptation to wrong-spot. Instead, I encourage you to engage in "difference-spotting." Even two people of the same race will likely see things slightly dissimilarly, depending on their genetics and experience, so there are a lot of differences to discover.

It's hard to talk about race because, whether we admit it or not, race is part of our identity. It's tightly enmeshed with our ideas about family and heritage and personal pride. It is at the core of who we are, for better or worse, as it influences the way we interact with the broader world. In many countries, race determines where you're born, what school you attend, what job you get, how much money you make, and even how you die. Talking about race in America makes Black people feel angry and, often, makes white people feel leery.

We've tried not talking about it, of course. It's considered impolite to discuss race in mixed company or at work. Instead, we soliloquize

about disparities and fairness and equality without mentioning racism, the very reason things are unfair and society is unequal. I see headlines that read, "Inequality in Health Care Is Killing African Americans," and think, "Well, someone had better arrest inequality for murder."

Not talking about it has not made it go away. We can't keep race in our peripheral vision anymore. What's needed are honest conversations that lead to greater understanding. Right now, the gap between the world Blacks see and the world in which whites live, or think they live, is far too wide.

Here's a perfect example: For a 2016 study, the Pew Research Center asked Americans why they think Blacks struggle to get ahead. African Americans blamed failing schools, discrimination, and few job opportunities. Whites blamed a lack of positive role models and family instability. Fewer than 40 percent of whites thought racial discrimination was the main reason white Americans become successful more easily than Blacks.[23]

Over and over, in survey after survey, white Americans underestimate the role that racism plays in the lives of Blacks and downplay the severity of inequality in our society. As the Yale professor Jennifer Richeson says, "People will not attempt to solve problems that they are either unaware of or believe do not exist."[24] That means progress is contingent on the conversations we have and how much we learn from one another.

As difficult as they seem, as frightened as we are that they'll lead to arguments and hurt feelings, honest conversations about race *must happen*. The question is, will your conversation about race enlighten you or simply confirm what you already believe is true?

Let me be absolutely clear, with no equivocation: This book is about talking to friends, family members, neighbors, people you bump into at the hardware store or the library. This is not a book about how to talk with elected representatives, who must bear a

higher level of responsibility for systemic racism because they have asked to be made responsible. It's also not about debating a troll on Twitter or shouting down a neo-Nazi at a rally.

I will never ask you to endure abuse or offensive language. I would never expect you to tolerate hatred or smile at someone who refuses to acknowledge your basic humanity or accord you the respect you deserve. I hope you encounter very few of those kinds of people in your life, and I don't suggest you bother talking with them.

However, there are people willing to talk, even if they don't expect to modify their opinions. There are many willing to discuss race, and to do so respectfully. These are the people whom I hope you'll seek out. These are the people, on both sides of the political and racial divide, who are willing to at least hear what you have to say. If there is a glimmer of light coming through that doorway, a tiny opening left by a door that's slightly ajar, I suggest you put your toe in there.

I want you to talk about race more often, and I want you to learn to be as honest as you can. As Ibram X. Kendi has written, "The heartbeat of racism is denial, the heartbeat of antiracism is confession."[25] You will not always agree with other people on issues of race, even if they share your skin color or voted for the same person you did. You will have novel views because this planet currently offers 7,834,000,000 independent experiences with what race is and how racism manifests in society.

Some believe Black people can't be racist. I don't agree. Black people have demonstrated virulent racism in past years, even as they are the victims of racist policies in the United States and so many other countries. Can gay people be homophobic? We know they can. Can women be sexist? Yes.

María de los Angeles Torres, the professor who fought with Harold Washington over language and identity, has said that she has

struggled to explain racism against Latinx* people to her Black friends. "I've never been allowed, even by them," she said, "as someone who has also suffered discrimination. That's always been denied me. . . . This has made unity so difficult to come by."[26]

Beverly Daniel Tatum, a psychologist and the former president of Spelman College, has written, "Prejudice is one of the inescapable consequences of living in a racist society. Cultural racism . . . is like smog in the air. Sometimes it is so thick it is visible, other times it is less apparent, but always day in and day out, we are breathing it in."[27] In this book, we will confront racism: the tendency to make assumptions about a person's character and personality (even positive assumptions) based on their race.

I make these kinds of assumptions all the time, even though I'm actively trying to overcome the racism I've learned. I walked into an Apple store not long ago, saw two people at the counter, and immediately turned to the East Asian man to ask my question. Turns out, he was a customer. The young Latinx woman beside him was the clerk. My error was based on my own racism. I have implicit biases; we all do. I have unconscious biases; we all do. The first step in addressing implicit bias, though, is to make it explicit. The first step in limiting unconscious bias is to make it conscious. That means we all have a lot of tough conversations ahead of us.

If you have been told you are a racist and you need to learn how to

* "Latinx" is a gender neutral term for someone of Latin American descent, replacing the gendered terms "Latina" and "Latino." While usage of "Latinx" is still not widespread, its use is growing. Research from the Pew Center has found that most adults from Latin America or Spain, often referred to as "Hispanic," actually prefer to identify themselves by their country of origin, describing themselves as "Mexican" or "Colombian," for example. These terms will likely continue to evolve in the years ahead and it's helpful to ask people how they choose to be identified rather than making assumptions.

explain yourself to others, I'm talking to you. If you know someone who bristles every time they hear the word "privilege," this book is for you. Using science and research and lived experience, I can teach you how to have the conversation *anyway*.

We all have work to do, and a lot to talk about.

PART I

THE CONTEXT

CHAPTER 1

WHO IS RACIST?

> I like to pretend that I have a scientific, intelligent attitude. I don't like to admit that I'm subject to being swayed by stupid things like racism. But in my mind, I'm worried. Maybe I am a racist.
>
> —GILBERT GORDON

There are many definitions of "racist," and none that I've seen are entirely wrong. You could say a racist is someone who discriminates against others who appear to belong to a different race. For the purposes of this book, this definition doesn't work, as it absolves people of being racist until they take concrete action to hurt another person. They can harbor very racist beliefs, but until they exclude Asians from their group or refuse to hire a Black employee, we don't consider them racist.

Yet the racist behavior that is most common and affects the largest number of people is not the behavior that breaks laws, but that which harms others incrementally: the casual racist comments thrown out over dinner, the choice to look at your phone while a person of color is speaking in a meeting, the unconscious decision to avoid looking at Black people as they pass you on the sidewalk.

Those behaviors are rooted in racist beliefs. Therefore, in this book, I will use this definition: a racist is someone who makes assumptions about another person (either positive or negative) because of their perceived race or ethnicity.

By that definition, we are all racist. Perhaps we don't think horrible things about Muslims, but we might subconsciously assume all Mexicans are immigrants or all immigrants from India are hardworking. Maybe we think Koreans are good at video games or Native Americans are inherently and profoundly connected to the natural world. These are all racist assumptions.

Let me tell you about a series of experiments designed to answer the question of who considers themselves racist and who doesn't. Researchers in Oklahoma and Pennsylvania presented people with a list of forty-six behaviors, including some racist ones, like "Have you ever avoided a Muslim person out of fear, laughed at a joke about an Asian person, or used the N word to describe a Black person?" Participants were asked to write down their honest responses, assured of anonymity. Months later, the participants were called back to the lab. They were given a list of behaviors that another person had engaged in and were asked to compare themselves to that individual. They were told the lists were randomly distributed, but in fact everyone was presented with their own list, a duplicate of the behaviors they either admitted to or denied. And yet most people rated themselves as significantly less racist than the "other person."[1]

This result can be partly attributed to what is known as "the better-than-average effect," or illusory superiority. In general, most of us think we're better than average at most things. But this phenomenon does seem to be more dramatic when it comes to prejudice. The psychologist Angela Bell, lead author of the study, said that "understanding why people fail to recognize their own racism—even when confronted with evidence of racism by their own definition—is a necessary step to reduce prejudice."

Our state of denial is not new; its history is as long as that of racial bias. For his book on race in the 1990s, the author Studs Terkel spoke with Peggy Terry, granddaughter of a poor white Oklahoma coal miner. As an adult, Terry became a passionate advocate for justice and equality. She told Terkel, "To a certain extent, we're all racists. Maybe not to the point of burning crosses, but we have attitudes that we don't even recognize in ourselves. I know I'll never be free of it. I fight it all the time. . . . I will never reach the point where I can sit with Black people and be unaware of their being Black."[2]

Another woman, in her conversation with Terkel, recounted an incident during which she was confronted with her own prejudice. Lynda Wright, a Black businesswoman, told the author she felt wary when she began working alongside a group of Asian Americans because she'd been told they'd come from Vietnam in order to take jobs from Black people. "I believed it," she said. "Finally, I got a chance at a one-on-one. It was a Vietnamese kid, a teenager, who decided to just be my friend and forced me to face my own racism."[3]

Then there's the civil rights activist Bill Hohri, who spearheaded the lawsuit against the U.S. government over the internment of Japanese Americans during World War II. Hohri once said he'd be more afraid of three Blacks approaching him on the street than of three whites. "That's because of my own racism and the way our culture works," Hohri said. "Am I a racist? I think so. I'm probably racist toward Whites, too. I don't have a real high opinion of White people. Racism is a hard thing."[4]

Hohri is right: racism is a hard thing. I urge you to accept that racism lives in your subconscious, partly because denying that fact can prevent you from making headway in anti-racist efforts. In 2009, researchers at Stanford discovered that whites who expressed public support for President Barack Obama felt they were justified in favoring whites over Blacks, since they couldn't possibly support a Black politician if they were racist.[5]

In a separate study with a similar aim, scientists asked people which candidate they would hire at a police department that had a history of racial misconduct: a Black officer or a white one. First, though, the participants were separated into groups. Those in one group were allowed to voice their support for Obama; those in the other group were not. The people in the latter group tended to say that both officers, Black and white, were equally suited for the job. Those who'd been given an opportunity to endorse Barack Obama were more likely to say the white officer was more qualified and better suited for the job.

In yet another experiment, people were given a hypothetical task: allocate taxpayer dollars to two different private organizations, one that served the Black community and one that catered to white citizens. Those who were allowed to openly voice support for Obama ultimately gave more money to the white organization than those who didn't. One of the researchers, Daniel Effron, concluded that approving of Obama is "the psychological equivalent of when people in casual conversation say something like 'many of my best friends are Black.' . . . They say that because they're about to say something else that they're concerned might be construed as prejudiced."[6]

Effron and his colleagues found that people who had the opportunity to endorse Obama in his first presidential campaign gave preference to whites over Blacks in job searches, for example, because they believed endorsing a Black president afforded them "moral credentials."[7] When we say that we are "not racist," we assure ourselves that nothing we do could possibly be discriminatory. We give ourselves blanket absolution.

Globally, there is a fundamental misunderstanding of what it means to be racist. If we are to move forward, we must stop denying our own biases. We must stop believing that the real villains all belong to neo-Nazi groups and sport swastika tattoos. As the diversity consultant Eddie Moore Jr. says, "When you say 'white supremacy' or

'white privilege' . . . people still think you're talking about the Klan. There's really no skills being developed to shift the conversation."[8]

During a discussion about race with dozens of my colleagues in public radio, I urged everyone to accept that they're biased and to watch for signs of prejudice in their own lives. One Jewish woman, Helen Barrington, an editor at Virginia Public Radio, told me, "I genuinely believe that older White women—especially Jewish White women—don't think they can be racist. We were told by our parents they were oppressed and hence, so are we. . . . I think if we can accept we are racists, because our society is foundationally racist, we can open our eyes and make ourselves better."[9]

When I asked Helen for permission to include this comment in my book, I said I could use the quote anonymously if she felt apprehensive about stating her opinion publicly. I had found, over the course of my conversations with public radio colleagues, that many people stayed silent during the meetings and then sent me private emails with their honest reflections. But Helen responded, "Perhaps you should not anonymously quote me. Time to step up and not worry anymore."[10] It takes guts to go on the record about race, but this kind of courage is what will ultimately drive anti-racist efforts forward.

Despite the very clear impact of bias on our decision making and our judgments, we're often unaware of our own racism. This is one reason why even David Duke, convicted felon and former grand wizard of the Knights of the KKK, can swear with a straight face that he's not a racist. It's possible he really believes that.

George Wallace Jr., son of the infamous Alabama politician who was governor when Bull Connor turned the dogs on twenty-five-year-old John Lewis and other protestors in Selma, has written that his father's "acceptance of segregation was with no sense of ill feeling, malice, or hate toward Black people."[11] You read that right: he

is suggesting that the man who said he was "out-niggered"[12] by a political opponent was not, underneath it all, a racist.

This kind of blindness is common. Once I reported a story for National Public Radio, in which part of the audio that didn't make it on the air was an excerpt from an interview with a man who claimed his great-great-great uncle—a plantation owner who owned at least two dozen human beings—was not racist, but just trying to be a good businessman, using the tools at his disposal.[13]

These examples may be extreme, but the point applies to us all. We can only begin to make progress when we acknowledge that, while some people *are* worse than others, none are free from the taint of prejudice. We all suffer from it; some make others suffer for it. It is human nature to classify people and take cognitive shortcuts by assuming this person who looks and sounds a little like another person also behaves the same way. We can allay our fear of the unknown by manufacturing "known" facts about others, pretending we cannot be surprised because human behavior can be predicted using demographics.

Being an anti-racist is not a status you achieve, but a skill you must constantly practice. Of course, I'm not saying everyone is equally culpable; some are working hard to fight their unconscious biases, and some refuse to even admit those biases exist. In her most recent book, the journalist Isabel Wilkerson chooses to set the word "racism" aside, writing that "resistance to the word often derails any discussion of the underlying behavior it is meant to describe, thus eroding it of meaning."[14]

I agree. It is not necessary to reach a consensus on the definition of "racism" in order to talk about race, and calling someone "racist" will almost certainly lead to argument, not fertile discussion. After all, says Wilkerson, "Who is racist in a society where someone can refuse to rent to people of color, arrest brown immigrants en masse, or display a Confederate flag, but not be 'certified' as a racist unless

he or she confesses to it or is caught using derogatory signage or slurs?"[15] In fact, we've seen several people get caught using ethnic slurs and skate by with an apology that says, in essence, "I'm sorry that I used that word, but I'm definitely not racist."

I want to help you have honest conversations about race, not argue over terms. In the view of the historian Ibram Kendi, the issue can be simplified down to the following statement: you are either anti-racist or racist. Either you are actively working to dismantle the systems that disadvantage some and benefit others, based solely on perceived ethnicity, or you are contributing to those systems through action or inaction.

Understanding that we all tend to stereotype others and that every human being has some bias hiding in their subconscious is crucial because it can help establish common ground. Without acknowledging our shared human weakness, it can seem we are calling someone inhuman when we call them racist.

I spoke about this with Mitch Landrieu, the former lieutenant governor of Louisiana and former mayor of New Orleans. As the white mayor of a majority Black city, Landrieu had many complicated conversations about race. In 2015, he proposed that the city remove the four Confederate statues remaining on municipal land; the city council agreed. Two years later, Landrieu made headlines because of what he said as the last of the monuments came down, in a speech that used one particular word more than a dozen times: truth.

LANDRIEU: I gave that speech for white ears. I directed that speech to white people. I don't ever profess to try to communicate well about race to African Americans, but I feel like I'm culturally competent to talk to white people about how to be white in the South. It struck a chord nationally because the timing was fortuitous. It just kind of hit when lots of people were thinking about it.

That's a very gentle speech, actually. The truth is searing, because it's a hard truth, it's not a watered-down truth. It's a real truth. But the tone in the speech, the language in the speech, the invitation in the speech was spoken to white people to almost plead with them and to offer them a pathway to a better place. That speech had eighty-eight versions and the first forty versions were all harsh condemnations—Why are you thinking this way? We waited too long. This is absurd. What we've done to the Black community is terrible. You ought to be ashamed of yourself. But when I was practicing it, my staff and everybody who was working on it with me said, "You cannot brutalize these people like that. They will run away from you." So I completely reversed my strategy. Originally, I was trying to condemn; I was trying to argue. I was trying to win the point. Then I thought, This is not going to work. How am I going to create a space for transformation? So I changed the language.

HEADLEE: When you say that you were offering an invitation, did you have anyone specific in mind who you were speaking to?

LANDRIEU: I was speaking to white male southerners. I was thinking about all of my friends I went to Jesuit high school with, who didn't understand what I was doing. They were saying, "Mitch Landrieu is a traitor to the white race."

My question to them is: How much have you lost? If you think about what we've lost—four million people leaving the South, taking their intellectual capital, that raw material, and doing great things in Los Angeles, in New York, and in California. My friend Wynton Marsalis is making music and making people happy, but he's in New York.

How many Jackie Robinsons, how many Oprah Winfreys, how many Louis Armstrongs left the South and took all of that talent and went someplace else with it? That's what we lost because we sent it

away. And so I wonder, what if we had gotten it right and, oh, by the way, we can still get it right, and what if we do? What does that look like for the country? Are you open to seeing that?

I tell people, You can't go over race, you can't go under it, you can't go around it. You have to go through it and going through it is painful.

We have never had a mature, thoughtful, productive conversation about race. So many people are so confused, even people that are trying hard, they don't know what to do. That's why I think the country has to actually decide that we need to have a strategic, thoughtful pathway to exorcizing this demon from our souls. We have to be able to identify this bone marrow that's inside our bodies, recognize it, notice it, make people aware of it without condemning them.

That is really hard because there are some 25 percent of people who actually *need* to be condemned, because they're so hateful that there's nothing you can do with them.

But we've never practiced having a productive conversation. How can we be good at it? Germany did it. South Africa did it. We've never done it. We've never done it in a thoughtful way. I'm not trying to excuse people and I don't think there is an excuse. I just see human beings saying, "I don't know how to talk about this." And so they ignore it and they're scared of it, you know?

HEADLEE: Do you think conversations about race have gotten worse? Is racism getting worse?

LANDRIEU: [He turns to look at a photo behind him in which he's embracing Congressman John Lewis.] I brought that up with John Lewis once, and he didn't say that the idea offended him. But he said, like Barack Obama, "Listen, my life was not in vain." He said we have made a lot of progress. He said, you know my history, all the suffering that we endured for everybody's sake. And

as a consequence, I can attest to you personally that the world is so much better today than it was in 1965. And every year it's gotten better.

The world may be better than it was 1965, but it is still far from inclusive and fair. The irony is that bias is incredibly human. That's why approaching these situations with a mindset that acknowledges underlying bias allows us to say, "Ah, you're making an assumption about that person because of their race. I understand because I used to make a similar mistake before I learned better. Let's talk about where that assumption comes from and maybe I can help you, just as someone else helped me."

We seem to be obsessed, though, with the idea of calling people racist. Perhaps the most common question I get is: Should I call someone a racist when they say something offensive? Unfortunately, there is no simple answer here. It's generally possible to label a statement or action as racist without labeling the person, and that's important because calling someone a racist tends to shut down the conversation. We can argue the rights and wrongs of this issue for days, but the truth is, once you say to someone, "You are a racist," they accurately believe they've been labeled, and they will usually become defensive. Calling someone racist might make you feel good, but what does it ultimately accomplish? I've been talking about race for most of my life and I've never had an experience in which I called someone racist and they responded: "Oh my God, I am? I'm going to stop thinking these racist things and using these racist words right now! Thank you so much for bringing this to my attention!"

That said, it's imperative that we call out racist actions and behaviors when we see them, so it can be helpful to learn how to do this in a noncombative way. I find that I'm most likely to tell someone

they're racist in response to their claim that they aren't. Such claims usually follow their utterance of a shockingly racist comment. These exchanges go something like this:

THEM: [ridiculously racist comment]
ME: Whoa.
THEM: I'm not racist!
ME: Yes, you are.

For example, when I owned a house near Detroit, my neighbor asked me to do him a favor while he was on vacation. A couple things you need to know, for context: I lived in Grosse Pointe Park, a now-diverse community that was historically all white because of aggressive civic action and redlining designed to exclude Blacks and Jews. Also, I lived two blocks from the border with Detroit, a city that has been majority Black for decades.

My (older white male) neighbor approached me while I was pulling weeds in the front yard and said, "Celeste, could you collect my mail for a couple weeks? I'm going to Belgium to see family, but our post office is in Detroit and I don't want those people"—here he pointed significantly toward the city line—"to know that I'll be away."

I answered, "I'm happy to get your mail. But just so you know, I'm Black, so I'm one of those people."

"No, no, I'm not racist!" he protested.

"You absolutely are," I said. "But I'm still going to get your mail, don't worry. Have a great vacation."

Because of my light skin, people (mostly white people) say things to me that they really shouldn't say, that they *wouldn't* say if they knew my ancestry. When I was younger, apprehensive about making people angry, I would ignore those comments and say nothing.

Since then, I've learned that to allow such remarks to pass is to normalize racism, so I respond every time, regardless of the situation or audience. Once, during a discussion onstage in front of thousands of people, I told an interviewer his question was racist.

The secret is, I try to use my pushback as an invitation to a conversation instead of a slammed door after an angry exit line. Not, "You're racist, you piece of crap!" but "Wow, that was a racist thing to say. Where did that come from?" If they respond, as they often do, by avowing that they're not racist, I ask if I may explain why their remark was inappropriate.

Racist comments should never be allowed to stand without opposition. Racist remarks are not just idle chatter—they reinforce harmful attitudes and policies, and they can damage the people who hear them. Racism is traumatic. If you had been beaten or harassed as a child, how would you feel if others cracked jokes about the source of your pain, or made offhand remarks that reminded you of the worst day in your life? If you asked them not to mention that kind of abuse again, how would you feel if they told you to "lighten up" or "stop being so sensitive"?

Before you ask someone "Why does it always have to be about race?" or tell them "That's not what he meant" or "He was only joking," stop and imagine how you might feel in their position. We all have sensitivities based on our lived experience, and they can help us comprehend the damage that insensitive remarks may cause.

My family has been harmed by racism again and again. It has cost us our safety and our security and our jobs. Racist comments are never funny to me, and if you care about my feelings, you won't make jokes about something that has hurt me.

This is partly why people of color get upset when they're told to stop complaining or to "get over it." In the end, when we talk about racism, we're talking about actual trauma that African Americans have experienced and are still experiencing. Instead of expressing

concern, people sometimes try to ignore or diminish what Blacks have been through. Would you make a joke about cancer to someone who's going through chemotherapy? A joke about death to someone who'd just lost a loved one? Probably not.

Think of it this way: We sometimes label humor as inappropriate because it is "too soon." That means the tragedy referenced is too serious and too recent to laugh about. Racism is recent—it is ongoing—and it is oppressing and killing people. It is always "too soon." If someone tells you that something you've said is racist, "It was only a joke" is never an appropriate defense.

That brings us back to the question of whether or not you should call someone a racist. You certainly can, if they've said or done something racist. There's a lot of value in identifying racist behavior when it arises, with honesty and courage, instead of allowing it to pass unaddressed.

If the person in question is a politician or public figure, it's important they be correctly labeled as racist, as their prejudice will affect their decisions and opinions, and those decisions might affect millions of people. What's more, the label is not as scary as some make it out to be. As Ibram X. Kendi wrote in *How to Be an Antiracist*, "'Racist' is not . . . a pejorative. It is not the worst word in the English language; it is not the equivalent of a slur. It is descriptive, and the only way to undo racism is to consistently identify and describe it—and then dismantle it. The attempt to turn this usefully descriptive word into an almost unusable slur is, of course, designed to do the opposite: to freeze us into inaction."[16]

After Dylann Roof shot and killed nine Black people in a Charleston, South Carolina, church in 2015, President Obama took a lot of flak for delivering a speech on race without using the words "racism" or "racist."[17] While it's true the president should not have been afraid to use those words, it's also true that he was trying to speak to all Americans in his remarks, even the white citizens who react

badly to the word "racist." The term may be accurate, but it's not always helpful. It's silly to deny that.

Calling someone a racist can end the conversation and the prospect for authentic connection. Is it wrong for someone to feel victimized when they're called a racist? I think so, yes. Can we stop them from feeling that way? Nope. By avoiding that term, though, we can continue to talk about race in a way that may enlighten them and us, and could possibly realign their views.

This is a decision you'll have to make in the moment, and your choice may depend on the environment and the tone of the discussion. You'll have to choose whether it's worth it to call someone racist or to further interrogate their ideas and dig deeper into their thought processes. I think the latter strategy is generally more effective, and it's crucial to make that choice if we hope to address the issues that threaten our society.

Perhaps you're interacting with someone who has made racist comments in the past or behaved in a manner you felt reflected racist beliefs. Before you openly label them a racist, are you sure they still feel the same way now?

Minds can change. Consider how society's views of the LGBTQ community have shifted over the past twenty years. If we acknowledge that public opinion can evolve, we must also allow for the possibility that the people in our lives can reform without being eternally burdened by their mistakes. Past racism does not necessarily prove someone is currently discriminatory.

We are all constantly in the process of realizing how racism has affected society and the lives of the people around us. It's a truism that the first step toward change is acceptance, and if we are to eradicate racism, or even lessen its death grip on our world, we must accept that it is everywhere, even our own homes. Like the proverbial fish that suddenly notices the water around it, we must awaken to the presence of racism surrounding us.

We have known for decades that children of all races internalize the values of white supremacy and accept them as truth. It was in the 1940s when the trailblazing African American psychologists Mamie and Kenneth Clark designed their famous "doll test" to study the effect of segregation on young children.[18] The Clarks presented 253 Black children, ages three to seven years old, with four dolls. The dolls were identical in every way except skin color. The children were then asked to identify the race of each doll and to say which doll they preferred. The majority of the children told the Clarks they liked the white doll the best and described that doll as nicer and prettier. In one case, Kenneth Clark asked a Black boy which doll looked most like him. The boy pointed to the doll with brown skin and said, "That's a nigger. I'm a nigger."[19]

Is that child racist? Yes. He assumed that white people were better, and Black people were inferior. Is that little boy as bad as George Wallace? Of course not. Wallace was a perpetrator of racism; the child is a victim. This is the tragedy of systematized racism; it can make a Black child believe the lies he is told about himself. It can make him believe he deserves to live in poverty, or that whites deserve to be treated with more respect than he does.

It is nearly impossible to grow up in our society, soaked in racism the way rum cake is soaked in booze, and not internalize racial stereotypes. Even Black folks are affected, subconsciously, by white supremacist messages that surround us all day, every day. The Reverend Jesse Jackson once said, "There is nothing more painful to me at this stage in my life than to walk down the street and hear footsteps and start thinking about robbery and then look around and see it's somebody white and feel relieved. How humiliating."[20]

This same principle holds true for Muslim people surrounded by anti-Islamic rhetoric, or Native children having to look at racist sports icons, or Asians who are subjected to characters like Punjab, the bodyguard in *Annie*, the Siamese cats in *Lady and the Tramp*, or

Long Duk Dong in *Sixteen Candles*. On some level, we internalize the underlying narratives in our media, even if they tell us negative stories about ourselves.

This is certainly true for women, who are born into patriarchy and bombarded with sexist attitudes, laws, and images throughout their lives. "American women, without exception," bell hooks wrote in her 1981 book, *Ain't I a Woman: Black Women and Feminism*, "are socialized to be racist, classist and sexist, in varying degrees."[21]

Don't get me wrong: growing up surrounded by racism is not a valid defense for tolerating white supremacy, and there is no equivalency between a Black person who harbors unconsciously racist thoughts and a white person who does the same. Racism among people of color causes self-harm; racism among whites perpetuates oppression. Racial bias may be universal, but the damage caused is almost entirely borne by communities of color.

While people of all colors are racist to some degree, racism writ large nearly always benefits the white race. Our systems and institutions were designed that way, because they were mostly designed by white people or by people of color who were raised to believe in a myth of white supremacy. That means it's the duty of white people to acknowledge their racism and work to dismantle the systems that weaponize bias. White communities have more power than communities of color, regardless of income or status.

Sometimes white people hesitate to enter these conversations, feeling that it's not their place or that they should allow people of color to speak for themselves. Yet research shows that white people are rewarded when they raise issues of diversity and inclusion, at least in the workplace, while BIPOC (Black, Indigenous, or other persons of color) individuals are often viewed more negatively when they draw attention to inequities.

Even more significantly, when a white person is confronted about racist behavior, they view the person who pushes back less nega-

tively when that person is white. They're also more likely to apologize in that situation and to be persuaded to change their behavior. As the social psychologist Dolly Chugh writes, "We do not feel like it is our place to say or do something, even when we are just as outraged about an issue as someone who is directly affected. It is not that we lack confidence or fear punishment. The risk feels great. . . . The challenge may not be a lack of outrage as much as a lack of psychological standing."[22]

So jump in. Don't let your fears of getting something wrong or revealing your biases deter you. You have more power than you realize to change perspectives and fight racism simply by speaking up and starting the conversation.

CHAPTER 2

THE SCIENCE

> The color of our ancestors' skin and ultimately my skin and your skin is a consequence of ultraviolet light, of latitude and climate. Despite our recent sad conflicts here in the U.S., there really is no such thing as race. We are one species—each of us much, much more alike than different. We all come from Africa. We all are of the same stardust. We are all going to live and die on the same planet, a Pale Blue Dot in the vastness of space. We have to work together.
>
> —BILL NYE

Science is no friend to racism. Biology does not recognize race. For centuries, racist scientists tried to prove that you can determine someone's ethnicity by testing their blood or, more recently, their DNA, but all of those "studies" have been thoroughly debunked and disproved in recent years.

There is no white race. There is no Black race. How could Asian even be considered a race when it's used to describe Indians, Koreans, Japanese, Cambodians, Pakistanis, Filipinos, Thai, Chinese, and more?

Yet race exists because racism exists. So long as our systems separate people into castes, race will be real. So long as whites are favored by governments, racism will persist. For the purposes of conversation, we must set aside the scientific evidence that race is imaginary and deal with the very real racism that results from our fantasies about ethnicity.

We will not, however, set aside science altogether, since a basic understanding of how humans think is critical to improving the way we discuss race. There are two reasons for this: (1) people who believe in inherent differences among the races often use specious or outdated scientific evidence to support their claims, and (2) your biology and neurology can make it difficult to discuss these issues. So let's talk about what's happening under the hood and how it affects your cognitive vehicle.

If you have already tried, on multiple occasions, to talk about race with your racist uncle, Ralph, each time using a different strategy, you might wonder why this is so hard for him, why he gets so angry, why he can't seem to understand simple principles that are abundantly clear in your mind.

I remember interviewing a famous, Oscar-winning actor (a white man) some years ago. When the interview was over, we sat in the recording booth and chatted about a movie he filmed in Brooklyn, and he was regaling me with stories of all the "Negros" and "Orientals" living there at the time. I looked through the thick glass into the control room and saw his publicist with her head in her hands. Later, as they were leaving, she apologized to me, saying, "We've told him again and again not to use those words. He just can't remember that they're inappropriate."

I didn't understand, at the time, how someone so smart and, by all reports, kind and progressive, could say such stupid things. I understand it better now. That actor was speaking too quickly. He had grown up using those terms and still used them out of habit. It

would have required a slower pace and considerably more effort for him to break the habit and stop using them.

It would also, not insignificantly, have to be important enough to him to invest the effort. He was obviously comfortable in life, and the discomfort of others was not of real consequence to him. In understanding why people say hurtful things, let us not lose sight of the damage such remarks can cause and the culpability of those who persist in saying them.

Your thoughts and feelings are not you; it's your *actions* that determine who you are. Let me put it this way: We all have thoughts that are best left unexpressed. Imagine if you uttered every thought you had. It would be horrible! Your brain thinks all kinds of things that don't really reflect your personality and values. You might see a good friend for the first time in a couple of years and think, "Wow, she's gained a lot of weight." While you couldn't have prevented the thought from arising in your mind, let's hope you could stop yourself before you said it out loud.

There are any number of reasons why a thought may form in your mind, any number of prompts—an article you read recently, a memory from childhood, a sign you caught in your peripheral vision, indigestion—but that thought may not reflect your actual opinion.

Most of the thoughts you think and the feelings you feel are beyond your conscious control. According to an estimate from the neuroscientist Eric Kander at Columbia University, 80 to 90 percent of thought is unconscious.[1] Those unbidden ideas govern what we do and say automatically, and it's mostly a good thing they do. Imagine how much longer it would take to open a door if you had to consciously think through every step, every turn of your wrist or contraction of your muscles. Yet an incredible amount of unconscious thought is involved in reaching out, turning a knob, opening a door, and stepping through.

This is also true of many of the biases that are buried deep in our psyches, and it's why they're often referred to as "implicit." The assumptions we make about others arise so quickly in our brains that we're often not aware a judgment has been made. Stereotypes lurk in the deep, dark crevices of your mind and influence what you say and believe. As the cognitive linguist George Lakoff once said, "Ideas don't float in the air. They live in your neurocircuitry."[2]

That's what makes it so difficult to change Uncle Ralph's mind; he could be entirely unaware of the influence his biases have on his thinking. And those thoughts are deeply entangled with the feelings over which he has no control as well, so simply presenting Uncle Ralph with new information, or telling a world-famous actor why he shouldn't use the term "Oriental," likely won't help.

The only thoughts we control are the thoughts we *can* control. We can't consciously change unconscious notions without a great deal of reprogramming. Again, Lakoff wrote, "If we do not realize that most of our thought is unconscious and that we think metaphorically, we will indeed be slaves to the cognitive unconscious."[3]

People can even be unaware of their discriminatory acts because they make decisions based on their gut instincts. And while we often tell ourselves we're objective, our guts are incredibly vulnerable to bias. Instinct is based on underlying assumptions. Hunches are based on your flawed memories, your sense of what is right and what is wrong. How does a manager know which employee is ready for a promotion? He knows it in his gut. How does a director know who should star in her film? She knows a star when she sees one.

If all people who were racist made a conscious choice to favor whites over people of color, or decided to create systems that oppress non-whites, then telling them not to do these things might stem the tide of racism. But racism (or sexism, ableism, ageism) is rarely a deliberate choice. It is often a result of unconscious thought instilled into our subconscious by a systematically racist society.

For example, if you confront a manager at work who only promotes white men, they might respond by saying, "I'm not racist! I don't have a racist bone in my body!" They're wrong, but they don't realize it. They may be unaware of what has motivated their choices. They can honestly say they weren't (consciously) thinking about race at all. Again, I am not justifying this behavior—there is no justification for racism. But it is helpful, I think, to understand *why* it's so hard to ferret out and destroy racist ideas. Stereotypes hurt people. As we've seen so many times, these assumptions are not benign. They can damage careers and steal opportunities. They can ruin lives, and sometimes end them.

While the research is clear on subconscious assumptions, actually making people aware of what's lying beneath the surface of their conscious minds can be devilishly difficult. You might think you already understand racism and bias and prejudice, and you don't need to learn any more about this issue. Yet research shows that the smarter you are, the *more* susceptible you are to bias. "If anything," one study reads, "a larger bias blind spot was associated with higher cognitive ability."[4]

I'm always tempted to laugh a little when someone is called out for doing or saying something racist and they issue an apology that says they've "thought deeply about their actions." That's not going to help, believe me, no matter how deeply they think. Introspection isn't a solution.

The irrational, illogical, unjust stereotypes that sway our decisions can't be touched by self-analysis, and they don't care how smart you are. One scientist who specializes in the study of unconscious bias said that even becoming aware of his bias didn't make him any better at combating it.[5] Do you see the problem?

The only way to truly thwart racist thoughts is to slow down so that our more mature and logical mind can weigh in before we speak or act. "System 1 thinking" is a term coined by the psychologist Daniel

Kahneman to describe the instantaneous, automatic thoughts—our "gut instinct"—versus "System 2 thinking," which is more considered and more careful.[6] In System 1 mode, our brains expend very little energy because the thoughts are intuitive and mechanical. We see a black-and-white-striped equine and think "zebra," not "oddly painted mule." System 2 requires more energy and time because it is slower, more measured, and more analytical. It requires focus. It sees a figure that looks like a child in the distance and thinks, "That's probably an adult who looks small because they're so far away." You have control over System 2, but not System 1.

Our values and loyalties are often based in System 1 thinking. They are based on ideas we can't always articulate. That's why conversations about race should focus on triggering consideration and deliberation—that is, on switching someone from System 1 to System 2—rather than on trying to intercept the instantaneous thoughts that bubble up from the psyche.

Values are formed using some particles of what we learned from our parents, a smidgeon from teachers, a scrap from childhood friends, plus a hint of the books we've read and the movies we've watched. Society has been feeding us racist images and stories for generations. They influenced what your grandparents believed, what they taught your parents, and what your parents taught you, whether you're aware of it or not. If your values are to change, they will do so only over time.

You'll find a great illustration of this idea in the closing arguments delivered by the legendary defense attorney Clarence Darrow in 1925, in what he considered the best-argued case of his entire career.[7] Darrow was defending an African American physician, Ossian Sweet, along with ten others charged with first-degree murder after firing into a crowd of angry whites who surrounded Sweet's home in Detroit, Michigan, killing one of them.

Sweet's fate rested in the hands of an all-white jury, and Darrow

later said that he "managed to get twelve men who said they could be fair," but he knew they were all prejudiced against Blacks. "No one knows so little about a man's ability to be fair," Darrow said, "as the man himself. To a man himself all his opinions, attitudes, and prejudices are fair or he would not hold them."[8]

The lawyer's plan was risky, to be sure, but he felt he couldn't win the case on the basis of the evidence, as the jury was incapable of objectivity in service of Black defendants. He told the twelve men that he knew they were biased but must work through that bias instead of denying it, as reason and rationality had no hope of winning the argument. "Prejudices," Darrow said, "do not rest upon facts; they rest upon the ideas that have been taught to us and that began coming to us almost with our mother's milk."[9]

Darrow's closing argument is more than twenty thousand words long and took two days to deliver. Over the course of his speech, he returned again and again to the idea that prejudice doesn't respond to evidence and that values are often too deeply planted to be uprooted. Prejudice, he said, "is so deep that we do violence to our own feelings, and, of course, to our own reasoning. . . . It is so deep that if we stop to think of it, we are ashamed of it, but it is there, and we can't help it." It was impossible for Darrow to know how strongly bias gripped the hearts of the jury members, how violent the negative reaction when they looked at those eleven dark faces sitting behind the defense table. "I have a right to ask you to overcome [your prejudice] for this case at the least," Darrow declared. "Treat these men as though they were white, and I would ask no more than that."[10]

I ask that you use a similar strategy to that employed by the great attorney: Waste no time trying to combat someone's deeply held prejudices, and focus instead on their critical thinking processes. Try not to say the first thing that comes to mind. Just as we've learned not to make an observation about a friend's appearance for

fear of hurting their feelings and possibly losing a friendship, we can learn to ignore some of the ignorant, stupid thoughts about race that pop up in our minds.

I'm not talking about tolerating others, by the way. I'm interested not in tolerance, but in a true understanding of consequences and the impact our behavior has on other human beings. We can form empathic connections by hearing someone else's story and learning their history. Empathy can be evoked, and bonds developed through honest conversation and active listening. That's not tolerance, which is merely the ability to live with someone without wanting to destroy them. It's not acceptance either, which means you're okay with someone's identity or choices.

When you sympathize with someone, you feel *for* them. When you empathize, you feel *with* them. You can imagine how difficult it's been for them, or how painful their experience. Randall Stephenson, the former CEO of AT&T, articulated this idea beautifully during a discussion with his employee support groups. He said, "Our communities are being destroyed by racial tension, and we're too polite to talk about it. I'm not asking you to be tolerant of each other. Tolerance is for cowards. Being tolerant requires nothing from you but to be quiet and to not make waves, holding tightly to your views and judgments, without being challenged. Do not tolerate each other. Work hard, move into uncomfortable territory, and understand each other."[11]

The goal is not to teach people to work or live alongside someone of another race by simply gritting their teeth. Over time, tolerance can breed resentment. The aim is to work through the frustration, to engage in critical thinking instead of subconscious assumptions. It is to disarm our fear of other races so that tolerance is unnecessary, because difference is no longer perceived as a threat.

Another cognitive phenomenon involved in conversations about race is defensiveness. We live in a largely verbal society, meaning

that when one person attacks another, it generally comes in the form of a verbal assault, not a thrown punch. Human beings are social animals, and we are hyperaware of comments that threaten our social standing. Our brains react to perceived insults in a split second, and when the insult occurs in front of an audience, we tend to have a stronger and much more negative reaction than when it occurs in private.[12]

One reason it's so challenging to talk about issues of prejudice and discrimination is that racial issues are inextricably linked to politics, and scientists have discovered that we are more likely to change our minds about food, cars, nature, pets, or just about anything else than we are to alter our views on politics.[13] What's more, when we are subjected to a verbal attack, our brain takes quick action to defend us. In this case, the word "defensive" is quite literal. "The brain's primary responsibility is to . . . protect the body. The psychological self is the brain's extension of that," the University of Southern California psychologist Jonas Kaplan explains. "When our self feels attacked, our [brain is] going to bring to bear the same defenses that it has for protecting the body."[14]

Much as if it were preparing to respond to a physical threat, our brain responds to a verbal attack by raising our heart and respiration rates, dilating our pupils to allow more light into the eyes and improve vision, and tensing our muscles so that they're ready to move. Our nervous system will tell the glands to secrete adrenaline, which increases blood pressure and breathing.

Essentially, after the perceived insult, our brain triggers fight-or-flight mode. Once that happens, not only are we physically primed to retaliate, freeze, or run, but our thinking processes are altered as well. The amygdala, the fear center of the brain that's sometimes referred to as the "lizard brain" for its primitive capacity, takes control and the outer layer of our gray matter, which includes executive function and higher reasoning, takes a backseat.

Our lizard brain operates on instinct. It doesn't reason things through or reconsider or engage in deep thought. When it's in control, we're more likely to make a mistake or say something we regret.

I talked to Tori Williams Douglass, an anti-racism educator who helps people become agents of change in their communities and workplaces through her program White Homework. She told me that one way she avoids triggering people's fear is by labeling their behaviors and thought patterns as racist, instead of applying that label to the people themselves. Here is an excerpt from our conversation about race.

DOUGLASS: I come from a neuroscience perspective. When someone's nervous system is really engaged, when they are moments away from fight or flight, that's not a helpful situation. If you feel threatened, if your options are narrowed to fight, flight, or freeze, your prefrontal cortex is basically offline. You will not be able to engage with what I am saying, because your body senses a threat.

It's not a real threat, of course. I'm not a lion in the savanna, which is what that response was evolved for. But it's a real response that people have.

I try to engage in such a way that people are less likely to just opt out. Or to turn it into just name-calling or screaming.
HEADLEE: How, exactly, do you do that?
DOUGLASS: When you are afraid, you can't learn. You can't take in new information. I think if you can explain to people that this thing that you did was racist, here's the harm that it caused, here is how it fits into the larger picture of systemic racism . . . if they're still with me at that point, then we have an opportunity to talk.

That is much more productive than just making people angry. If it's somebody who's committed, they have to go and sit with that for a couple of weeks probably and talk to some people and try to process what they experienced. I'm all about efficiency when I'm

having these conversations. If I can leapfrog over that defense response, I feel like that's a better use of my time.

HEADLEE: What would say are the skills necessary to have these difficult conversations?

DOUGLASS: One obviously is going to be resilience. You are not so emotionally or psychologically fragile that you don't have mental space for the conversation. You have to have a little bit of margin in order to be able to have these conversations. Otherwise, you're gonna get freaked out. And it's just going to devolve into nothing. It's gonna be a screaming match.

Also, know who you're speaking with. Be able to pick up on verbal cues or body-language cues, to understand that if you say this thing and you see somebody pull back, cross their arms, if you see changes in their face, maybe that didn't work. These are all interpersonal skills that we aren't really taught. I think that some of us have to learn them because it's a means of survival.

Neuroscience and psychology can also help explain why some people are so prone to feeling defensive. Scientists estimate that one in five of us is emotionally reactive and has difficulty self-regulating our emotional responses. Randi Gunther, a clinical psychologist in California, calls emotional reactivity "the bane of intimate communication."[15] If someone is reactive, the smallest hint of criticism or confrontation can send them into intense emotional territory, making it likely they'll escalate a discussion into a dispute.

If an emotionally reactive person has a conversation about race that upsets them, the odds increase that they'll be triggered by all future discussions on that topic. With each repetition, a path is essentially carved in our brain matter directly from "conversation on race" to "anger." The social psychologist Jonathan Haidt explains it this way: "The amygdala has a direct connection to the brainstem that activates the fight-or-flight response, and if that amygdala finds

a pattern that was part of a previous fear episode . . . it orders the body to red alert." Sadly, there is no parallel response to positive interactions, so complimenting someone during an exchange doesn't deactivate this emotional bomb. "Bad news," Haidt says, "is emotionally louder than good, and thus will have a bigger impact."[16]

It can take up to an hour for the body and mind to return to normal after these physiological changes are activated and the hormones start pumping, so having a mature and constructive conversation after someone becomes defensive is well-nigh impossible. Bearing this physiology in mind, it's imperative to protect against feelings of defensiveness when you enter a highly charged conversation.

Luckily, there are some simple methods that can help counteract or prevent feelings of defensiveness in your own mind. For example, you can ask yourself, *What's the worst that can happen during this conversation?* Really think through what might be said and how you might react.

This exercise could elicit a realization that your fears are outsized in relation to the actual threat, as "the worst" is not often that bad. Thinking through possible outcomes can also prepare you to handle negative feedback so that you are calmer in the moment. Self-analysis stimulates the left side of the prefrontal cortex, the part of the brain associated with resilience and moderation. It can put the amygdala back to sleep.

Here's another question to consider: What if the comment that upset you was directed at your sibling or friend, instead of you? How would you tell your loved one to respond? When we are at least one step removed from the criticism, it's easier to evaluate it objectively and respond in an intelligent, patient way.

All adults have the ability to self-regulate—this is a function of a fully matured brain (it may come as no surprise that young children are not always able to moderate their behavior). Self-regulation includes the ability to manage our emotions, to be disciplined about

what we say and do, and to behave appropriately in various environments. For example, we don't say the same things to our parents as we do to our children, and we don't speak the same way in staff meetings as we do when some jerk on the highway cuts us off. Self-regulation is a type of self-control. People who have a lot of self-control, say Rachel Ruttan and Loran Nordgren of Northwestern University, are also "more able to withstand the short-term pains of accepting negative feedback in order to yield the long-term rewards,"[17] say, of a productive discussion on racism and oppression.

Some of the most powerful disincentives for difficult conversations are fears of embarrassment and vulnerability. We are all troubled, on some level, by the idea that we'll feel incompetent or inferior— or, worse, that we will be humiliated and therefore lose some of the social standing that is so important to us as human beings.

Gaining a deeper understanding of your body's responses to stressful situations can only be helpful. Becoming aware of how you process information, how you react when you hear dissenting opinions, and what works to calm your anxieties can give you the ability and opportunity to engage in transformative conversation, the kind that can truly change hearts and minds.

CHAPTER 3

THE STAKES

> Racial understanding is not something that we find but something we must create.... [Our] ability to work together, to understand each other, will not be found ready-made; it must be created by the fact of contact.
>
> —MARTIN LUTHER KING JR.

I don't need to tell you that the stakes are high for us, as a society, when it comes to racial bias and systemic discrimination. Human lives hang in the balance, as well as economic growth, education, and even effective responses to climate change. For too long, the very seriousness of the subject, with its seeming intractability, has prevented many people from talking about it or even acknowledging its existence.

But hiding from the truth is never an effective strategy. Refusing to address systemic racism has been compared to looking outside, seeing that the house next door is on fire, and then shutting your blinds so you don't have to see the flames. Sooner or later, that fire will threaten you and the ones you love. When it comes to race, we've already passed "sooner" and "too late" is almost here. We must open the blinds and face the inferno.

While it's important to recognize the urgency of the problem and the gravity of the issue, it's not necessary to carry that burden into every conversation. While the stakes are high for society at large, they're relatively low in a chat with your neighbor or co-worker or the guy behind you in the grocery store. You are not expected to change their values. It's not obligatory for you to reach an agreement on race during your talk, nor is it even likely. If there were a definitive answer to the question of race, discussion would be unnecessary. If there were a manual that explained how to recognize racism and how to stop it, we would have solved this problem hundreds of years ago.

No manual exists because there are no definitive answers. Modern race scholars disagree with experts who wrote on the subject just a few decades ago. Understanding and opinion evolve as we learn more. While the writing of Frederick Douglass is still relevant, for example, culture has moved on. Douglass on many occasions delivered a speech on the self-made man that I take issue with.[1] I think the specter of the self-made man has haunted us for generations, perpetuating the idea that the system is fair and we can succeed if we work hard enough. I think the fable of meritocracy has long been used to justify inequity, especially in regard to communities of color. That's the nature of race. It's a powerful and dangerous fantasy, and every generation's imagination alters the conceit a little bit.

What's more, the issues surrounding ethnicity and power in the United States differ from those in Denmark or Afghanistan or Vietnam. Our perspectives and solutions vary according to our conversation partners at any given moment in any given location. No matter how knowledgeable an individual may be, no one is an all-encompassing authority. As the attorney and television host Eboni K. Williams said, "None of us are the sole expert during these conversations. We are each experts in our own personal experiences."[2]

In other words, relax. You're not expected to know everything about race and fairness. You are not expected to understand every

nuance of inclusivity; a degree in critical race theory isn't required for this conversation. It's okay to admit you don't know something, and it's understandable if you make a mistake. (We'll talk later about how to handle mistakes.)

Mistakes can be forgiven, patience can be exercised, offensive opinions can be heard. Discussions of race are exercises in cognitive dissonance: words matter, yet words alone will not change policy; offensive views cannot be tolerated by society, yet individuals can hear them and calmly question them; racism is one of the most destructive forces on our planet, yet one racist person has very little power over your life.

Your enemy is racism, not this person.

The more conversations we have, the more we learn about how racism affects people's lives. We need to hear about other people's experiences so that we can break out of our ideological bubbles. Since we are all equally likely to think the "other side" is more biased than we are, there is no pressure to prove you are more or less biased than someone else, or to demonstrate that you have earned the moral high ground.

It's common, when we consider how important these discussions are, to think mostly about the consequences should things go awry. But instead of drilling down on the dangers, I'd like to focus on the benefits of having a respectful conversation with someone who disagrees with you.

Research shows that disagreement and cognitive diversity are very good for you. The human brain doesn't particularly enjoy having to cope with opposing opinions, but the endeavor makes us better. Cognitively, emotionally, and morally, we are less prone to error in the presence of dissent than in the presence of agreement. We are more creative and more careful when we're forced to consider other viewpoints.

Seeking out a diversity of opinions and perspectives makes us

better, both individually and collectively. For example, in one study, researchers grouped people into teams of three and asked them to solve murder mysteries. Some of the teams were racially diverse; others were all white. The scientists then divided the clues into two categories: some information was shared by all three members of the team, and some was known only by individual members, meaning that the solution could not be reached without cooperation and communication. No one person could solve the mystery alone. In the end, the racially diverse groups reached the right answer more often and more quickly than the homogenous groups. The study report explains, "Being with similar others leads us to think we all hold the same information and share the same perspective. This perspective, which stopped the all-white groups from effectively processing the information, is what hinders creativity and innovation."[3]

It may surprise you to know that the boost in performance didn't happen because the racially diverse teams got along better. On the contrary, researchers found the racially mixed groups expected to argue among themselves. They assumed people of different ethnicities would challenge their ideas and opinions, so they worked harder to prepare for the anticipated confrontations. They hesitated before throwing out ideas and double-checked their work so they wouldn't be embarrassed by mistakes. The racially diverse teams were better performers not despite their differences, but *because* of them.

As James Surowiecki wrote in *The Wisdom of Crowds*, "The best collective decisions are the product of disagreement and contest, not consensus or compromise."[4]

I'm sharing this information to help alleviate your anxiety about having conversations with people who are different from you. You don't have to *like* the person you're talking to. You can dislike them and still have a great discussion that challenges and enlightens you (and maybe them as well). In fact, research suggests that you might have a more thoughtful and intelligent exchange with someone you

don't like than you would with someone you love. That might comfort you, whether you're talking with a rideshare driver or, more likely, with a family member you dread seeing at holiday get-togethers.

So why are these conversations so damn hard?

The difficulty in talking about race stems not from the outcome, but from the input—what we bring to the discussion. We bring our bias and our baggage. That's the heaviest load, a burden we often stubbornly refuse to set down.

Study of the lifestyles of early humans suggests that we are innately tribal in our views of others, especially those who think differently from us or who challenge our ideas about the world. An important report titled *The Hidden Tribes* was published in 2018 by the nonpartisan organization More in Common, which used survey responses from more than eight thousand Americans and a statistical process called hierarchical clustering to identify seven groups that share the same values and core beliefs. "Once a country has become tribalized," the report said, "debates about contested issues from immigration and trade to economic management, climate change and national security, become shaped by larger tribal identities. Policy debate gives way to tribal conflicts."[5]

Our current state of extreme politicization is at least partially fueled by loss of identity and belonging, which is itself caused by our philosophical isolation and our reluctance to talk to people who are not like us. We are all too often incapable of talking without shouting over one another, and we have turned everything into a political issue. So we turn inward, interacting mostly with our own tribe and avoiding others. Ultimately, as *Hidden Tribes* concludes, "millions of Americans are going about their lives with absurdly inaccurate perceptions of each other."[6]

We are tempted to think those who disagree with us are the real extremists. Context comes through comparison, and we are comparing ourselves not with a broad array of viewpoints but with a

narrow, selective group of people who agree with us on just about everything and share mostly the same background. But this study and others like it have shown as great a tendency toward extremism on the left as on the right. (This is not about whether one side is more dangerous to society than the other or does more damage to the body politic. It's only an examination of the tendency to suffer from confirmation bias and to occupy the extreme ends of the political opinion spectrum.)

Extremism, as defined by the Anti-Defamation League, is a political or religious belief system that lies significantly outside the mainstream.[7] While there are many different definitions of extremism, as is true of so many words in this field, here it's used simply to describe beliefs that are far to the left or the right of center.

As I write this, I'm reminded of just how difficult it is to define and articulate terms and concepts related to race. Even while trying to write in simple prose, to be understood by the largest number of readers, I find I must stop again and again to explain terms, to clarify my points. Imagine how much harder this would be if you and I were talking in person, with emotions and tensions running high.

This is all to say that it's imperative to keep your expectations low for the undertaking of talking with others about race. The harder the task, the lower the promise for success. If you're talking to your best friend about tacos, you can expect agreement and possibly even expertise. Not so with a discussion of race.

Most of us believe, to some extent, that a criticism of our race is a criticism of ourselves and our families, so we rush to defend our identities and our traditions. Defensiveness is a shield, preventing us from having to experience emotions we don't want to feel, including guilt. It can be a tool to shift blame, so we don't have to take responsibility for our actions or our opinions or our history.

It's a natural and human reaction, but it's really about protection instead of problem solving. Part of the defensiveness we feel when

our racial identities are challenged is rooted in the mistaken belief that we have nothing to learn from another person because they are wrong. We rebuff them because we believe they have nothing we need.

 This is true not only of white people but of all people. Deciding whether to get past your anxiety and engage, or protect yourself and walk away, is a calculation we all must make in the moment. The journalist, author, and radio host Farai Chideya, a Black woman, says sometimes she chooses to have the conversation and sometimes she doesn't. Chideya was a fellow at Harvard's Shorenstein Center on Media, Politics and Public Policy studying newsroom diversity and editorial protocols, so I asked her about how she weighed the decision to engage in conversations about race, knowing they can be painful.

CHIDEYA: I have a lot of racial resentment to deal with, and I'm working on it. But part of it is also protecting myself. You know, like, I just can't be swimming through the waters of racial sewage every day. The question is, Am I emotionally well enough to engage in this conversation? If I've got steam coming out of my head, it's probably not the best time for me to engage, even if I'm morally right. So, am I emotionally well enough to engage in this conversation? Two, have I thought deeply about this and do I have anything to say? Three, is there an immediate or long-term benefit to saying something?

 It's like this is cost-benefit analysis that is super complex. I find that for myself as well, there's the added burden of the future generations. Right. Like, you don't want to let things go by regardless of your own personal calculus, because you don't want to allow people to think that's acceptable and the norm. And so, there's also this burden of sort of your society. What is my responsibility to society? What's my responsibility to the Black people and Brown people who come after me?

HEADLEE: Do you feel a responsibility to change people's minds?
CHIDEYA: It's a rare day that I try to convince white people of anything. I just try to live in my own truth. I'm just tired of trying to convince people about stuff, you know? And it doesn't mean I don't have dialogues with white people. I have them all the time.

But there are people who have no interest in people who are not like them. Many different types of people have no interest in really understanding what life is like for people who are outside of their perceived in-group. And to me, that's a total waste.

I just think that there's a lack of willingness to admit that understanding *how* to have these conversations is both a life skill and a business skill. If we treated it like that, we could be transformative. But I also just don't count on white Americans wanting to do the work. There is so much defensiveness.

HEADLEE: Do you think it's productive to say to someone "You're a racist"? Has that ever worked well for you?
CHIDEYA: I don't think I've ever said "You're a racist" to anyone, nor for me is it productive. But that doesn't mean it's not productive for other people in other situations. I think a lot of it is situational. It's like, what is your role and what is your intention? I'm much more likely to talk about white supremacy. White supremacy is a belief system that whites are better. White supremacy is not limited to white people. It's predominantly among white people, but there are plenty of other people who actually buy into it. It's sort of like bell hooks saying patriarchy has no gender.

Instead, I ask, are you hoping to knit together or tear apart the fabric of society? In whose interest are you acting? What power and privilege do you have? I want to ask deeper questions about how we operate.

Listen, if you're a racist and all you do is sit around your house being racist and writing down racist things and amusing yourself with racist jokes you tell yourself . . . you are not affecting my life

in any way. You can be racist by your own damn self in your own damn house.

However, if you bring that to work or to the ballot box, then we've got a problem. To me, it's really about the impact your behavior has on civic life and on people.

We're living through an era where we can see the bodies piling up from the effects of racism. It's not that racism isn't real, it's just that calling someone a racist hasn't been a productive strategy for me. I don't rule it out, though, for someone else under other circumstances.

HEADLEE: Have you had an experience where you've had this kind of conversation with someone who disagrees and there was authentic communication and cross-dialogue between you?

CHIDEYA: One of the most surprising things to me is that it is often by example that people really see who you are. In high school—I grew up in Baltimore, which is, to say the least, polarized—and there was a white working-class girl at my school who was not magnificent on racial issues.

But she wrote an effusive message in my yearbook about how much I changed her mind on race because I was always mouthy and spoke up in class. When I read that, I realized that, just by being myself, I had made a profound impact on her.

That's what I see in my life: there are times when I'm just being me and I'm being me consistently. And later I find out that I made an impact on someone, but I wasn't trying to make an impact. I think that longer-term conversations generally have a higher impact than the short-term interventions.

Research shows people often believe they know more than they actually do, and this delusion can shut down conversation when a white person assumes they understand what people of color endure, or when people of color think they know how a white person feels about issues of police brutality or inequality.

Defensiveness is triggered by fear, fear that the stakes are higher than they really are, that being forced to admit your ancestors were immoral will somehow disrupt your current way of life. If you think too much is at risk, you may believe it's dangerous to speak with a racist person. Perhaps you believe you somehow help the cause of white supremacy by allowing a racist to talk. Perhaps you're worried that you will be called a racist if you say the wrong thing.

The cure for all this fear and distrust and defensiveness is more conversation, not less. I want to eradicate this reluctance to talk about race by talking about race as much as possible. Lots and lots of short, low-stakes conversations.

Think of it as a form of exposure therapy. In therapeutic settings, a doctor will sometimes treat anxious patients by exposing them to the very object, environment, or situation that makes them nervous. We can use this model to help us overcome our fears of engaging in stressful conversations.

So let's try a little exposure. If you're white, I want you to carry out a thought experiment for me right now. Imagine you get onto a public bus and take a seat. You're looking idly out the window, watching the shops and streets go by, feeling relaxed and comfortable. After a few minutes, you glance around you on the bus and discover that all the other passengers are Black people. Black people with Afros or dreads, perhaps a couple have shiny do-rags on their heads. A few young Black men are laughing loudly in the back, their belts barely holding up their sagging jeans.

Close your eyes and picture the situation. Take a moment.

How did that feel? Did your heart rate increase? Did you start to feel a tightness in your shoulders or your chest? Most likely, your body reacted to the fear generated in your subconscious. Somewhere in-

side your mind, there lingers unconscious bias about Black people, stereotypes you don't consciously believe, but that are deeply entrenched in your nervous system.

If talking about race makes you apprehensive, let's treat your fear by talking about race more often. Let's talk about race in thirty-second exchanges with perfect strangers, let's talk about it for ten minutes at a time with family members. If you don't raise your expectations of the outcome, your trepidation may remain low. The more you talk, the weaker fear's grip on your heart will be.

Karin Tamerius is a former practicing psychiatrist, social scientist, and the founder of the nonprofit group Smart Politics—an organization that teaches progressives how to speak with people who hold opposing views. Tamerius has said exposure therapy helped her overcome the trauma she suffered after Donald Trump—a person whose views she distinctly does not share—won the 2016 presidential election. When she realized how profoundly the country's politics were affecting her, she decided to start talking to Trump supporters. "I knew I couldn't influence others if I flew off the handle every time they said something positive about the president," Tamerius concluded. "I had to change before I could ask them to."[8] Exposure therapy works through habituation, and Tamerius says this practice of engaging with people on the other side of the political spectrum helped her become physiologically accustomed to the election results. This type of progress—and healing—cannot happen if we avoid what we're afraid of.

Certainly, talking to people who may disagree about issues of race can be risky. After all, the task demands radical honesty. Sometimes it means acknowledging that you have done or said something racist without believing that your mistake negates all the good you've done in your life. Sometimes it means having yet one more exchange with a white person who refuses to admit they've said something

offensive. It's about responding intelligently when the subject of race arises and not allowing anxiety to lead you to diminish the concerns of others or become defensive.

Defensiveness, rooted in fear, is the cause of most arguments. Luckily, there are proven ways to disarm your defenses, including using the tool of self-affirmations. You've probably heard of self-affirmations before, and you might wonder why, in a book about talking to other people, I'm suggesting that you talk to yourself. Bear with me.

For a long time, psychologists have advocated for the use of affirmations to help people combat negative self-talk or reduce anxiety. More recent research shows they can also be quite effective at preventing arguments, if you use them before a conversation begins, or just as you start the exchange. There is some incredibly cool and persuasive research showing that, used properly, affirmations can help train your brain, create neural pathways, and change your behavior.

The psychologist Carl Rogers suggests reading the following paragraph to yourself before you engage in a fraught discussion with another person:

> *I'm interested in you as a person, and I think that what you feel is important. I respect your thoughts, and even if I don't agree with them, I know that they are valid for you. I feel sure that you have a contribution to make. I'm not trying to change you or evaluate you. I just want to understand you. I think you're worth listening to, and I want you to know that I'm the kind of a person you can talk to.*[9]

You can use this language or devise a statement of your own that helps prepare your mind for deep listening.

Many of us would rather talk about *anything* except race. Even the people I interviewed who make their living in this space either

put strict limits on those with whom they will discuss the issue or have accepted that this is a task they won't take pleasure in but must undertake. They all described self-care practices they engage in to protect their well-being. I have my own routines for emotional recuperation, including meditating, walking my dog, and watching sitcoms. Racial dialogue can be an exhausting activity.

After completing research into the difference between white views of fairness in the United States versus Black views, the social psychologist Michael Kraus says that "as painful as those conversations might be," we must take an honest assessment of the disparities in our society. Those difficult and sometimes intense exchanges "will lead us to see the world for what it is and may actually actively lead us to have the kinds of policy discussions that will ultimately solve these problems."[10]

It's best to assume you will view these conversations not as fun, but as important, crucial, and possibly life-changing. Looking back, so many of the events and relationships that changed me the most and shaped the human being I have become were not pleasant experiences.

It's hard to think about even now, but I remember when a colleague told me to stop referring to the United States as a melting pot. Because I'm a living amalgamation of multiple ethnicities, I used to call myself "the ultimate melting pot," but she explained the history of that phrase, which originated in a play penned by a Jewish man whose parents immigrated to England from Russia.

"America is God's Crucible," Israel Zangwill wrote, "the great Melting-Pot where all the races of Europe are melting and reforming."[11] How could Zangwill, a lifelong activist for the poor and the oppressed, have known that the promise of American assimilation was intended only to whites? He held up assimilation as a virtue, but was he aware of how the pressure to turn their backs on their ethnic traditions and culture affected immigrants?

When my colleague challenged me on my language, I became defensive. I was afraid that my lack of knowledge about history would say something awful about me, reveal my ignorance, or worse. But getting past my fear and allowing her to enlighten me inspired a journey of discovery.

The more you face your fear, the more resilient you become. The goal of this book is to make you not a fearless conversationalist, but a resilient one.

CHAPTER 4

WHEN IT HAS WORKED

> I can understand why people join extreme right-wing or left-wing groups. They're in the same boat I was in. Shut out. Deep down inside, we want to be part of this great society. Nobody listens, so we join these groups.
>
> —C. P. ELLIS

Have you ever experienced an epiphany? The word, Greek in origin, is used in the Christian faith to describe the manifestation of the baby Jesus to the Magi; the Feast of the Epiphany is celebrated annually on January 6. The word in general use has come to mean a sudden understanding or enlightenment, a flash of insight.

Epiphanies are rare. Most of us gain new understanding and insight regularly—that's part of learning—but to qualify as an epiphany, the new idea must shift the philosophical ground on which your life or work is founded. The insight should be life-changing, like the enlightenment of the Buddha under the Bodhi tree or the conversion of Paul on the road to Damascus.

As infrequent as these moments are, it is yet more uncommon for them to happen over the course of a single conversation. We

sometimes experience small epiphanies while listening to lectures or watching documentaries, possibly because we approach those events prepared to learn, so we really focus on what someone else is saying.

When it comes to the act of merely talking with another person, however, we seem to find it difficult to open ourselves to new information or absorb that information with the kind of intensity needed to significantly shift our understanding. Perhaps the fear of having to represent and defend our own views overwhelms our capacity to fully take in someone else's.

And yet meaningful conversations have sparked epiphanies before, and will again.

The question is, How do we have these kinds of conversations? As you prepare to confront your racist family member or steel yourself to speak with a co-worker who belongs to an opposing political party, it may help to know about a few examples of conversations between real, deeply divided people that did change hearts and minds for the better. I want to share three case studies of conversations that resulted in epiphanies. After all, a great conversation is not a magic trick. We sometimes believe soul-stirring interactions just "happen," or we wrongly assume that some people are gifted with persuasive abilities and the rest of us don't have a prayer of doing what they do. The truth is, productive disagreement is the result not of talent, but of skill and patience. Skills can be learned and practiced and improved; patience can be strengthened. We can learn from what has worked in the past and create a set of principles that might increase our future chances for success.

To illustrate these transformative experiences, I've selected stories that involve extremists. Before we dig in, though, there is one big, glaring caveat to having conversations with actual, avowed white supremacists: don't try this at home. Far-right extremists, including neo-Nazis and skinheads, were involved in 330 murders

in the United States between 1991 and 2011, and the Department of Homeland Security said in 2020 that violent extremists are the "most persistent and lethal threat" in the nation.[1]

There are organizations, like Life After Hate and the Free Radicals Project, that help members of hate groups safely leave that world behind, but dealing with radicalized people is dangerous and requires specialized training. If you meet someone who is sporting swastika tattoos or a T-shirt with Pepe the Frog (originally an innocent cartoon character that was co-opted by white nationalists), I strongly suggest you avoid that person. Perhaps not all white supremacists are dangerous, but many of them are and it's not worth risking your safety to find out which type you're facing.

The purpose of revisiting instances in which ordinary people successfully convinced white supremacists to renounce their ideology is not to encourage you to replicate what they did, but to help you learn. I don't expect you to have a conversation with a member of a hate group, not least because that would violate the most basic requirement for good conversation: mutual respect. If you are ever in a situation in which you feel unsafe or threatened, I hope you will get away as quickly as possible.

However, there are several cases in which people have not only sought out conversations with extremists but also continued meeting with them. In some rare instances, those conversations ultimately led to conversion, to a denouncement of hate and a turn toward love and acceptance.

First is the story of Derek Black, godson of David Duke (former grand wizard of the KKK) and son of Don Black, who founded the neo-Nazi online forum Stormfront in 1996. Derek was raised in a tradition of hate and became a true believer in the white nationalist cause. Then he went to college and two things happened: he met a girl who refused to give up on him, and a Jewish student began inviting him to eat Shabbat dinner with his friends every Friday.

In my conversation with him, Derek told me that the other students who attended these dinners were members of racial and religious groups that Derek had railed against in his writings and on the radio: Muslims, Jews, Blacks. Yet he originally didn't see a discrepancy between what he said about *all* Blacks and his relationship with any *particular* Black person. "My idea was that individual people could be one thing," he told me, "but my ideas about race would be true in the aggregate."

BLACK: I did not show up at the college looking to have my mind changed. Actually, it was the opposite. I was extremely confident. I guess if there was anything I expected, it might have been that I'd be able to improve my own arguments by encountering people who genuinely believed that I was wrong. In retrospect, it was surprising, really surprising, to feel like there were legitimate grievances, that maybe there were factual problems.
HEADLEE: When you went to the first Shabbat dinner, it sounds like your friend decided—and tried to make everyone else adhere to this idea—that they weren't going to bring up issues of race or anti-Semitism.
BLACK: He was very explicit that he didn't want people to bring it up because he thought that would cause a confrontation and that a confrontation would maybe be a one-time thing and I wouldn't come back because it would be incredibly tense. So he thought that by having himself and people at the dinner who were directly impacted by white nationalism, that itself would be a challenge. That [I would be] internally confronted on some level.

As weeks passed and Derek began developing relationships with his classmates, his feelings toward them became more and more incongruous with his white supremacist principles. What's more, the girl who would eventually become his girlfriend, Allison, repeat-

edly engaged him in conversation, asking him pointed questions. Derek said she challenged his beliefs and asked him to explain himself.

BLACK: "Can you defend why you believe this? What are the facts behind it? What is your moral justification for it?" Those were the moments when, because all that context was happening, we could have individual factual conversations.
HEADLEE: It sounds like she challenged you mostly through asking questions. Is that accurate?
BLACK: She felt obligated because I was willing to engage. I was willing to listen.

When I felt condemned by the community, I wondered, "In what way are they getting this wrong?" I cared about the people in the community at that point. I lived there for a semester. And I wanted to know, was there a way to reconcile this? Was there something that they were misunderstanding? It was not me being entirely defensive. It was like being open a little bit to seeing there was a middle ground.
HEADLEE: Almost like you were trying to help them.
BLACK: Yeah. I felt like I was connected and a part of the community. And if they were super clear that I was harming them, I wanted that to not really be true. I didn't see myself as going out, trying to make their lives worse.

In fact, community had a powerful influence on Derek. He was careful to tell me that his worldview evolved not because of one conversation, but because of many that occurred over a long period of time. And the campus culture around him—made up of people who came from diverse backgrounds, who held various perspectives, and who did not tolerate hate speech—offered a markedly different backdrop from the one in which he was raised.

BLACK: It was not that I encountered a friend who shared articles and talked to me. Maybe that would have worked, but that's not actually what happened in my case. I was away from white nationalists. I was away from my family. I was in a whole social structure that had many layers of anti-racist activism and anti-racist pedagogy and social justice events and a real sense that they were trying to build an anti-racist community.

There were people who were extremely hostile and people who I had gotten to know but who felt afraid of me. People were organizing events that were not at all about me, that were about making people feel safe, who were feeling threatened because of my presence. All these different points of connection, I don't want to go so far as to say that's always essential to try to change someone's mind, but I cannot help but note that it was not one relationship. It was a whole bunch in a big network. And I suspect strongly that that is what it takes for somebody to be willing to entertain that they're wrong, to change their mind. That's changing your society, really.

HEADLEE: If someone knows a racist and they don't want to cut that person out of their life, what advice would you give them?

BLACK: You must be able to understand how they actually see themselves and their worldview before anyone is engaged in [a] conversation. You have to be clear with yourself that you are willing to not believe what they're saying, but to be able to argue it the same way they would, to be able to reiterate back to them: "Here is your argument. Here are your facts for it. Here's why you think this is true," in a way that they can honestly say, "Yes, that's exactly what I believe." Because there's no way you're going to convince somebody that they're wrong if you have not first convinced them that you fully understand what they believe and you're rejecting it.

Minds don't change overnight; they change over time. Fortunately for Derek, he met two people who were determined not to ostra-

cize or alienate him. One pointedly refused to talk about bigotry and focused on forming a connection with Derek. The other took the opposite approach and consistently challenged his beliefs. Instead of haranguing him, though, she questioned him. She forced him to explain his views, articulate his ideas, and get specific about the source of his opinions and the effect they might have on the world.

For us, Derek's story offers an important lesson: You can engage with someone over dinner and pointedly avoid discussion of the subjects on which you disagree, trusting that the empathic bond formed when two humans share stories and food will ultimately transform the other person or at least not drive them further into the arms of hatred and bigotry.

You can also choose to engage with them through curiosity, using a series of questions intended to increase your understanding of their views, knowing that you're also forcing them to think through their ideas on a deeper level than they may have before. Whichever approach gives you the courage to keep the lines of communication open is the right choice.

Now let's look at another case study: Claiborne Paul Ellis and Ann Atwater in North Carolina. In this case, the framework was not friendship, but problem-solving.

Ellis, known as C.P., grew up dirt poor in Durham, ashamed of the worn-out clothes he wore to school. "I still got some of those inferiority feelin's now that I have to overcome once in a while," he said during an oral history interview in 1980. His father worked hard, yet his paycheck was never enough to cover the bills.

That became true for C.P. as well. He dropped out of school after eighth grade, married young, and had four children, including one child with special needs. He was working seven days a week at a gas station and then delivering bread, but never got ahead of the bills. C.P. described a large drum of heating oil sitting outside his house and said, "I would run up to the store and buy five gallons of oil and

climb the ladder and pour it in that 265-gallon drum. I could hear that five gallons when it hits the bottom of that oil drum, splatters, and it sounds like it's nothin' in there. But it would keep the house warm for the night."

As weeks became years and his life never got easier, no matter how long he labored, Ellis began to feel angry and resentful. He started looking around for someone to blame for his hardship and penury, and he didn't have to look far. Black activists were making headlines in North Carolina, picketing the state capital, staging sit-ins, and demanding an end to segregation.

"Hatin' America is hard to do because you can't see it to hate it," Ellis said. "I had to hate somebody." He joined the KKK and rose through the ranks to become the "exalted Cyclops" of his chapter.

That could have been the end of his story. C. P. Ellis could have been just another poor, racist white man in the South, but he got an opportunity to change his life because of his involvement in his children's schooling. In 1971, Ellis was invited to co-chair a committee on segregation in Durham City Schools. His partner in leadership was a Black woman, a civil rights activist named Ann Atwater. Ellis later described her as "some black lady I hated with a purple passion." At the first meeting, he refused to shake her hand.

Still, around this time, Ellis was beginning to question his allegiance to the Klan. He remembered seeing fellow Klansmen who were also city council members pass him on the street without making eye contact, and he felt the sting of their disdain. He described watching a poor Black man walk by and remarked that the "guy'd have ragged shoes or his clothes would be worn. That began to do somethin' to me inside."

When he was asked to help lead the schools committee, Ellis says he felt a blossoming pride in his chest, and a sense that he now had membership in another group where he belonged. He took the job seriously and was disquieted by the fact that he and Atwater

couldn't seem to get along. He brought a gun to the committee's first public session, and Atwater once pulled a knife on him during a city council meeting.

Ellis had come around to the idea of desegregating schools at this point, convinced it was the best way to improve education for all students, rich and poor, Black and white. But agreeing with Atwater on the mission didn't mean they liked each other any better. After days of tension and undercurrents of anger during ten-hour-long meetings, Ellis called Atwater on the phone and said, "Ann, you and I should have a lot of differences and we got 'em now. But there's somethin' laid out here before us, and if it's gonna be a success, you and I are gonna have to make it one. Can we lay aside some of those feelin's?"

She responded, "I'm willing if you are."

Ellis and Atwater set aside their mutual hatred in order to solve a problem that was important to both: segregation in the public school system. They tramped through the streets of Durham, knocked on doors, and spent hours in brainstorming sessions. It was inevitable that they would talk, and equally inevitable they would discover they were not as different as they'd assumed.

At one point, Atwater shared a story with Ellis about her daughter coming home from school in tears because her teacher had mocked her in front of the class. He was stunned; the same thing had happened to his son. Struggling not to cry as he recalled the incident, Ellis said, "I begin to see, here we are, two people from far ends of the fence, havin' identical problems, except hers bein' black and me bein' white. From that moment on, I tell ya, that gal and I worked together good. I begin to love the girl, really." And as he recounted this to the interviewer in 1980, C. P. Ellis began to weep.

Ellis eventually earned his high school diploma and became a union organizer for the International Union of Operating Engineers. He loved the work. He ultimately ran for the office of business manager

for the union, going up against a Black man in a chapter where the membership was 75 percent Black. Yet Ellis won by a landslide.

Ellis said it's a mistake to ostracize those who join hate groups. Although he eventually denounced the Klan, he was troubled whenever he heard people criticizing individual members of the organization instead of critiquing the group as a whole. "The majority of 'em are low-income whites, people who really don't have a part in something," Ellis said, "They have been shut out as well as the blacks. Some are not very well educated either. Just like myself."[2]

C. P. Ellis's friendship with Ann Atwater was the subject of a book[3] that inspired a documentary, a 2011 play, and a 2019 film called *The Best of Enemies*. When Ellis died in 2005 at the age of seventy-eight, Ann Atwater delivered the eulogy.

As with Derek Black, it was not one person or one conversation that changed Ellis's mind. It was day after day of working alongside a brilliant Black woman, weeks of laboring together to achieve a common goal. That woman, Ann Atwater, didn't engage him in conversation in order to transform his worldview. She was just there to get a job done.

Problem-solving in groups offers a way for people to work toward a shared goal and can be a powerful method for a diverse group to arrive at consensus. We see this again and again in research studies—humans are highly motivated to solve problems, and we will bend rules and work with people we may not like in order to accomplish specific goals. Therapists often suggest exercises in collaborative thinking and collective problem-solving to address anger issues in children and adolescents. It can work just as well among adults.

The transformations of Derek Black and C. P. Ellis also demonstrate that sometimes exposure and proximity alone can lead to a closer relationship. At the University of Kansas, the communications professor Jeffrey Hall has used both surveys and a six-month-long longitudinal study to examine how people form bonds of friendship.

His research indicates that it takes about forty to sixty hours to develop at least a casual friendship. What's needed, according to Hall, is not necessarily long, intimate tête-à-têtes, but small talk and chitchat. Especially in his longitudinal study of college freshman, Hall discovered that "keeping abreast of friends' daily lives by catching up and joking around predict change in friendship closeness above and beyond the number of hours together."[4]

This suggests you can develop a meaningful relationship with someone, even when you disagree on important issues, simply by spending time with them. Remember the Shabbat dinners that Derek Black attended? The guests talked about classes and family and hobbies, not race and discrimination. Of course, at some point, a friendship can't endure if both people ignore their conflicting worldviews, but the task of bridging that gap is easier once a bond has been established.

We must get beyond the notion that conversations go badly because of someone else's beliefs or behavior. As these examples illustrate, it is possible to have a productive exchange with people whose beliefs differ greatly from yours. More than four in five people, when surveyed, cite poor communication as having played a role in a failed relationship; but fewer than one in five think they're to blame when a conversation goes wrong. I'm sure you see the problem with the math here. Although we understand the importance of improving communication, we think the other person bears the responsibility for making that happen.

Let's consider one more example of the power of conversation: Daryl Davis and the transformation of the Maryland Klan.

Daryl Davis has had a long and celebrated career as a blues pianist; he's played with Chuck Berry, B. B. King, Bruce Hornsby, the Platters, the Drifters, Percy Sledge, and Bo Diddley, among many others. Davis doesn't just play rock and roll; he stomps and dances with the ground bass. Watching him play is a thrilling reminder that the piano is a percussive instrument.

In the 1980s, he was playing with a country band in Maryland when a man approached him and said that was the "first time he heard a black man play as well as Jerry Lee Lewis." This was a blatantly racist comment on the surface, but even more so when you consider that since boogie-woogie and blues are Black inventions. Lewis, the Killer, learned them from Black musicians.

Davis was amused instead of irritated by the comment and continued the conversation long enough to discover that the man in the bar was a member of the KKK. Most people of color would likely have walked away at that point, and understandably so. Instead, Davis kept talking to him, not about race but about music. "We struck up a friendship," the pianist remembers, "And it was music that brought us together."[5]

Years later, Daryl Davis couldn't get the Klan out of his head. As he explained in a TEDx talk in 2017, he decided to interview members of the white supremacist group in order to answer a question that had lingered in his mind since he was ten: "Why do you hate me when you know nothing about me?" He set up a meeting with Roger Kelly, imperial wizard of the KKK in Maryland, and over the ensuing months, the two developed a friendship. Kelly asked Davis to be his daughter's godfather and told his fellow Klan members, "I would follow that man to hell and back. . . . A lot of times we don't agree about everything but at least he respects me to sit down and listen to me."[6]

Eventually, Kelly left the Klan, crediting his friendship with Davis for his change of heart. Davis convinced at least twenty more white supremacists to denounce the KKK, he says, including the three most powerful Klan members in his home state. "When the three Klan leaders left the Klan and became friends of mine, that ended the Ku Klux Klan in the state of Maryland," Davis said during a 2015 interview.[7] (That claim has been disputed by experts in extremism and, if it ever was true, it is certainly not true now.)

Daryl Davis published a book in 1998 (*Klan-destine Relationships:*

A Black Man's Odyssey in the Ku Klux Klan), and he's spoken extensively about his crusade to dismantle the KKK, one friendship at a time. In interview after interview, he has been asked how to argue with a racist, but he has no advice to offer on that subject. Instead, he says, "Invite them to a conversation, not to debate. . . . You say, 'Hey, I want to have a conversation with you. I want to understand why you feel the way you feel. I want you to convince me that I need to change my way of thinking, and I appreciate your sharing your views. I'm interested in how you feel.' And that's what a lot of people want. They want to be heard."[8]

I will add one note to Davis's story, however, as it's important to understand the full, complicated context of his perspective. A few years ago, he testified on behalf of Richard Wilson Preston, an imperial wizard of the Confederate White Knights of the KKK who pointed a gun at a Black man and then fired at the sidewalk during the Unite the Right rally in Charlottesville, Virginia, in August 2017. Davis says he posted half of Preston's bond. "I'm testifying because he's my friend," the musician told the court. "He's in trouble and I'm trying to help."[9] Preston was eventually sentenced to four years in prison for his actions.

One year after the violence in Charlottesville, Daryl Davis took Preston to the National Museum of African American History and Culture in Washington, D.C. The KKK leader wore a bandana with the Confederate battle flag on it, claiming, "It's just a piece of history . . . It's not against anybody." In an interview for CNN, Preston said he still believes the Klan is not racist, but rather patriotic. "I want to see the Klan become what it once was, not what it became," Preston told the reporter, adding that he plans to be buried in his Klan robe.[10]

It should go without saying that while we can admire Daryl Davis's ability to connect on a human level with people who hold inhumane views, it is not the responsibility of anyone—least of all, a

person of color—to give cover to white supremacists. It's healthy to develop empathy for even the most unsympathetic among us, but I would suggest that there is an important line between empathizing and endorsing.

I would talk with a white supremacist if I felt safe; however, I would never be their character witness. About Daryl Davis, Mark Potok of the Centre for Analysis of the Radical Right wrote this: "The much-discussed 'conversation about race' is certainly something the United States needs as it continues to wrestle with its ancient demons and the original sin of slavery. But a black man who hugs Klansmen, goes to their weddings, listens to their racist jokes and even testifies in court to help them avoid prison time, may be more of a balm than an antidote to the scourge of hate."[11]

This book is focused not on the morality of talking to white supremacists, however, but on *how* to have conversations about race. At that, Daryl Davis seems genuinely gifted. By the way, I reached out to him for an interview for this book, but he declined. Still, his advice on how to talk with racists echoes the guidance we get from others, including experts on extremism and radicalization.

The themes of listening and nonjudgmental interaction crop up again and again in stories about dramatic change. Authentic human connection has surprising power to inspire conversion. In a 2017 TEDx talk, Christian Picciolini, the former skinhead who founded the counter-extremist Free Radicals Project, described how he left the white supremacist movement that he helped build only after he talked with a young Black customer in his record store about the customer's mother and her cancer diagnosis. He also spoke with a gay couple who clearly loved their son as much as Christian loved his.

Christian joined the skinheads, he says, because he was searching for identity, community, and purpose. He thought he had nothing in common with Blacks, Jews, and the rest of the people he hated. But he took the time to learn about the people who belonged to the groups

he despised when they entered the store that provided his income. When he was forced to speak with them, he discovered they shared common fears and desires and goals. "Hatred is born of ignorance," Picciolini says. "Fear is its father and isolation is its mother."[12]

In an episode of her Hulu show, the comedian Sarah Silverman spoke with Picciolini and later responded to the idea that someone like him might never be allowed to forget his racist past. She says when Picciolini was a lonely fourteen-year-old, someone found him and gave him a place where he belonged, "where he was accepted and cared for and loved . . . and that was a hate group, a neo-Nazi group, where he found family and camaraderie."

While it's true that most people feel anxious and lonely at some point in their lives, and only a small percentage will relieve their anxiety by joining a hate group, Silverman's point is that we must provide a process through which those who do choose hate can later change their minds. "If we don't give these people a path to redemption," she says, "then they're going to go where they are accepted, which is the motherf***ing dark side." Finally, she asks an important question, one that I hope you will consider if you are ever confronted with a racist: "Do we want people to be changed or do we want them to stay the same, to freeze in a moment we found on the internet from 12 years ago, so we can point to ourselves as right and them as wrong?"[13]

It's possible that you've spoken with an extremist and didn't realize it. But remember, history proves that sometimes even an entrenched racist can be reached through respectful conversation and deep listening. You'll notice I didn't say persuasive talking, but listening. In his TEDx talk in 2017, Picciolini said that people in hate groups "became extremists because they wanted to belong." His mind was changed simply because he received empathy and compassion from someone who had no reason to give it.[14]

By this point, I've pored over dozens of stories that are similar

to Christian Picciolini's and C. P. Ellis's and Derek Black's. In tale after tale of those who've renounced a deeply held belief, it becomes clear there was no single life-altering event that sparked an epiphany. No highly skilled and intelligent debater who argued them into submission. Instead, it was months and months of patient conversation and listening without condemnation.

I found that similar themes echoed in most of these discussions, tactics common in stories of persuasion and epiphany. First, conversations evolved over time and required a great deal of patience. Not one or two discussions over dinner, but dozens of them spanning months. Also, in every case study I read, the interactions were face-to-face conversations rather than exchanges over social media or email.

There are also commonalities in approach, the way people talked with extremists and how they framed their responses. Often, they asked a lot of questions rather than focusing on making statements or citing facts. Also, they seemed to have striven hard to avoid making judgments and accusations. Instead of saying, "You don't care about other people," they asked, "Why do you think that way?"

Finally, the most persuasive stories were personal. In describing their "lightbulb moments," their epiphanies when they began to realize they might be wrong, Black and Picciolini talk about what they learned about the lives of others—their loved ones, their fears, and their dreams—not statistics and data. We will talk about the power of personal stories a little later, but it's important to note that even extremists can be moved by the life experiences of other people.

You don't need magic to make that work; you don't even need to be a highly trained professional. All that's needed is your willingness, your focus, and your humanity. As Daryl Davis explained in 2017, "I am a musician, not a psychologist or sociologist. If I can do that, anybody in here can do that . . . so, keep the conversation going."[15]

PART II

THE CONVERSATION

CHAPTER 5

FIRST, GET YOUR HEAD STRAIGHT

> Opinion is really the lowest form of human knowledge; it requires no accountability, no understanding. The highest form of knowledge, according to George Eliot, is empathy, for it requires us to suspend our egos and live in another's world. It requires profound, purpose-larger-than-the-self kind of understanding.
>
> —BILL BULLARD

To paraphrase Shakespeare, some are born to converse, some achieve good conversation through effort, and some have conversations thrust upon them. When it comes to discussions about race, the latter scenario is most common. We are often thrust into these conversations when we least expect it. Because we can't always control the time or location of such exchanges, I recommend putting in the effort now, in order to be prepared.

All too often, potentially meaningful conversations go off the rails because people don't stop to consider their own expectations. You know it'll be difficult, that it will balance on the knife's edge between productive and contentious. Instead of focusing on your fears, though, think about your underlying objective: What is it that you hope to

learn or achieve? It's important to be honest with yourself about what you want to get out of the conversation before you begin talking.

Perhaps you want to demonstrate to someone that they've misunderstood something you've said. Maybe you want to educate them about an issue that's important to you. These desires are natural, but not necessarily reasonable. Conversations rarely result in feelings of vindication; at their core, they are about giving and receiving feedback. Unless you're someone who loves the experience of undergoing an annual performance review, you know that accepting feedback is usually a challenge.

Therefore, before you engage in any conversation about race, I encourage you to take a moment and ask yourself *why* you want to talk about it. Ascertain why this discussion is important to you, and be prepared to articulate your motivation to others, should they inquire. Challenge yourself to finish this sentence: "I'd like to talk about this because . . ." Keep in mind that confrontation is unlikely to lead to effective conversation.

Setting a goal that does not involve proving someone else wrong or changing their mind is something you can do before you engage with another person or are forced to respond to something a friend or co-worker has said. This is mental work that you can undertake at any time.

As you begin to explore your own motivations and desires, it's also important to think about what the other person's goals might be, to consider their objectives and even their fears. This kind of reflection demands that you consider the emotions of others and establish ethical boundaries based on the principle of doing no harm to anyone involved.

We rarely consider the ethics of conversation these days, but it's a topic that once occupied the minds of great philosophers and thinkers such as Sophocles and Aristotle in ancient times, and Paul Ricœur and John Dewey in the twentieth century. I'll assume that

if you're concerned about racial equity and justice, you're also concerned about acting ethically. Fortunately, this is an achievable goal—you don't need to have a degree in rhetoric to ruminate on the ethics involved in a discussion of race; all you need is a commitment to fairness and mutual respect. From those fundamental precepts, we can construct a set of guiding principles.

So let's create our own version of the Geneva Convention,[1] governing the ground rules of conversation rather than the protocols of combat. These guidelines will establish not only our own rights and limits but also our responsibility to others. Because the discussion of racial identity so often involves stories of injustice and loss and pain, and because there is a perpetual risk of hurting feelings or causing insult, we must tread carefully.

Let me ask you this: Are you always in the mood to talk about race and racism? Even I am not, and it's part of my job. Sometimes I'm too tired or distracted, or simply not mentally able to focus at the intensity level that's required. Perhaps I feel the time or place is inappropriate. Maybe I'm too hungry, angry, happy, lonely, frightened, or irritated.

The reason itself doesn't matter. What matters is that if I don't want to have the conversation, my boundary needs to be respected, and that I afford the same consideration to everyone else. If I hear someone make a racist remark, I will point it out to ensure they don't think their comment was acceptable, but I will not badger them into a conversation if they do not want to engage at that level.

As with most everything else in life, consent is nonnegotiable. A conversation cannot be productive if one or more participants feel they are being coerced or manipulated. It's also impossible to demonstrate mutual respect if one person says, either explicitly or through tone and body language, that they don't want to continue the conversation and the other person refuses to honor that request. This is especially important if you're speaking to a person of color,

as they may be too tired to discuss race with you. Being a person of color in a racist society is *exhausting*.

"Can we talk about this?" It's an important question, and it only takes a few seconds to ask. "I don't agree with what you've said, but I'm curious to hear more about your thinking," you can say. "Is that all right?"

When a story about racial violence or intolerance is making headlines, you might feel an urge to discuss it, especially with your friends and colleagues of color. But don't underestimate how draining and traumatizing the news coverage can be for people of color, Blacks in particular. For many in BIPOC communities, news stories about police violence or inequities in legal, education, health-care, and other systems are personally traumatic. It's difficult for them to read about an unarmed Black person dying at the hands of law enforcement without worrying that they or their loved ones could suffer the same fate.

To that end, in these particularly heightened moments, please avoid asking your Black friends, "Are you okay?" Before you ask them how they're doing—which demands an answer they may not feel ready to give—you should ask for consent. I'd suggest saying something like, "If you feel like talking about what's happening, I'm here to listen. I understand why you wouldn't want to discuss it, but I care about you and I'm here to support you, should you need it." This lets them know you are available for support while allowing them the space to pass on the exchange if they're not feeling up to it.

The importance of establishing consent increases when there are other people nearby and you have an audience. Offering your support to a friend or colleague in private is one thing; if you ask these questions while in the presence of other people, it can increase the pressure on everyone involved. No matter what you're discussing, an audience changes the dynamic of a conversation, making it even more crucial that you proceed with caution.

On the one hand, you may want to wait to open up a conversation on racism until you have some measure of privacy. On the other hand, if you are in a public setting where others are discussing racial issues, you have a heightened obligation to call out racist or ignorant remarks when you hear them. This is an instance in which you should not wait to respond or pull someone aside for a private chat. If people at your workplace are talking about why Black employees aren't fit for leadership and you say nothing, then they may assume their remarks are acceptable or that you agree with them. Silence is complicity.

It's understandable if the prospect of pushing back in these instances and possibly courting conflict makes you feel nervous. That's why it's useful to have some guidelines to conversational conduct ready at hand. Ethically, racist remarks should be verbally noted, delineated as racist, and denounced, but further discussion is not encouraged unless others express their desire and consent for further exploration. (These rules, of course, differ for leaders or people charged with the safety and conduct of others. In those instances, discussions can be compulsory.)

The problem is, we rarely set boundaries for our personal dialogues. Modern conversations are more like free-for-alls, with very little thought given to expectations or morality. So, in order to create a useful guide to ethics in discussions of race, I spoke with an expert, Dr. Hugh Breakey, a senior research fellow in moral philosophy at Griffith University's Institute for Ethics, Governance and Law in Australia, where he studies the boundaries of morality in conversation. I asked Breakey about consent, and how we can respond to racist remarks when we hear them, without crossing the lines of ethical public discourse.

BREAKEY: There's always a line that, when you step over it, I'm no longer going to respond to you respectfully. Where what you've

done is bad and it is worthy of social punishment, and that's what you're going to get.

The first thing that's worth saying for both call-out culture and cancel culture is: these things aren't new. They've been around since time immemorial. Every society has always had places you can go in public discussion and places you'll be punished for going.

That said, it's worth understanding the consequences of what happens if you do punish someone for crossing a line, if the bounds of what you're willing to accept are very narrow. The narrowest version is, "I'm not going to accept anything unless someone says something I believe in."

HEADLEE: But that is common right now. More common than not.

BREAKEY: It does look like across your culture in the U.S., and I think across ours in Australia as well, that those boundaries have been changing radically. Previously, it was okay to debate people across the political spectrum unless they turned out to be a fascist or Klansman or something similar. But generally, they were able to be tolerated, which is to say not harangued, not punished or ostracized for what they were saying.

If somebody is engaging in good faith argument and they're trying to do their best, but they say something that the other person decides is out of bounds, then the haranguing is almost certainly, from their point of view, going to seem like a violation of the rules of arguments.

This is because almost every account of respectful argument is going to include a provision prohibiting ulterior punishments. That is to say, you can persuade the person, but what you're not allowed to do is to persuade them by threatening them, by attaching punitive consequences to them not forming the right view. That moves us from discussion and argument into the terrain of coercive manipulation.

In addition, if it's a public discussion, you've got issues about what

philosophers like me would call deliberative democracy or deliberative legitimacy, which is to say that democracies don't function simply because everybody has a vote. The idea is that there's meant to be a discussion. People are meant to be informed. People are meant to be able to listen to lots of different views, speak their own mind, see what other people have to say, and then through that process, come to a position where they will be able to vote and others will be able to vote in an informed and thoughtful way. That's one of the ways that democracy attains legitimacy.

Now, if you take a whole part of the political spectrum and you say you can't deliberate with these people, these people are beyond the pale, then one of the natural consequences is that the society itself, the culture, loses respect for its political institutions because they no longer have the legitimacy that they used to have.

And this is true sociologically as well. We know that, even in small collective decision-making groups, if people are allowed to speak their minds and they get listened to, then even if the decision of the group goes against what they want, they are happier and they are more likely to go along with the group decision than if they were just not allowed to offer their view. So the ability to actually listen to people and take them seriously has larger political consequences.

Also, haranguing someone is just a terrible strategy for persuading somebody that you're right. The best thing you can do, strategically speaking, is make them feel comfortable. Make them feel happy and respected. If you make them feel bad, if you make them feel defensive, if you make them feel like they're not a worthwhile person, then they're absolutely not going to be persuaded. That's when all the defensive mechanisms go up and they rally themselves, because now it's not just their belief that's in question, it is their ego. It's their status.

So even though I acknowledge that there is a point at which haranguing becomes acceptable, the reality is that it's really ethically

fraught to go around with a very wide swath of things that you will get offended about or that you'll determine are harmful and inappropriate. It can stop you from being an open-minded person.

It can encourage the group around you to engage in groupthink because nobody's willing to say anything that might be against the grain. Because once you shut down that ability to take in information from other sources, then a group can really sort of go off in very strange ways, cognitively speaking.

HEADLEE: I just had this conversation with a young woman recently. I asked her how she thinks it might turn out if she chooses to ignore the people who didn't vote for the same person she did. And she said, "Well, would you have let the Nazis talk?"

As somebody who thinks about ethics, how does that argument strike you? If someone has caused harm to others, either through their action or inaction, is it therefore okay to ostracize them?

BREAKEY: Generally, the ethical onus is on us to make really sure before we decide that this person deserves to be ostracized, that this person deserves to be harangued. Because if nothing else, there's what we call "rule of law" considerations. The punishment has to fit the crime.

You know, people do bad crimes all the time and we expect them to be punished. And once they're punished, we expect them to be able to resume their normal place in society.

If the problem is you've got 25 percent of the people who are problematic in terms of their political views, it's likely that some (let's say 5 percent) are untouchable in the sense that they will just be this way forever. But there'll be a very significant amount of them who are changeable.

The last thing we'd want to do would be to ostracize that group where change is possible, and to make sure they only keep talking to each other and that terrible 5 percent. It is much better to start asking, "How can we change this group?" because people do change.

Are these people condemned to forever hold these terrible beliefs? The answer is plainly no. So even though it might be morally permittable to harangue or ostracize this group (because they have awful views), it still might not be constructive. It might not help us achieve the important political goals we need to secure.

Dr. Breakey's thoughts on the ethics of discourse can help us form a set of rules:

- Obtain consent at the outset of the conversation.
- Ensure that your beliefs are consistent and not hypocritical. (If it's wrong for them, it's wrong for you.)
- Base your stated beliefs on evidence, not feeling.
- Ensure that the punishment fits the crime, and the outrage is in proportion to the offense.
- Allow all to express their views.

Coercive manipulation or threats are unacceptable. Breakey also suggested that we must accept what others share about themselves, an important point we will discuss in more detail later. We must, as much as possible, avoid discounting someone else's instinctive reactions and remember that feelings can't be controlled or prevented. The most any of us can do is deal with the feelings *after* we feel them.

Ethical behavior can be as simple as the Golden Rule: Do unto others as you'd have them do to you. Some version of the Golden Rule exists in dozens of religious practices. In Islam, the thirteenth hadith of Imam al-Nawawi reads, "None of you [truly] believes until he wishes for his brother what he wishes for himself." In Hinduism, it's phrased this way: "This is the sum of duty: do not do to others what would cause pain if done to you." And in the tradition of the Pima, a Native American people, "Do not wrong or hate your neighbor. For it is not he whom you wrong, but yourself." Simply

put, if you know your expectations of others in conversation, then you know what they might expect from you.

Now that we've established some ethical ground rules, the next step in preparing for a fraught and possibly confrontational conversation is to predispose your mind to accept new ideas. This involves developing the ability to imagine that you could be wrong, as well as the capacity to give your full attention to someone else while they speak. In essence, we want to help the brain more easily achieve a state of true curiosity, in which it is most receptive to learning and feedback.

Research suggests there are three ways to do this: practicing metacognition, or thinking about your own thoughts; engaging in what is known as "beginner's mind"; and expanding your empathic capacity.

Metacognition is an ability that can be taught and improved through regular mental exercise. "Cognition" means thinking, of course, and "meta" means "on top of" or "beyond." This skill will help you go beyond the current limitations of your thinking. It is obligatory to rise above confirmation bias and the natural resistance to being wrong. It's also essential in order to evaluate your own beliefs and embrace the possibility of changing them. This ability is as rare as it is valuable.

If you've ever thought about how well you memorize song lyrics, if you've ever planned to think through a problem or analyzed why you reacted emotionally when someone used a certain word or phrase, then you have practiced metacognition. Social metacognition, for example, is thinking about how your mind works in relation to others.

Changing a deeply held belief is one of the most difficult challenges a human can face and the task becomes even more onerous when the belief is unconscious, when we aren't aware of what implicit biases are influencing our behavior. Learning to be aware of

our thought processes and how we make decisions is crucial if we hope to identify the assumptions underlying our ideologies. Research has shown that our beliefs are more entrenched than we may realize.

In one study on metacognition, researchers first polled participants on their political beliefs. Then they presented the participants with two pictures and asked which picture contained the most polka dots. When the participants responded, researchers asked them to state how confident they were in their choice.[2] The cognitive neuroscientist Stephen Fleming, who oversaw the study, explained that when people guessed incorrectly, those who had the most extreme political beliefs "were less likely to decrease their confidence"[3] in the correctness of their answer, even though there was no question about the facts, no way to spin the results, as one picture simply had more dots than the other. People whose political beliefs landed on the ends of the political spectrum had a more difficult time questioning their own ideas than more moderate people did. This helps explain why some are not persuaded by evidence that disproves their beliefs: rather than change their opinion, they simply decide not to believe the evidence.

This finding is relevant to our exploration of conversations about race because race and politics are so deeply intertwined. According to research from Pew, when you control for other factors, "partisanship has a greater association with views about the country's racial progress than demographic factors."[4] A person's answer to a question like "How much progress have we made on issues of racial justice?" is more strongly correlated to their political party than their skin color. That's why metacognition, the ability to evaluate whether you are right or wrong on an issue, becomes key: loyalty to political party can override all other considerations.

While learning to think critically about our own thinking is a powerful way to broaden our perspectives beyond such allegiances,

the reality is that retraining the mind is incredibly difficult, and few tactics have been proven to be effective. One method that *is* backed by solid science, though, is the use of affirmations. These repeated phrases bring results because what we tell ourselves about our thinking and our attitudes matters.

For example, there are two opposing stories you can tell about yourself and your relationship to the wider world. Some believe a person's talents and perspectives are set and inflexible (this is called entity theory). If you believe this, you might think a person who is raised in a racist household will always be racist. Others believe that an individual's abilities and attitudes can evolve as the result of concerted effort or life experience. (I assume that, because you are reading this book, you are among the latter group.) This is known as incremental theory, and it's the idea that we have some measure of control over our beliefs.

To practice metacognition, let's start with a technique that is often used to boost creativity: mind-mapping or radiant thinking. Get a blank piece of paper and write a word in the center. I suggest you choose one of the following five words:

1. Race
2. Respect
3. Argument
4. Learning
5. Defensiveness

Draw five short lines extending outward from your chosen word, and take note of the first five words that come to your mind. It's very important that you do not edit yourself. Some of the thoughts that bubble up through your consciousness may seem silly or irrelevant. Write them down anyway.

Repeat this process for every word you've written: draw lines radiating outward, and record the first few things that float to the top of your mind. You'll see quite clearly why this is so often referred to as radiant thinking; the branches radiate out from the center. The more you do this exercise, the better you become at writing down exactly what comes to mind instead of editing your responses according to what you think makes you look smart.

Now glance over your page. Take a good look at the words written at the farthest ends of the branches and compare them to the original prompt at the center of the page. Try to understand how you got from one word to another and why some branches are so different in tone from others. You have thus created a map of your thinking and can now examine your thought processes. This is metacognition.

The type of metacognition I'm most interested in is the process of imagining that you might be wrong, or that your attitudes might be based on bad information. As Socrates said, "The only true wisdom is in knowing that you know nothing." The ability to accept that your opinions are sometimes misguided is relatively rare, however, and getting rarer all the time.

It's quite easy, though, to detect the strength of your resistance to being wrong. Ask yourself the following series of questions:

1. Is every opinion you hold based on research and experience?
2. Is at least one of your opinions (on food, lifestyle, religion, politics, morals, race) based on hearsay (what someone else has told you, either personally or through a blog or social media post) or on insufficient information (one article in a newspaper, one documentary, one book)?
3. Is it possible that one of your opinions could change if you received new information?

Once you've answered these questions, take a moment to visualize the following scenario: You are disagreeing with a friend about something. Perhaps she tells you that a human being's ears continue to grow throughout their lifetime. You tell her that's not true. You *know* that's not true because you read that people's bodies shrink as they age.

You argue back and forth. You're very sure of your opinion; after all, you just read that article a month ago, and it was in *Smithsonian Magazine*. A reputable publication, for sure. After at least five minutes of debate, she shows you indisputable evidence that the ears and the nose continue to grow through our lifetimes because they're made of cartilage, not bone.

Stop for a moment and imagine how that feels. What would go through your head if you realized that you'd aggressively argued a point and then were proven wrong? Are you angry? Embarrassed? Ashamed? Would you try to downplay the whole thing?

Forcing yourself to conceptualize this situation not only leads to metacognitive exercise but also prepares you emotionally for accepting error. It's a valuable drill because—this may come as a surprise—you are wrong about something right now and you don't realize it. Our understanding of facts is highly influenced by our racial identity, income level, education, and experience, which means that not everything we believe is based on evidence.

One study at Yale University, for example, established that whether you think the American economy is fair or not depends a great deal on your race. Researchers asked people to estimate the wealth of a white household versus that of a Black household. The average guess was $100 for whites and $85 for Blacks, but the real answer is far more dramatic: $100 for white households versus $5 for Black. When people were asked about average income for whites versus Blacks, they guessed that for every $100 a white family earns, Black families earn about $14 less. Here again, the truth

is far worse: Black families actually earn about $43 less.[5] So, if I were to ask a white person if the U.S. economy is basically fair, they might say yes, based on faulty assumptions. It would be difficult to alter that supposition because it's based not on facts, but on emotions and on strong opinions about the country and meritocracy.

Beliefs sometimes have roots that go deep inside our psyches, and it therefore won't avail you to argue against them. Much better to dig deeper until you get to the underlying assumptions that bolster opinion. This is not just something we should help others do but also something we must do for ourselves. Be prepared to admit you're wrong in order to recognize both the primary error and the faulty reasoning that follows.

How confident are you that your memory of facts and statistics and history is accurate? It's possible you don't precisely remember some details about racial history and disparities, and that the opinions you've formed over the past few years have been skewed as a result of your imperfect memory. Our conversations with others can protect us from further error by making us aware of holes in our logic, but only if we prepare ourselves for the uncomfortable experience of being wrong.

There is good news on this front: In that Yale study involving the fairness of the U.S. economy, researchers found that people's perceptions were flexible. When scientists asked people to imagine a parallel America, one in which discrimination was widespread, and then to estimate the income gap in that *other* America, their guesses became more accurate. This is an example of how using our imagination and undergoing thought experiments can improve our cognitive abilities and allow us to rethink our perspectives.

The next technique that can be useful in preparing for a conversation about race is to reach a state of beginner's mind, which is a concept drawn from Zen Buddhism, where it is termed *shoshin*.

The goal here is to approach new information as though you're an amateur, even if you've attained a level of expertise. To achieve a beginner's mind, you must learn to let go of preconceptions. Shunryu Suzuki, the author of *Zen Mind, Beginner's Mind*, wrote, "In the beginner's mind there are many possibilities; in the expert's mind there are few."[6]

Of course, it's not possible to truly forget all that you know and approach important issues with a blank mind, nor would you want to let go of all you've learned and experienced in the past. What's more, our views on racism, particularly among people of color, are often influenced by past trauma, which is sometimes impossible to dismiss from our thoughts.

Yet even making the attempt to approach issues with a fresh perspective can be a worthwhile endeavor. What's more, bringing all that knowledge and mastery and painful memory to bear on a problem can backfire in spectacular ways. Think of it as choosing to ride a train that can only travel to predetermined destinations instead of a Jeep that can drive off-road and end up anywhere.

It's common for people who know a lot about a subject to fall into what's known as the "expertise trap." This phenomenon, in which smart people stop learning because they're so confident in their own scholarship, has been studied carefully in the workplace setting. The famed Harvard business theorist Chris Argyris wrote about it in 1991, saying that successful people don't have a lot of experience with failure, so when they make a mistake, "they become defensive, screen out criticism, and put the 'blame' on anyone and everyone but themselves. In short, their ability to learn shuts down precisely at the moment they need it the most."[7]

The more you learn, the better you are at identifying patterns and themes and the more likely it is that you'll try to place new information within those existing patterns. Unfamiliar ideas can seem wrong because they don't match what you've seen in the past. You

can be tempted to disbelieve facts and data that appear to contradict what you know.

The expertise trap is a persistent issue for business executives and can impede progress and innovation. It can also preclude honest communication with another person whose experience has been vastly different from yours. As Argyris wrote, when smart people are confronted with their own error or lack of knowledge, they attack those who want to explore the mistake, saying they're intimidating or overly aggressive. They also "deal with their feelings about possibly being wrong by blaming the more open individual for arousing these feelings and upsetting them."[8] They are presented with an opportunity to learn via correction and instead lash out at the person who offered the criticism.

What have you been wrong about in the past? Have your opinions changed on homosexuality? On policing? On the environment? Perhaps your views on Confederate monuments have evolved. Perhaps your change of mind happened privately, and you weren't confronted with your error and forced to defend yourself in public. Imagine, though, what it would require for you to hear criticism of your beliefs from another person and accept that critique as a gift and not an assault.

With practice, beginner's mind can be a mindset you dip into at will. Learning and honing this skill will help you in conversation, certainly, but also in many other areas of your life. To accomplish this, it's necessary to let go of expectations and preconceived notions. It's particularly vital to question those things that supposedly "go without saying."

You can use this technique to question your core values and interrogate your own beliefs. It "goes without saying" that racial equity is a positive goal, right? Ask yourself why, and whether humankind has ever lived peacefully in a true state of equity before. What does "racial equity" mean, anyway?

Another method for cultivating beginner's mind is to act as your own devil's advocate—imagine you're debating someone else and take on the view of the opposing side. Write down what you might say if you were the competing debate team. Research has shown that this type of exercise, which forces you to walk a mile in someone else's shoes, helps us see the weaknesses in our own arguments and shift views predicated on stereotypes.[9] It's even more effective if you adopt the persona of someone you know, like a friend or family member.

For example, if you believe Black Americans deserve reparations from the U.S. government, write down your most persuasive arguments in support of that action. Then imagine that you are someone who does not agree with the idea of reparations and write down your arguments against them. Take this assignment seriously. The point is not to create a caricature of anyone, but to get inside the head of those who hold differing opinions, to accept that your opinions might be flawed or even specious, and to lessen your emotional resistance to hearing opposing views.

Finally, before you initiate a discussion on race—or any discussion at all—I encourage you to consider your capacity for empathy, or the ability to imagine what others are feeling. Empathy is a skill we all use to better understand what others may be thinking and feeling. It's true we're born with a certain measure of empathy. Scientists in one study found that when infants as young as eight months saw their mothers experience physical pain, they showed true empathy, through facial expressions and sympathetic sounds, as they searched their mothers' faces.[10]

But the choices we make throughout our lives—as well as our life circumstances and environments that are largely outside of our control—can diminish our ability to empathize with others. An erosion of this ability is problematic in a number of ways, but when

it comes to conversation, empathy is required in order to understand someone else's point of view, especially if it diverges from ours.

Luckily, just as empathy can decrease over time, it can also increase, and there are practical ways to enhance your ability to connect with someone else's felt experience. One method is to indulge your curiosity about others. As often as possible, learn something new about a complete stranger. Ask a barista about the town where they grew up, or about the tattoo on their forearm, or their favorite season. Ask your neighbor about the plants in their garden, about a TV show they like, or the exercise they prefer.

Another way to increase empathy is to open yourself to new experiences. Go to a live performance of music you typically don't enjoy and leave yourself open to the sounds and the enthusiastic response of the audience. Attend a service at a church, temple, mosque, or other religious organization that you don't belong to and open yourself to the ideology and communal nature of the experience. Spend a day in a completely different part of town, watching people leave for work in the morning, walk their dogs, eat lunch, pick up their kids, or go back inside to end the day. You might be very surprised by how much life is the same wherever you go, and how different it is, depending on where you live.

Research shows the most effective way to increase your empathy is to hear the stories of others, to learn about their dreams and their struggles, their triumphs and failures. This is perhaps the simplest technique I can suggest: listen to someone. In fact, you can make it a daily exercise-to ask someone else to tell you a story about themselves. As soon as the conversation is over, stop for a moment and write down what they told you, as much as you can remember. Again, this is a skill that will serve you well in nearly every aspect of your life, but this kind of active listening is crucial to discussions about race. You simply can't have a productive conversation about

this subject unless your listening skills are strong, so you might as well start working on them as soon as possible.

If you can analyze and critique your own thoughts, if you believe you can evolve, and if your listening skills are good, then you're ready to have an effective conversation about race. Realistically, if you want this to go well, you must create an atmosphere that lessens anxiety, rather than feeds it. Because we all experience race differently, because we are all discovering the boundaries of systemic racism, entering conversations on the subject means accepting you will hear things you believe are wrong and possibly offensive.

Recently, I was discussing trans rights with a friend, talking about the need to protect people in the trans community, since they are so much more likely than others to be the victims of violence in our society, and I used the word "hermaphrodite." My friend could have scolded me, if she chose, and told me that most people no longer use that term and instead say "intersex." She could have said that I'm old and ignorant (one of those adjectives applies to me). However, she simply corrected me, saying, "You mean 'intersex,'" and then the conversation continued. Later, I researched the term in order to truly understand why the word I used had fallen out of favor.

My point is, if you want to get the most out of the conversation, if you want to learn more about someone else's perspective, then you must create an atmosphere in which you both can share your stories without fear of judgment and allow for honesty and authenticity without fear of reprisal.

One final note before we dive into the strategies you'll employ during a conversation about race: there are times when you should *not* talk about race. Safety is always a primary concern for you, for the other person, and for those around you. In late 2020, I conducted a survey of roughly eight hundred people. The short list of questions was distributed through email and social media over a period of six weeks. Respondents were mostly white, with 5 to 6 percent identify-

ing as either Black or Latinx, and nearly 3 percent Asian, among other ethnicities. A large majority reported that race came up in conversation at least two or three times a week among their family and friends, and nearly 90 percent said they were at least somewhat willing to discuss race with people of a different race. Yet nearly 30 percent of respondents said they were somewhat concerned that a conversation about race would result in an argument. The last question of the survey asked what prevents them from talking about racism with people who disagree and allowed for short paragraphs in response. A surprising number mentioned a fear of physical violence.

One person wrote that they've been hesitant to engage on the issue ever since one man said "he would be willing to kill [them] for [their] views on racism and oppression." Another said some people are simply "too dangerous and/or too steeped in hate to change their views," while another respondent who is LGBT and Jewish said they sometimes avoid these discussions out of fear for their own safety. In a word cloud based on the responses to this question, the most prominent word was "fear."

If you have any fears for your own safety, walk away. If the other person seems volatile—if they are raising their voice, invading your personal space, or adopting an aggressive posture—walk away. There is nothing to be gained from risking your safety or forcing yourself to remain in a situation that frightens you.

The bar for leaving a conversation doesn't have to reach "threat of physical violence," though. There are several other situations that can, and should, trigger an end to the discussion. One such situation is a lack of respect for the basic humanity of others, expressed as a disregard for their safety or hope that someone else will come to harm. As one person said in my survey, "It's difficult for me to see it as a legitimate disagreement when people deny others' experience or make others' humanity a subject of debate."

A discussion cannot be productive unless both participants are interested in a productive discussion. If someone uses a racial slur, you should be able to say, "That term is personally hurtful. For the duration of our discussion, please don't use it," and get a reasonable response. If someone doesn't care how you feel about the language they use, they probably don't care about you. Walk away.

Even more common is the person who wants to argue and tries to escalate the conversation into debate and then into conflict. If you're in a discussion with someone whose goal seems to be conflict, even if they're a family member or friend, tell them that you'd love to discuss the issues calmly and respectfully, but will not engage in an argument. Invite them to talk about it at a later time. Then walk away.

I hope these cautions apply to very few of your interactions. Despite our fears, it's unlikely that a conversation that doesn't involve alcohol or kids' sports will devolve into a fist fight. Concerns over serious altercations are not entirely supported by evidence. For example, many people worry they'll argue about politics during holiday get-togethers, but a 2017 survey showed that only 3 percent of Americans thought it very likely that they'd get into a fight.[11]

For the most part, we circumvent disputes by refusing to engage on the subject. One person says, "Can you believe the election results?" and we respond, "Hey, how is your cat doing?" We ignore provocative comments, deflect volatile inquiries, and divert attention away from remarks that might spur debate.

You can continue to use those tactics and remain safe from battles within your social community. Alternatively, you can hone your conversational skills and avoid arguments because you're so good at having calm and respectful dialogue. The next few chapters are designed to help you do that. The only way to get past racist behavior is to get through it.

What follows are the nuts and bolts of this endeavor, the scientifically verified techniques for having a potentially fraught conversation without descending into rage. If you use these strategies, they will help. Although you can't control the behavior or reactions of another person, you can increase the odds that they'll respond positively and respectfully to what you have to say. Let's get started.

CHAPTER 6

RESPECT AND ACCEPTANCE

STEP 1: RESPECT, NOT AFFECTION

> If you could only sense how important you are to the lives of those you meet; how important you can be to the people you may never even dream of. There is something of yourself that you leave at every meeting with another person.
>
> —FRED ROGERS

As a journalist, I interview people I don't like or whose views I find problematic. Over the years, I've learned how to discipline myself before these interactions so that I can respond calmly, regardless of what may be said. Obviously, I want to avoid an argument, even with guests who are passionate and combative.

If there is a better-than-even chance of conflict, I will sometimes prepare with an affirmation, saying to myself, "This person is a human being doing their best in a tough world. I may not agree with them, but they deserve respect."

Because life, as we know, is hard. You probably think someone else doesn't know what it's like to be you, to have endured the

hardships you've endured. That may be true, but by the same token, you also don't know what they've gone through or how they've suffered. And while you may not like how they've dealt with life's setbacks, while you may believe you would have found a better way, they believe they're doing their best. Respect does not imply agreement or endorsement, but it does imply recognition of someone's humanity.

My research into authentic conversation and the importance of acknowledging our collective humanity has brought me back, again and again, to the life and work of Fred Rogers. As host of the long-running children's television show *Mister Rogers' Neighborhood*, Rogers had a talent not only for speaking to children as equals—never condescending or professorial—but also for recognizing the inherent value of everyone he met.

In 2019, the journalist Tom Junod—whose 1998 *Esquire* profile of Fred Rogers[1] formed the basis for the movie *A Beautiful Day in the Neighborhood* (starring Tom Hanks)—wrote a piece in *The Atlantic* in which he wondered what Rogers would say about our nation's polarized and racially charged political chaos. "It's obvious that he would have been devastated by the cruelties committed in our name at the border, and shaken by our lack of mercy in all things, particularly our policies toward helpless children," Junod wrote. "But even more obvious is what his position would have been regarding the civility debate. Fred was a man with a vision, and his vision was of the public square, a place full of strangers feeling *welcome* in the public square, and so civility couldn't be debatable. It couldn't be subject to politics but rather had to be the very basis of politics, along with everything else worthwhile."[2]

I know "civility" has become an unpopular word, and for good reason—the word is heavy with a history of abuses. It's often used by those in power to criticize and downplay legitimate protest and has been frequently coupled with racism. Lunch-counter

sit-ins, for example, which began in Greensboro, North Carolina, in 1960, were described as "uncivil," and, as Martin Luther King Jr. noted in his "Letter from a Birmingham Jail," critics said, "Why direct action, sit-ins, marches, and so forth? Isn't negotiation a better path?" More recently, in 2019, Gaye Theresa Johnson, a professor of African American studies at UCLA, told NPR, "People of color don't get to orchestrate the terms of civility. Instead, we're always responding to what civility is supposed to be."[3]

There is no need to reclaim the word "civility," but the essential quality Junod described is a respect born out of compassion for another human being's lived experience. Remember, respect is not the same thing as affection. It's easy to get preoccupied with concerns over likability; we often worry about whether someone will like us, or if we'll like them. What's more, we sometimes assume that good conversation occurs only between two people who like each other. But liking someone is not a prerequisite to talking with them. The goal is mutual respect, not mutual admiration. Take a moment and think about two people you respect but don't want to go to dinner with. Heck, I can name ten people who fit that description right now.

Concerns about likability can also inhibit the authenticity of a conversation; if you're overly concerned about being likable, you might edit what you say—and not in a good way. You might agree with outrageous statements so as not to seem inflexible, or you might even bite your tongue to avoid conflict. While tempering emotions is important, saying what you think someone wants to hear is not conducive to meaningful discussion. The goal of these conversations is not friendship but learning.

This holds true even with our close friends and loved ones. When we speak to someone we care about, the desire to avoid conflict can understandably be stronger than with strangers. Yet it's more effective to preserve those relationships through respect than to pretend

you're in agreement and build the connection on an illusion of consensus.

I like to approach these encounters as if I were welcoming guests into my home. I don't necessarily love everyone who arrives on my doorstep; sometimes they're "plus ones," or relatives of someone else I've invited. But they are still my guests, and there is an unspoken guarantee that they will not be attacked or diminished while they're under my roof. They will be shown courtesy, as long as they extend the same grace to me and my other guests. I will not break this unspoken pact unless they break it first.

How do you demonstrate respect to someone? In a 2001 interview, Studs Terkel, the journalist and oral historian, spoke of giving people permission to speak for themselves and express their grievances: "We're talking about presence acknowledged. Acknowledged by you, and at the same time your own presence is acknowledged, too."[4] The act of showing respect requires little of you, in an active sense, and it begins with acknowledging someone's presence, their existence as a thinking human being.

While the concept may be uncomplicated, the practice of mutual respect is sorely lacking these days, especially when we talk about hot-button issues like politics or race. The ethics of conversation demand that you accept that the person you're speaking with is capable of rational thought. That sounds facile, but it's a courtesy not often afforded to people in opposing political parties. Since discussions of race inevitably involve politics, it's imperative that we learn to humanize our political opponents. Instead, all too often, when someone believes you're wrong, they're prepared to dismiss anything you say.

The British journalist Reni Eddo-Lodge has written about her experience of being dismissed in conversations. In her 2019 book, *Why I'm No Longer Talking to White People About Race*, she describes being interrupted and treated with condescension in racial discussions. She writes that she can "no longer engage with the gulf

of an emotional disconnect that white people display when a person of colour articulates their experience." Speaking of people who start these conversations, she observes, "Their intent is often not to listen or learn, but to exert their power, to prove me wrong, to emotionally drain me, and to rebalance the status quo."[5]

Eddo-Lodge's experience is not uncommon. I've heard from many people of color who say that when they're speaking to someone who disagrees on important issues, they are often disbelieved or told they've been brainwashed by politicians, or are blind to their own biases. Our own opinions are often so entrenched that we assume those who don't share them are less intelligent, less rational than we are. In doing this, we fall into the very trap we decry in others. Making judgments about an individual's personality based on the stereotypes of a group to which they belong is at the heart of racism. This is where respect is critical; we must be vigilant to avoid the assumptions that deny the humanity of other people.

In *Beyond Good and Evil*, Nietzsche warned of the dangers of dehumanizing other people. Aphorism 146 is his famous caution: "Whoever battles monsters should take care that he doesn't become one in the process. And if you stare for a long time into an abyss, the abyss looks into you, too."[6] Today, these words seem particularly relevant, as the abyss threatens to engulf us all.

It's possible that our tendency to "otherize," to see people from outside our own circle as less human, less deserving of compassion than those within it, is more a by-product of laziness than malice. Stereotypes are easy; they require little thought or deliberation. Perhaps we are more prone to them now because we are simply overloaded. Our ancestors encountered a few hundred people over the course of their lives; because of social media, we might encounter tens of thousands, and the followers of posts we make or read might reach into the millions. It could be that we find the process of affording everyone the same amount of respect is overly taxing.

Further, it requires effort to consider new viewpoints and perspectives. From a neurological perspective, it's much more demanding to listen to someone with an open mind (that's the System 2 thinking we discussed in chapter 2) than it is to allow our brains to switch to autopilot and make our decisions with the least amount of thinking possible. Sadly, the impact of those stereotypes on others can be significant.

In his 2019 book, *Love Thy Neighbor: A Muslim Doctor's Struggle for Home in Rural America*, Ayaz Virji writes about grappling with the stereotypes he confronted in the small midwestern town where he moved with his family in 2013. After the 2016 election, Virji—who is of Indian descent—found that racial tensions were rising in Dawson, Minnesota, and as he traveled the streets near his home he encountered suspicious looks, and even some threats.[7] He said in an interview in 2020, "You can tell the hate mail because there's no return address."[8] Two years earlier, in the wake of anti-immigrant comments by then President Donald Trump, Virji had said, "It felt as though if [my town] could take the brown, Indian person and put him on a registry and export him, and keep the doctor, [they'd] have done it in a heartbeat. I felt betrayed."[9]

A Lutheran pastor in Dawson also took note of the increasing anti-Muslim sentiment and asked the physician to deliver a lecture on Islam to the public. Despite his fear, Virji agreed and opened his lecture by asking his audience, "Do I look like a terrorist?"[10] It was an attention-grabber, a way to dispel tension, but in fact Virji was so worried about the response to his lecture that he'd hired security and considered wearing a bulletproof vest. He was entering a space where he didn't feel safe and had no expectation of receiving respect. But instead of allowing stereotypical thinking to flourish unchecked, he chose to address the issue head-on. "It's easy to demonize," he told his audience. "You know, 'Everybody is crazy and I'm just *right*.' And what kind of society does that create? That's

what ISIS does. That's what [the] zealots do. Do we want to be like that? As Americans, don't we want to be better than that?"[11]

Virji ended up giving a series of lectures in and around his Minnesota community. Although he stopped giving public speeches on Islam in 2020, he told Twin Cities PBS that he believed he'd reached people. "Initially," he said, "the voices against us were certainly louder.... We don't have any metric... [but] my feeling is we were getting some traction."[12]

I often hear people say they won't show respect to those who don't show respect in return. I would never suggest that you are obligated to engage with an individual who doesn't treat you respectfully, but before you enter into a discussion on the defensive, I suggest you shift your expectations.

Don't hold back, waiting for proof that they respect you. Assume instead that they will treat you with courtesy. They may in fact prove you wrong, but if someone is going to be discourteous, let it be the other person. As Jackie Robinson told his white teammates in 1947 before stepping onto the field, "I'm not concerned with your liking or disliking me. All I ask is that you respect me as a human being."[13]

There are a lot of subtle but important ways we can convey respect. One is listening—truly listening, without judgment—to what someone has to say. Another is to speak to them in a manner that acknowledges their intelligence and appreciate the ideas they share that are intriguing or interesting.

You might offer them positive feedback to balance out the negative, noting even minor details. It can't be all bad, can it? Research shows that small compliments can have a powerful effect, positively impacting the attitudes of both the giver and the receiver, as they activate the reward pathways in the brain. These regions in the brain, especially the striatum, are deeply involved in translating thought to action, meaning they help shape our choices.[14] In fact, psychologists

have shown that approval from others has a significant impact on the decisions we make every day. While criticism can trigger a defensive response, compliments slide into someone's consciousness stealthily, activating neural reward pathways and ultimately influencing what that person says and does.

The compliment must be sincere, though. Empty flattery can, in contrast, create distance in a relationship. If someone believes you're being disingenuous or attempting to manipulate them, they may lose trust in you and what you say. Thus, an empty compliment can backfire: instead of creating confidence, it can make someone wary. That means your praise must be based on truth. Take note of the words the other person uses, laugh at their jokes (those that are honestly funny), pay them the compliment of giving them your full attention.

Do your best to start the conversation on a positive note. I'm not suggesting you imitate a Walmart greeter, but you can create an opportunity for both of you to share a positive moment. Again, science validates the power of integrating these moments into an exchange. When someone feels proud of themselves at the outset of a discussion, they're more likely to be open-minded during the rest of the exchange.

In a series of experiments conducted in 2002, participants were given information that proved they had made mistakes or bad decisions. Some athletes learned about what had led to a recent defeat, for example, and other participants were informed that their behavior put them at risk of contracting HIV. However, before they took in the unpleasant information, some of the participants were asked to describe a time in their lives when they lived up to their values. Those who had started by feeling proud took the later correction in a healthier way than those who had no such preparation. The study report explains that "self-affirmed individuals are more likely to accept information that they would otherwise view as threatening, and subsequently to change their beliefs and even their behavior."[15]

By the way, there's nothing wrong with sharing this information with someone before you enter a tough discussion, since knowing that it's a mind trick doesn't lessen the positive impact. I've started conversations by saying, "I'd love to talk about this without arguing, and I read that talking about something you're proud of makes you more open-minded. So you tell me about the best thing that's happened to you in the past month, and I'll do the same, and perhaps we can start off on the right foot." There could even be a benefit in making the practice of offering respect a joint exercise.

Just be sure that before you begin to speak, you take a breath and say the following words, either aloud or in your head: "No matter how much we may disagree, I recognize our shared humanity and I will show you respect until I am disrespected." If you can do this, you will lay the groundwork for a productive dialogue.

STEP 2: ACCEPT WHAT YOU'RE TOLD

> I was thinking about how we celebrate George Washington. If we do anything to knock him off his pedestal, we're really gonna run into opposition. But we got to start telling the truth. He owned other people. If they were good slaves, somebody made them good by beating them half to death or whatever you have to do to a person. It's kind of like the Jews being made to celebrate Hitler. That's the way black people have to celebrate slave owners of our past.
>
> —JOSEPH LATTIMORE

In the 1990s, Joseph Lattimore, a middle-aged insurance broker in Chicago, called in to a radio show, responding to a request for stories about racism. He told the listeners and radio hosts about growing

up in Mississippi as a young Black kid, recalling how terrified he'd been that he might someday be injured or killed by white men. He was later interviewed by the guest on that radio show, the journalist Studs Terkel, and said racism persists in the United States partly because Americans don't want to discuss "ugly truths."

Lattimore went on to say, "Being black every day in America to me is kind of like being forced to wear an ill-fitting shoe. That's the only shoe you got. But you don't necessarily like it."[16] He said he was terrorized by what had happened to Emmett Till—the teenager who was lynched in Mississippi in 1955 for allegedly flirting with a white woman in a grocery store—and worried that something similar could happen to him.

Think about this for a moment. If you were talking with Joseph Lattimore and he told you that, as a child, he could have been abducted from his home, tortured, and shot in the head, how would you respond? Would you tell him he was exaggerating? Perhaps you'd say, "Come now, no one was going to kill you."

If someone tells you they've had reason to fear for their life, the proper response is to accept that their terror was real, and express empathy. To question the validity of their feelings is to imply that they're either deluded or lying. Their emotions are their own. If they are telling you something about themselves, their experience, their feelings, or their thought processes, it's never appropriate to offer critical feedback.

This is one of the most basic lessons you're taught in negotiation: accept what someone tells you about themselves. To do otherwise is to imply that you know their minds better than they do and to create conflict over something that can't be settled. How can you prove they didn't feel happy or depressed in any given situation?

It's also a core concept in the world of improvisation. If you've ever taken an improv class, one of the first exercises you're taught is "Yes, And." You are partnered with another student, and one of you

makes a statement. From there, everything you say to each other must start with the phrase "Yes, and . . ."

Here's an example:

PERSON 1: It feels like we've been on this train for hours.
PERSON 2: Yes, and the kid behind me keeps kicking my chair.
PERSON 1: Yes, and every time I look at him, he makes a face.
PERSON 2: Yes, and he keeps throwing spitballs at me.
PERSON 1: Yes, and I can't believe our son would behave like this.

I use this exercise a lot when I lead workshops in communication or racial equity and inclusivity. When I explain the rules, many people nod confidently, clearly believing the game is easy, only to discover they struggle not to respond to each statement with "Yes, but." Their initial instinct is not to accept, but to correct or debate or resist.

If you tell someone that Confederate monuments don't bother you, and they respond by saying the monuments upset them, it's wrong to say, "Yes, history can be complicated, but you're too sensitive." Should you do that, you're refusing to accept their opinion as valid because you think they don't have a right to feel upset. You are delegitimizing their experience.

A couple of months ago, I overheard an argument in the grocery store between a husband and wife. The wife said she was afraid the country might be headed for civil war and the husband countered, "You're not really afraid of that." With that response, he was quite literally telling her that he knew her emotions better than she did and implying she was lying about her feelings. She said, "Yes, I am!" and they began to argue while standing near the pasta selection.

In conversation, it's never appropriate to counter what someone tells you about their own lived experience. And it is certainly not a show of respect. There must be a shared acceptance that what they have to say is not *the* truth but *their* truth.

Developing the ability to accept what people tell you, even when it angers you, is not easy. It requires practice. I asked Karin Tamerius, the psychiatrist we met in chapter 3, for advice on how to go about it. She has had many discussions with people who expressed racist views and has become an expert in teaching white people how to talk with their peers about race and racism.

HEADLEE: How do you [talk to white peers about racism]?
TAMERIUS: It's really about normalizing differences of opinion, acknowledging that we are coming at this from very different places and that's okay. I might say, "As you know, I'm a strong supporter of Black Lives Matter, and it sounds like you're not. I'm sure you have good reasons for why you feel that way and I'm very interested in hearing more about your perspective, because I know you're a good guy. I care about you a lot. And I bet if we talk this through, we can come to an understanding that makes sense to both of us."
HEADLEE: What would you say to someone who sees that sort of approach as being conciliatory? Someone might argue that it's not their job to make someone feel better about being racist.
TAMERIUS: First, I want to make clear that everything I say here is about white people talking with white peers about race and racism in the presence of other white people.

So now, to answer your question, I'm not making him feel better about being a racist. I'm making him feel better about being a human being and acknowledging our common humanity. I am recognizing that being racist and being a good person are not mutually exclusive.

We are all socialized in a racist system. Racism is a part of how we are all brought up. And the fact that someone is racist says nothing about who they are as a person. What I am trying to do in these conversations is connect around that common goodness before chal-

lenging the problematic ideas. It's not the person who's bad, it's the ideas that are bad.

The second thing I think is really important is paying attention to the ultimate goal. A lot of times, when I talk with people who think my approach is problematic, what they tell me is that we have to call out racism because it's wrong and we must make that clear. The question for me is, Does that actually accomplish your goal? Isn't our ultimate goal to make people less racist, to create a less racist culture and society? If that is your overriding goal, then you should focus on the methods that work, not the methods that *seem* like they should work. When people call out racism, they're doing it not because they think it will change the racist, but because it feels like the right thing to do. They get a rush of righteous self-satisfaction from doing it, even though it doesn't change things in a productive way.

HEADLEE: The most common type of conversation that I hear on race lately is arguments over facts. What's the mistake people are making here?

TAMERIUS: The mistake they're making is engaging at a cognitive level. Our belief systems and our attitudes are not driven primarily by facts or data or reason, they're grounded fundamentally in emotion, and you can't change an emotion through appeal to the cognitive brain. You've got to go deeper.

The danger in calling someone out is that we don't talk about these issues enough in our society. Often, people actually haven't learned where the line is. A lot of times people are very emotionally wound up when they start talking about race, particularly when it's the first time and they have a tremendous amount on their minds, and they want to get it out there. And the more defensive they feel, the more they have to say. Part of what you just need to do is let them say it. Just let them talk.

Let them say all of the horrible stuff that is on their minds, release it into the open air. Then you can start to deal with the mess and come to terms with it. But first, you must give them the room to speak. The psychologist Mark Goulston, in his 2009 book, *Just Listen: Discover the Secret to Getting Through to Absolutely Anyone*, talks about the importance of "helping people exhale."[17] When people are angry or triggered, they are too wound up to breathe, but when you listen, they calm down. Goulston says this kind of listening is like lancing a boil, like you are letting all the emotional pus out.

When you first initiate one of these conversations and someone starts talking about race for the very first time, the amount of racism that comes to the surface can be stunning. Perhaps these ideas have never seen the light of day because the other person hasn't ever had a chance to talk about them with anyone and actually reflect on the opinions and feelings that have accumulated. So it's not enough to just ask people what they think.

It's not even enough to let them talk. You have to let them talk without judgment, without interruption. And when they finally finish talking, you have to ask them if there's anything more you need to know. Because a lot of times people will talk until they're exhausted but not until they've said everything that's on their mind. Keep them going until they have spilled everything out.

That's the point at which they will kind of emotionally recalibrate. They'll get centered again, and you can start having a real conversation. They need time. When you change one thing in a belief system that is as central as your attitudes on race, it destabilizes your entire worldview. These are not small changes. This means reimagining their place in the universe, and that doesn't happen quickly. It's really, really hard work. What we're asking people to do is difficult, and we need to give them the room to do it.

You don't have control over the outcome. What you do have control over is the process. So if you succeed in adhering to the process

of having a good conversation, then that is your victory. Knowing how to focus on the process rather than the outcome is a learned skill. Professional facilitators often refer to this mindset as "conversational receptiveness." One way to signal to the other person that you're receptive to their point of view is to use language that acknowledges their contributions. For example, you can respond with "I think what you're saying is . . ." or "I understand that you think . . ."

It can be difficult to respect what others tell you, especially when it angers or offends you, but you must get into the habit of acknowledging that they're being honest about their opinions. Rick Hanson, a psychologist and senior fellow at UC Berkeley's Greater Good Science Center, says, "Accepting people does not itself mean agreeing with them, approving of them, waiving your own rights, or downplaying their impact upon you. You can still take appropriate actions to protect or support yourself or others. Or you can simply let people be. Either way, you accept the reality of the other person."[18]

This acceptance does not extend to facts about the broader world that can be proven or disproven, of course. I utterly reject the idea of "alternative facts," a phrase used to imply that any statistic or historical event can be reinterpreted to mean what we want it to mean. Not everything is up for debate. Facts exist, and sometimes the facts don't align with your opinions.

The tricky part, though, is that facts can be technically true and yet be articulated, or spun, in order to create false context. As a journalist, I was trained in how to handle this situation, and many diplomats and hostage negotiators also learn how to respond to skewed statements without escalating into conflict.

For example, while I was walking my dog one day, I met a man who began talking to me about "the lies of the Black Lives Matter movement."

"Can you give me an example of the lies you're talking about?" I asked him.

"Sure," he said. "They make it sound like police officers are out there just shooting down Black people for no reason. The truth is, more white people are killed by police than Black people." This statistic is often cited by those who oppose the Black Lives Matter (BLM) movement, including former president Donald Trump.

My initial instinct was to retort, "You don't understand what you're talking about." Instead, I answered: "Factually, that's accurate. You are technically correct."

He tried to move from there to a comment about how BLM activists lie to the media, but I calmly asked if we could talk a bit more about that statistic. My goal was twofold: to point out why the fact he'd cited did not demonstrate any deception on the part of the BLM movement and to pull the conversation away from general ideas and back to personal experience.

I explained that his statistic was correct because whites are the largest racial group in the United States. That means that while more whites than Blacks have been shot and killed by police in recent years, those deaths have occurred at a rate of fourteen per million. But because Black people make up only 13 percent of the population, the rate of fatal police shootings among Blacks is thirty-five per million.[19] That means Blacks are two and a half times more likely to be shot by police than whites.

I followed up by asking the man why the statistics about race and police shootings matter to him, prodding gently at the reason he brought it up. What was he trying to tell me? What was it he wanted me to understand?

If he had said he's afraid to go into Black communities because he believes he'll be mugged, I wouldn't have argued with him. While such a fear might be based on racist assumptions, I would have avoided calling him a racist and instead asked more questions about

his anxiety. Has he ever been a victim of a crime? How much time has he spent in Black communities? There are many statistics I could have offered to counter his fear. For example, I could have said that people's perceptions about crime in a given area are related to the number of young Black men in that area regardless of actual crime statistics. In other words, some people believe that largely Black neighborhoods are crime-ridden, even if that's not true.[20] What's more, research dating back to the 1980s shows that the belief that crime is common in one part of a city is more strongly related to the departure of white residents than to official data. Translation: When whites leave a neighborhood, they assume crime will rise.

But would the facts have changed his mind? If, like many other white people, he was frightened to venture into areas where there are large numbers of Black people, I could have led him to explore those feelings. Instead of telling him not to feel that way, I could have nudged him to think more critically about his views by prompting him to articulate what, specifically, he was afraid of.

Sadly, I didn't get time to delve into that conversation. We were passing each other along the trails in Rock Creek Park. He was going one way, both literally and metaphorically, and I was going another. We parted after just a few minutes.

Accepting others as they are, meeting them where they are, is how we engage in conversation that is respectful. I certainly didn't change this man's mind that day in the park, nor did he change mine, but I hope that by avoiding an argument, I left the door open to future discussion. After all, minds are typically not changed during the course of one conversation; the change takes place over time, through many conversations.

If we happen to run into each other again, I hope he'd be willing to talk with me.

CHAPTER 7

TAKE TURNS AND BE SPECIFIC

STEP 3: TAKE TURNS

> I won't say another word—not one. I know I talk too much, but I am really trying to overcome it, and although I say far too much, yet if you only knew how many things I want to say and don't, you'd give me some credit for it.
>
> —L. M. MONTGOMERY, FROM *ANNE OF GREEN GABLES*

By the age of three, most children understand the concept of fairness and are capable of some degree of emotional regulation. Ideally, adults would be adept with these abilities, having had decades of practice, but many of us have lost both the sense of fair play and the self-control that are needed for healthy conversations. We talk over each other, we dominate discussions, and very often we hold forth. We get excited by what we're saying, and we just keep talking.

Early childhood educators know that sharing is hard for kids, which is why they often teach "turn-taking" in preschool rather than sharing. I'm going to ask you to do the same thing in your conversations. You may think that sounds condescending, but it's

a highly practical approach to meaningful dialogue. Most of us are simply not aware of how long we talk before we allow others to respond. Turn-taking is part of the human linguistic style, and the balance of speaking versus listening is unique to each of us.

It's critical to know who is being heard when you're talking about something as fraught as racial identity. It's more difficult to stop talking during a conversation about race than it is in a discussion of movies or work or pets, because we often feel passionately about racial issues. We want to be *heard*. What's more, there is so much gray area in these discussions, we often feel the need to keep talking because the other person doesn't seem to be getting it.

The remedy for this is simple: spend the same amount of time listening as you spend talking. Instinctively, we know this is the right thing to do, just as children know they should let others use the swings on the playground. Turn-taking, in fact, is a defining characteristic of a conversation. If one person talks, it's a lecture or performance. In order to converse, we must allow others to respond.

Research shows that this skill is innate in us—humans naturally tend to take turns in conversation[1]—but individual personality traits, perception of rank, and emotional cues can interfere with this intrinsic pattern of speaking and then listening. Who gets to speak and who gets to be heard is deeply connected to social rank, and often determined by race and gender.

In other words, while you might think you're good at taking turns, that impression could be distorted by gender and racial dynamics. We live in a patriarchal society founded on systemic racism; our legal and social structures, not to mention cultural values, enable white men to dominate conversations, and it sometimes requires a force of will for a Caucasian guy to share space equally. Giving equal time to all participants in a discussion may feel uncomfortable or unnatural, even if you are a person of color, as that is not generally the norm.

This phenomenon has been validated by researchers time and again. One study revealed that while women are more talkative than men in private conversations with their friends and family, men dominate group conversations by a three-to-one margin.[2] And in research dating back to the 1970s, scientists have consistently found that men are more likely than women to interrupt others so they can talk. Other studies have shown that, in meetings, men speak more often and for longer periods than women do.[3] This remains true in online discussions[4] and even on video conference calls.[5]

These results were so worrisome that in early 2020, the software company Basecamp limited online meetings and moved toward written communication[6]—only to find that men tend to write more and aggressively challenge others, even in email.

Now there's an app for that; businesses (and individuals) that are concerned about equitable communication can make use of an app called Woman Interrupted, which analyzes conversations to detect how often women are interrupted by men.[7]

The research on racial differences and interruption in conversation is not nearly as thorough as the study of gender differences, but a survey in 2018 found that nearly one out of five women of color in academia feel invisible and excluded during faculty meetings. More than 40 percent of Black and Latinx women say they are often interrupted and spoken over in work meetings.[8]

Interrupting others is, of course, a reflection of the power dynamics in a conversation. Power is also at the root of racism and oppression, so the issue of turn-taking becomes inextricably linked to perceived social status. That's why turn-taking is a key component of productive conversations about racial identity.

People of color have been talked over, interrupted, and ignored for far too long. The unspoken rules of conversation have allotted more time and space to whites, especially men, than to people of color. I spent four years hosting a national radio news show on which

it was so common for my male co-host to talk over me that his interruptions became part of the show's character. During one discussion about the script, my producer explained that I would start a segment by talking about marriage. "And then he will probably interrupt you," he added. (That's precisely what happened, by the way.) But the ubiquity of male interruptions isn't confirmed only by my experience; it's also backed by decades of research. Making space for people of color to voice their opinions is, on its own, an anti-racist act.

While I don't think the solution to this problem is to silence white men, I can empathize with the desire others feel to do this. A Black student at Dickinson College named Leda Fisher sparked a vigorous debate in 2019 when the school paper published her essay "Should White Boys Still Be Allowed to Talk?" "I'm so g****mned tired of listening to white boys," Fisher wrote, and then asked her readers to talk with "someone whose perspective has been buried or ignored and listen to them."[9]

Not surprisingly, reaction to the essay was swift and mostly negative. One person posted a comment comparing Leda Fisher to a Klansman, and dozens called her a racist. If she had replaced "white boy" with "black woman" in her essay, people wrote, her piece would be considered openly discriminatory and would never be published in the school paper. Sometimes it seems like people are concerned about fairness only when they believe *they* are being treated unfairly; injustice that targets others doesn't merit comment or outrage.

But if our goal is to use authentic dialogue to help create a more just and inclusive society, I think we can all agree that everyone deserves a chance to speak, along with equal time to voice their perspectives. How do we ensure that we're creating space for other perspectives? The first step is one we've just covered: awareness.

Becoming aware of our conversational habits is not easy, of course. To learn how to accomplish it, I talked with John Biewen.

Over the course of his thirty-year career in journalism and audio storytelling, Biewen has reported on stories from all over the world. He led a community storytelling project in Durham, North Carolina, that focused on experiences with race and class, and his podcast series, *Seeing White*, is an honest and thorough examination of racism from the perspective of a white male. I asked him how he was able to get past the instinctive urge to debate with people and allow them to speak freely.

BIEWEN: I'm probably better at that as a journalist-slash-documentarian than I am in my personal life. When I'm having a conversation with a conservative member of my own family, I don't feel I'm as good at it. I may not be as forgiving or understanding as I would be with a stranger, honestly, because I feel like: Come on, we grew up together. We were taught a set of values. *What happened to you? What are you thinking?!*

Then of course, then you're on social media or whatever, and you can get into these little back-and-forths with people where it's pretty easy to see they're actually not arguing in good faith. They're not there to listen to reason; they're there to attack and to score points. But let me try to go back to your question.

You alluded to my apparent willingness to look at how deep and pervasive and problematic white supremacy and patriarchy are when those are actually systems that benefit me. Some of that is upbringing and having progressive parents who were skeptical about those things from an early age. Even though I was growing up in a very white place in southern Minnesota, my dad was really interested in the problem of racism. He talked to us about it, made us watch the Sidney Poitier movies and *Sounder* and *Raisin in the Sun* and *Roots*, and there was a willingness to be skeptical about the systems and about the society that we live in and to be critical of it and to say, oh, this is actually not fair.

HEADLEE: As journalists, we end up talking to a ton of people that we do not like or agree with. And we have to establish some kind of rapport because we want to get the best interview out of them. I wonder if there's something to be learned there in terms of forming empathic bonds, even with someone whose views you find detestable.

BIEWEN: The first thing that comes to mind is to listen, to ask them questions and draw them out. What do you think? And then let's maybe talk about it. Tell me about your earlier life and how you came to see things this way. It's a kind of interview that we do that's not necessarily confrontational, but that is about just drawing out. Who is this person? What do they think? Why do they think the way they do?

And yes, I think that probably increases the odds that you could then find common ground. I might see where they're coming from, given their background. And I can respond by asking more questions and keeping the exchange going. I can say, "What if you thought about it this way?" or "What if I told you that one piece of information you have is actually wrong?" Some people are going to reject that and say they don't believe it. But maybe there are people who we see as unreachable who might not necessarily be unreachable, if you could establish some sort of rapport, some shared storytelling about your lives and each other.

As a white male, John Biewen had to recognize that his voice is more likely to be heard and respected than that of others. He consciously decided to make space for others by asking about their opinions and experiences. Everyone occupies a unique space in the power hierarchy; there's no value in feeling ashamed or, conversely, self-righteous about your position. A more effective approach is to acknowledge the truth that, historically, some have talked more often and longer than others, that some people's voices have been val-

ued more than those of others. Then make it a priority to do all you can to balance the scales.

Next, create a personal incentive for hearing someone else's ideas. Giving another person equal space in a conversation is hard, and "doing the right thing" is probably not a strong enough motivator. I spoke to an acquaintance recently who described herself as "not a talker." At the time, she was complaining about people who don't listen and how irritating it is when someone talks and talks without allowing her to get a word in edgewise. Her comments surprised me because I have more than once been stuck in a conversation with her in which she's spoken for ages while I've listened, mouth closed.

She believes she's not a talker because not talking is effortful for her, so the instances in which she's stayed quiet—which is not necessarily the same as listening—pop up readily in her memory. However, when she *does* get a chance to speak, she talks at length. I would say she is *quite* a talker and doesn't really know how to take turns. I suspect that she wants to be known as a person who listens, and making that kind of impression could be a strong motivator for her to improve her skills.

Taking turns in a conversation is about sharing the attention and the space. Too often, our interpretation of taking turns is to alternate between talking and preparing to talk again, meaning that we may close our mouths every few minutes, but we don't really pay attention to what the other person is saying.

This is especially true in provocative discussions about volatile subjects like race. We have important things to say, we're passionate about our point of view, and we're pretty sure we know what the other person is going to say. We get frustrated when it seems to take them so long to say it. What's more, the stakes feel high and the consequences for saying the wrong thing seem equally momentous, so we're likely to spend extra time thinking through the details of what we want to express. But all of this preparation prevents us from listening to others.

Yet research shows that allowing others to speak is easier when we stop worrying about the impression we're making on other people. The relentless inner voice that analyzes what you've said and worries that you're behaving awkwardly can create obstacles. It turns out that we sometimes talk too much because we are overly obsessed with sounding smart or funny. What often gets in the way of our inherent communicative gifts is self-consciousness.

There is a simple and elegant solution to this: focus on the other person. Conversation is quite cognitively demanding, and in order to truly listen and comprehend what another person is saying, we must bring the full might of our big brains to bear. Instead of worrying about what or how much you've contributed, shift your attention from what to say to what you hear. Try to ascertain the underlying message of what they're saying and ensure that you understand what you've heard. Listening for deeper meaning can improve your focus and prevent you from getting distracted.

Depending on the person and the context, you might even gamify this process. You could make an agreement with the other person that you will take turns and not interrupt, then choose a method to signal if the other person is dominating the conversation. For example, you can pass an object back and forth—a pen, sunglasses, a coffee mug—and only the person with the object can speak. Often, when there is a tangible reminder to give others the floor, people are more likely to recognize when they hog the airtime.

This method derives from traditional practices of tribes in North America, Africa, and New Zealand, who used speaker's staffs or talking sticks to designate who had the authority to speak. Such sticks are still used in Native American councils and potlatches. Elders speak first, and when they're done speaking, they pass the talking stick to the next person. Everyone present is expected to wait their turn and, when not speaking, listen attentively to others.

Talking sticks are often quite beautiful; they can be elaborately carved to resemble miniature totem poles. But you don't need to use a work of art in order to follow the principles of the speaker's staff (and because Native talking sticks often have a great deal of cultural and spiritual meaning, they shouldn't be used by those with no connection to the Native tradition)—just pick an object and hand it to the person who gets to speak first.

It's a general rule of mine that I don't proffer my own opinion until I feel I fully understand the view of the other person. If I have questions, I ask them before I put my two cents into the pot. I've found this is an excellent way to guarantee that I'm sharing the conversational space.

However you track your time, find a way to make certain that you're affording to others the same time you want for yourself. Follow the rules of the playground: take turns.

STEP 4: BE SPECIFIC

> How precious words are and how real speech is in its impact on the way people live and die.
>
> —NELSON MANDELA

During a holiday dinner at my house last year, there was a fight between two guests. It ended when one person decided she couldn't tolerate the discussion any longer and walked out. It began, though, with a disagreement over what is true about "white people." Again and again, over the course of the argument, I tried to pull back from talking about white privilege and white guilt and move toward a discussion of what we had personally experienced. I was unsuccessful: what began as a friendly chat about my work ended in a quarrel over

who had suffered more—Jews or Blacks—and how responsible our ancestors were for contributing to racial oppression and systemic discrimination.

As awkward and painful as the argument was, I couldn't help but think it was a perfect example of what happens when we debate big, important ideas instead of sharing personal stories. It's said that great minds discuss ideas, average minds discuss things, and small minds discuss people (a quote that is often misattributed to Eleanor Roosevelt).[10] That may be true when it comes to philosophy, but it's awful advice when it comes to talking about race.

People who want to converse without conflict should begin with stories about people. The conversation can eventually lead to discussions of ideas, but starting at the macro level is a great way to lay the groundwork for a fight. My advice is this: Don't start with race, start with you. Don't talk about the legacy of the transatlantic slave trade; talk instead about your family. Forget about the national statistics on criminal justice and share what you know, what you care about, what you've been through. It's common to want to broaden a discussion of racism to include all kinds of separate issues, but you'll find it's easier to keep the conversation congenial if you address one thing at a time.

We all tend to veer away from the subject at hand when we converse. We go off on tangents, especially if we don't want to address an issue someone else has raised. I once overheard a man asking a woman in a restaurant, "How come Obama deported all those people and you don't think he's a racist?" The woman responded by asking, "Why did Trump's travel ban only include Muslim countries? Because he's racist."

This behavior has been identified as "switch tracking" by Douglas Stone and Sheila Heen of the Harvard Negotiation Project.[11] The term describes our tendency to divert the flow of conversation away

Take Turns and Be Specific

from a topic that's uncomfortable, or on which we don't think we can score points, and toward a topic we prefer.

Switch tracking happens in all kinds of difficult conversations. Here's an example:

BOB: Brenda, you're late again. You've been late three times in the past two weeks, and Sean had to cover for you every time.
BRENDA: Sean was late almost every day last month, and you never said a word. You don't care that I had to cover for him?

There are two problematic issues worth discussing in this exchange: one is Brenda's tardiness, and the other is Brenda's sense that she's being treated differently from her co-worker. Both issues should be addressed, one at a time, independent of each other. Brenda can respond to Bob's complaint about her punctuality problems first, and then bring up the preferential treatment she believes Sean is receiving.

It's more challenging to talk about both topics at the same time. In fact, I've often heard people in these situations stick stubbornly to separate topics as the conversation goes on. In practice, that would mean Bob continues to discuss Brenda's lateness, while Brenda reinforces her views on Sean's behavior and Bob's management.

It's unlikely they would reach a resolution in that situation, because odds are low that they would truly hear and absorb each other's complaints. These kinds of exchanges are not conversations as much as they are two people ranting about two different subjects and then parting without making any progress toward understanding each other or solving the problems.

What does this sound like during conversations about race? One person says, "Black lives matter," trying to call attention to the number of Black Americans who are shot and killed by police officers.

The other person responds with "All lives matter," making the point that every human life is valuable and precious.

Both are valid statements, but responding with "All lives matter" is often a means to avoid a discussion about the systemic racism that puts Black people in danger and, possibly, to invalidate justified complaints that Black lives do *not* matter as much as white lives. As the comedian Michael Che has said, "That'd be like if your wife came up to you and was like, 'Do you love me?' And you were like, 'Baby! I love everybody, what're you talking about?'"[12]

Here's a fictional example:

MIKE: The Chinese are more racist than Americans are.
KIM: Trump said his tariffs would punish China, but you don't even realize that we're paying for those tariffs. The American people are paying!
MIKE: Obama let the Chinese get away with murder.
KIM: We're not talking about Obama!

Kim is right; the conversation is not about Barack Obama, but it's also not about tariffs. Mike suggested that Chinese people are more racist than Americans. Why not dig into that assumption? I'd be interested to know what metric he's using.

In 2013, the *Washington Post* created a map of the world, ranking countries by racial tolerance, with the standard of measurement the percentage of people in each nation who said they wouldn't want to live near someone of another race. By that measure, Jordan was the least racially tolerant nation.[13] However, there are many other standards for measuring racism—racial violence, diversity in corporate and political ranks, and scientific tools like the Implicit Association Test (IAT), which measures the unconscious beliefs we are reluctant to admit to holding,[14] or the Affect Misattribution Procedure

(AMP), in which test takers make negative or positive judgments about neutral images.[15]

In nations like the United States and the United Kingdom, it has become increasingly less acceptable to openly express bias. This is why we often see politicians and news commentators employ what's known as a "dog whistle," a seemingly innocuous phrase with strong racist undertones. In July 2020, for example, Donald Trump tweeted that people in the suburbs would "no longer be bothered or financially hurt by having low income housing built in your neighborhood. . . . Crime will go down."[16] While Trump didn't mention race specifically, "low income" can be taken as referring to Black people, given that Blacks make less money than whites and are less likely to own their homes.[17] What's more, there is an underlying implication that Black neighborhoods suffer from higher crime rates than largely white suburbs. Keep in mind that, according to a 2019 report from the U.S. Census Bureau, there are 34 million people living in poverty in the United States and only about 8 million of them are Black.[18] That's a high percentage of the Black population, but whites below the poverty line far outnumber Blacks. Further, the connection between poverty and crime rates is questionable, at best.

The political consultant Lee Atwater infamously said in 1981 that politicians could, by 1968, no longer say the N-word: "That hurts you, backfires. So you say stuff like, uh, forced busing, states' rights, and all that stuff, and you're getting so abstract. Now, you're talking about cutting taxes, and all these things you're talking about are totally economic things and a byproduct of them is, blacks get hurt worse than whites."[19] People can thus use carefully chosen words to create a murky picture of what is considered racist and what isn't. Sometimes, people use these dog whistles to talk about race in such a way that they can never be held accountable for biased views.

Let's go back to Mike and Kim's conversation. Kim could ask

Mike to outline what he thinks qualifies as racism. How does he know if someone is racist or not? Not only should Kim remain focused on the issue Mike raised, but she should bring it back to personal experience and belief, rather than broader questions of what country is more or less racially tolerant than the United States. Why does he care? Frankly, it doesn't matter to the average Black American if the Chinese are less tolerant than Americans are. Knowing that it's worse somewhere else doesn't diminish suffering here.

If you change the subject often, jumping from issue to issue, you are having a horizontal conversation. That kind of discussion might be broad in scope, but it will never dig into profound issues. What you want (I hope) is a vertical discussion, in which each person delves deeply into their beliefs, drilling down on specific ideas and opinions.

This also applies to situations in which someone brings up their own struggles or suffering. It is tempting, when someone tells you they are exploited or underprivileged, to tell them it's even worse for you or for someone else. This is quite common, for example, when white people describe their precarious financial state or their difficulty in rising through the ranks at work. Some well-meaning people may see this as an opportunity to explain the concept of privilege, pointing out that it would have been even harder if they'd been born as a Latinx or Black person.

While that may be true, it's also off the topic. The white person is talking about what they have been through, not what Blacks have endured. Switching to the subject of racial inequality can create the impression that you're not listening to their story or don't care about their anguish.

There's no winning in the race for "most disadvantaged." I explained it to my son this way when he was small: Imagine you're talking with a soldier who lost her arm in combat. She's describing how difficult it is for her to cope in an ableist world. Would you

respond to her by saying, "You don't have it that bad. Some people lost both arms."

Of course you wouldn't, because the fact that others might suffer more doesn't alleviate the soldier's distress in the slightest. By comparing her situation to someone who has it worse, you are invalidating her pain.

This is a tricky subject, as it's objectively true that it's harder to be a Black person in America than it is to be white. Of course, white privilege is real. Of course, the odds are often stacked against people of color when it comes to housing, business loans, education, and health care. The evidence proving that is voluminous.

But for the purposes of conversation, it's important to hear what someone is saying to you ("I'm suffering") and to respond to that statement ("I'm sorry that you're in pain"), instead of responding to what you believe they are implying ("I suffer just as much as Black people do"). By focusing on the specific story they're telling you, by digging deeply into the reasons they've brought it up, you may ultimately get to the underpinnings of their worldview.

On the one hand, if you change the subject, it's likely you'll escalate the exchange into conflict or shut down the discussion completely. On the other hand, if you focus on what they're saying and what they mean by it, you at least maintain the possibility that a more impactful exchange can occur.

If, however, a white person says, "I've suffered more than any Black person has"—something that I was once told by a white man sitting in first class during a flight to Vancouver—you can address the comparison because they brought it up. Respond specifically to what they say, not to the implication or your assumption about what they really mean.

If a Black person tells you they've experienced racial discrimination, that's not an opportunity for you to prove them wrong, or to demonstrate that you, too, have suffered. Listen to the story they're

telling you, ask specific questions that pull you deeper into their experience, dig into the details.

The same advice applies if you're speaking to an Asian American person, a Native American person, or even a white person. We all struggle; we all have stories to tell. Those individual experiences can ultimately lead to big, important questions of identity and oppression when we have an opportunity to share those experiences with others.

More important, keeping discussions focused on specific statements or beliefs forces us to abandon the facile, meaningless catchphrases that we learn from politicians and activists. If you say you "want your country back," be prepared for the other person to ask, "Who do you think took your country?" If you say you want to "return to normal," don't be surprised if you're asked to define what "normal" is. If you want to "defund the police," be prepared to explain exactly what that means and how communities would enforce laws if your ideas were enacted.

Specificity is powerful because it keeps us focused on the person in front of us—this person instead of "Asian people," for example—and it holds people accountable for what they say. No dog whistles, no generalizations, no broad statements about what Black people do or white people think, but distinct details about individuals and what they believe. Stay focused on the topic that's been raised. Dig deeper instead of wider.

CHAPTER 8

LOCATION AND LANGUAGE

STEP 5: WHERE, WHEN, HOW

> For all the large-scale political solutions which have been proposed to salve ethnic conflict, there are few more effective ways to promote tolerance between suspicious neighbours than to force them to eat supper together.
>
> —ALAIN DE BOTTON

In March 2015, the CEO of Starbucks, Howard Schultz, announced a plan to address systemic racism. He encouraged employees at thousands of coffee shops across the United States to have a conversation about race with at least one customer every day. He suggested these workers explain to caffeine-addicted Americans "about the need for compassion, the need for empathy, the need for love towards others." If that happened once a day, in coffee shops from Anchorage to Fort Lauderdale, Schultz postulated, then the nation would see "a significant difference."[1]

This effort did not succeed at sparking heartfelt discussions: it was the wrong place and the wrong time. Talking about racism,

about privilege and privation and oppression, is weighty and emotional work. It's not something you bring up as you hand someone their grande cappuccino with three shots, caramel syrup, and no foam. As the media strategist April Reign tweeted, "Not sure what Starbucks was thinking. I don't have time to explain 400 years of oppression to you and still make my train."[2]

While we may smile indulgently at Schultz's failed plan to solve racism one awkward, unwelcome conversation at a time, the lesson of this botched attempt is an important one: choose the right location, the right time, and the right format. One thing Schultz got right was that these conversations really should happen in person. We love to send messages by email when we think the subject matter may upset someone. Email allows us to maintain physical distance; it permits us to say everything we want to say without fear of being interrupted as well. But hiding behind an email will make you feel better only in the short term. Digitally mediated communication often causes more problems than it solves.

The first email was sent in 1971, so researchers have had more than half a century to analyze our in-boxes. The jury has rendered its verdict: Email is not an effective format for difficult conversations. It can lead to miscommunication and tends to escalate conflicts. What's more, it doesn't provide the positive biofeedback we get from conversations on the phone or in person—the facial expressions and vocalizations that lower stress levels.

I know some people say they feel comfortable using email in the way that previous generations used handwritten letters. They spend time writing long missives, going back through what they've written to make changes, and thinking deeply about how best to articulate their views. As a writer, I can understand the desire to craft a careful message and take your time to ensure clarity. Perhaps a member of your family has a history of making casually racist comments when you meet but resists your attempts to discuss their behavior.

A carefully worded email might help you broach the subject in a nonthreatening way and serve as an invitation to a discussion about bigotry. Or you could use email to ask a co-worker to sit down for a meeting on bias in the workplace, again using the remote nature of email to make them feel less defensive. In this way, email can be effective as an invitation to conversation.

However, while email may be appropriate in some situations, not all digital communication is of value as a platform for conversations about race, and I strongly discourage the use of social media for this purpose. Full stop. You can make statements about race, or express your carefully worded views, or link to a thoughtful article you believe could be helpful to others, but don't expect to have any kind of productive discussion with other users.

Not only are social media platforms often antagonistic environments, but the way we communicate on them—in brief snippets—makes for incredibly reductive dialogue. You may respond to a racist comment and believe you're fighting for a just cause, but in reality you are contributing to the simplification of complex issues. You're also contributing to the competitive atmosphere and "dunk culture" that prevents progress.

Do you honestly believe that, after centuries of racial inequity and violence, your biting tweet is going to move the needle toward justice and fairness? The only way to finally eradicate systemic racism is to expand understanding to include even those who believe it's in their best interests to maintain white supremacy. Turning racism into a binary battle between the good and the bad increases the chances that this issue will become a war, that those who are labeled as irredeemable will become immovable.

I've heard from some that they've established positive relationships with strangers via social media, by exchanging private messages over long periods. I don't doubt the truth of those anecdotes, but they are exceptional. Statistically speaking, even if you

communicate privately, through text or DMs, the chance that you'll have a productive conversation is incredibly low.

The quality of interactions on social media has been studied so many times that I could spend the rest of the book just citing the research. Instead, I will cite only one study, a rigorous investigation that concluded that when we use Facebook, "we get the impression that we are engaging in meaningful social interaction" even though that is not the case. "Our results suggest," the scientists wrote, "that the nature and quality of this sort of connection is no substitute for the real-world interaction we need for a healthy life."[3] Facebook, Twitter, and other social media platforms are useful for making connections that can become authentic relationships offline, and they are an effective tool for information sharing, but they are a disastrous choice for discussions of oppression, bias, and racial identity.

These are not the only dangers associated with social media, though, and digital communication in general. If you receive a private message that includes offensive language or a racist comment, resist the temptation to fire back an angry response. Digital communication is prone to miscommunication, so you have to choose your wording even more carefully on the computer than you do in person. What's more, digital communication is a permanent record. In conversation, you may say something out of anger that you later regret. After a sincere apology and time, those mistakes are usually forgotten. But if you express your fury on social media, your momentary emotion is preserved forever and could ultimately be conflated with who you are.

When you deliberate on whether to engage with someone on social media, your standard should go at least one step beyond "Would I say this if this person were standing in front of me?" Instead, the question you must ask is, "Would I say this if they were standing in front of me and my mother/partner/pastor/anyone whose opinion I value was also in the room?" You might consider asking them to

explain their position further, to ensure there is no miscommunication. If the person in question is someone you know, you could even schedule a time to speak to them over the phone or in person.

However, if you are provoked by someone you do not know and have never met, ignore the message. Don't reply or respond, even to explain why the person is wrong or racist. This may seem to contradict my instruction to call out racist comments when you hear them, but the truth is, the world of social media has its own rules.

Sometimes we're tempted to respond to misinformation or hateful ideology out of a desire to correct the record. We want to let the broader public know our position: that this person is wrong, and the information is inaccurate. But as with so many things in the digital realm, the action we take out of a desire to help may ultimately makes things worse.

For example, if a tweet generates enough replies or retweets, even if those engagements are intended to denounce the original message, the platform's newsfeed algorithm will give that tweet a higher priority and therefore show it to more users. Tweets can go viral on Twitter based on the number of people who reacted to a particular message and not whether the reactions were positive or negative. While the "like" to "retweet" ratio might indicate that people don't approve of a particular message, getting thousands of retweets will likely earn it a place on the trending list. Your response saying "This message is racist and wrong" could cause the original tweet to be seen by more people.

So let's leave social media out of this equation and focus on how best to discuss race in a setting that involves the human voice: in person, over the phone, through video chat. If the subject arises on any other format, I advise you not to engage. Request a phone call instead, or table the discussion until you can see each other through video conferencing or face-to-face. As the research suggests, face-to-face is the gold standard. That should always be your first choice.

Remember, you can usually walk away from a discussion with another person or postpone it, which means you should be able to choose the best time and place to talk about race. Your priorities should be privacy and comfort.

Privacy allows both people to talk without fear of attracting an audience who might not be invested in a productive and honest conversation. The possibility for radical honesty decreases as the number of people participating in the exchange increases.

Your secondary concern is comfort, and the intention here is also to encourage authenticity. Let's be honest: many people are scared to talk about race, especially with those they perceive as having a different background or ethnicity. When the topic arises, their fear may activate the amygdala and flip them into fight-or-flight mode. If that happens, it will be very difficult to break them out of their anxious state and the conversation might as well end there.

As much as possible, I encourage you to choose a location and time that makes both you and the other person feel comfortable. Remember, Daryl Davis talked with Roger Kelly of the KKK while sitting in Kelly's living room, sipping lemonade. Derek Black's friends engaged with him over dinner.

I was sitting in a hotel lobby once, in Texas, waiting for the shuttle to the airport. An older man was also waiting, tapping his toe idly against his scuffed blue suitcase. He asked me about the book I was reading, *Incidents in the Life of a Slave Girl*, an autobiography written by Harriet Jacobs in 1861.[4] My fellow traveler wanted to know why I would read such a book, and whether I found it depressing.

I told him that I did think the story was upsetting, as history often is, but it had been written partly to inspire the abolitionist movement, so it wasn't entirely dispiriting. "It is about humanity's great cruelty," I told him, "but also about our capacity for courage and strength in the face of adversity."

"I get that," he answered. "But those books always make it look like every slave owner was a monster."

I had a choice to make in that moment. I remember gazing at him for what seemed like a long time, weighing whether to engage him on the subject of "good slave owners" or say something non-committal and return to my reading. In truth, my silence probably lasted only a few seconds before I opted to have the conversation and smiled at him.

"It sounds like you don't think all slave owners were immoral, and I am interested to hear why you say that. Talking about this stuff is tough, though, so I'm going to get myself a coffee." I gestured to the Starbucks kiosk on the other side of the brightly lit lobby. "Can I buy you a drink?"

He wanted a cappuccino. When I returned with the drinks, he had moved, with his luggage, to a seat closer to mine. We talked for about fifteen minutes while we waited for the shuttle, and then another thirty-five minutes during the ride to the airport.

I have no idea how much influence the free cappuccino had, or if anything I said changed his opinion of slave owners, but I do think I gained a better understanding of his position as the descendant of a plantation owner in North Carolina. I also think he better understands my feelings, as the descendant of both a plantation owner and a slave.

By the time we parted, me heading for the security line and him for the Delta desk, he took my hand and thanked me for talking with him. "I'm going to remember our conversation," he said. "I think I learned a lot."

I can't say for sure what he learned. Maybe he was simply ready to have a conversation about race and I happened to be there. But I do know it's never a mistake to try to make people feel comfortable when you're talking about something discomfiting. Allaying his fear may have made the conversation seem less scary, and our

exchange might make him more willing to have another discussion in the future.

That's why I suggest you openly acknowledge the difficulty of the conversation and consider what you can do to lower the tension. Move to comfortable seats, step inside to get out of the heat, or head outside to enjoy fresh air and a view of trees. Pause briefly to assess whether you're in the right place and whether it's the right moment.

We can learn a lot about the best approaches to these discussions from research on workplace communication, specifically, feedback on performance. After all, discussions about race inevitably involve feedback of some kind. Feedback about your perceived race ("White people don't understand their own privilege") or about the place where you live ("New York is dangerous and there aren't enough cops to handle the crime") or about you ("This is not about race. I just think you'd be taken more seriously if you had straight hair").

Feedback is hard enough to take when it's true; it's exponentially harder to respond respectfully when the feedback is based on sweeping generalizations and stereotypes, like the statements above.

Imagine you're giving a workplace performance review and you must tell a good employee that they've made some mistakes. How would you go about softening that blow? What time of day would be best for that discussion? You can employ the same type of tactics to make the discussion about systemic discrimination and oppression feel less fraught. Certainly, every person is different, and the best time of day will vary, but science offers a few hints that might help guide your thinking. For example, we know the ability to control our behavior influences whether we react to criticism with openness or defensiveness,[5] and we know that we are less able to self-regulate as the day progresses.[6] Taken together, these findings suggest that people are more open to negative feedback in the morning than they are in the evening.

I can imagine many people respond to this idea by thinking, "The

last thing I want to do in the morning is get into a discussion about racism." I understand that point of view, but I also believe we can work with our own cognitive tendencies to make this task easier. It may seem like a good idea to delay that talk until dinnertime, but that could mean everyone is simply too worn out and irritated to respond positively or to welcome new ideas.

Certainly, the best strategy is an individualized one. So pay attention to the other person's reactions, or, better yet, ask how they're feeling and if it's a good time to talk. And, of course, be mindful of your own energy level as well. You want to set yourself up for success. Choose a time when you can focus, when the conversation will feel less like an onerous task and more like a stimulating challenge.

While it's important that we try to have more of these conversations, it's not your responsibility to take this burden onto your shoulders if circumstances are not right. Remember, the stakes are low in any individual circumstance; you are not tasked with solving racism. You must choose whether to engage or not. If you feel it's not the right time or place, then I suggest you walk away.

STEP 6: DITCH THE TERMINOLOGY

> Use familiar words—words that your readers will understand, and not words they will have to look up. No advice is more elementary, and no advice is more difficult to accept. When we feel an impulse to use a marvelously exotic word, let us lie down until the impulse goes away.
>
> —JAMES J. KILPATRICK

Sometimes, in our earnest attempt to be precise and careful with our language during conversations about prejudice, we start to sound like we're giving lectures on critical race theory. We don't converse;

we orate. Instead of discussing, we give a dissertation. Consider the following paragraph:

> *I'm so grateful for the opportunity to talk about the oppression perpetrated by assimilationists who don't recognize the rampant cultural appropriation happening every day in our movies and TV shows. It's so important for allies to recognize the microaggressions that members of the model minority must cope with and strive for more multicultural competency. White supremacy culture in the United States is rooted in settler colonialism, and it's important we focus on reframing our history so it's more in line with reality and so it can lead to racial reconciliation.*

Don't worry, that's not a direct quote from an expert. I wrote it as an illustration of how complicated the modern language of race can be. I also tested it out on someone who understands every term I used. I asked a professor I know if she would use those terms when speaking with, for example, a sixty-five-year-old white guy from rural Texas. She grimaced a little as she considered the question and answered, "Only if I didn't actually want to talk to him."

I'm grateful for race scholarship and the work that's gone into creating a precise language to describe some very complicated and nuanced issues. If you are comfortable with these terms and you've done the study necessary to understand their meaning and context, I applaud your commitment and dedication. But for the purpose of your informal interactions, I encourage you to set aside that vocabulary.

When producers prepare doctors, academics, or other experts for radio and television interviews, they warn guests not to use industry-specific terms or acronyms. In essence, they want the guest to avoid language the audience will not understand.

Instead of saying "gastroesophageal reflux disease (GERD),"

it's better for a doctor to say "heartburn." Instead of talking about "acidulation," perhaps a chef can tell people to add lemon juice. All industries have terms that most people don't understand: a plumber talking to me about closet augers and saddle valves will get only a blank look in response.

Using specialized vocabulary can make those who don't understand it feel excluded. You might create an impression that you're trying to intimidate them or make them feel stupid. Either they'll admit that they don't know what "microaggression" means and you'll have to spend time explaining it to them, or they'll stay mum and the conversation will continue under a fog of misunderstanding. There's no need to say someone is "virtue signaling," if it's more clear to say they are putting on a performance of goodness and righteousness. Odds are, Grandma Pat doesn't know the difference between "street race" (the racial identity you display publicly) and "socially assigned race" (the racial identity someone believes others assign to them).

Your goal in a conversation is understanding, not obfuscation. The aim is not to sound smart or prove how much you know about race and racism, but to converse in a way that's as inclusive and comprehensible as possible.

Instead of using the term "microaggressions," I sometimes talk about the small insults and offhand comments that erode my well-being like death by a thousand cuts. I'll ask someone if they know anyone who is passive-aggressive, always making comments that sting or belittle. Just about everyone has experienced this kind of hurt in some form. They understand that those remarks can build up over time until they cause real emotional trauma.

Terminology associated with the study of race can also move the conversation away from the personal stories that help build empathic bonds and toward broad, intellectual themes. Using unfamiliar vocabulary can create distance at the exact moment when you are striving for human connection.

In the news business, we often tell reporters to write their stories as though they're talking to their grandmother. I would advise that you simply imagine you're talking to an old friend over coffee. When that guy tried to cut in front of you in line, it wasn't a microaggression, it was rude. If he does it every day, it's a pattern of behavior that reveals his inconsideration. If he cuts in front of dark-skinned people only, he's not just rude but also racist. You should talk about it like two normal humans, like not doctoral candidates defending their theses.

I discussed this issue with Tanner Colby, a white guy who had hundreds of conversations about race with all kinds of people while writing his book, *Some of My Best Friends Are Black: The Strange Story of Integration in America*. Tanner also co-hosted the podcast *Our National Conversation About Conversations About Race* and worked as a segment producer for *The Daily Show with Trevor Noah*.

HEADLEE: How do your conversations about race usually go?
COLBY: People want to tell me their "I'm a good white person" story.
HEADLEE: Interesting. What does that sound like?
COLBY: Just, you know, one time there was a new Black girl in school and I really tried to be friends with her. Something like that. And then they run out of material. That's all they have to say. I get less of the inadvertent racism. I get more of the fumbling, trying to say the right thing, but not necessarily saying it in the best way kind of stuff.
HEADLEE: How did you learn to have these kinds of conversations with people?
COLBY: I just went out and formed my own opinions about things so that when I give my opinion on something . . . first, I know how much I don't know, and I don't offer opinions on those things. When I offer an opinion on something, it's my educated opinion. It's not just me as a white person repeating what a white liberal said I was

supposed to say or what a white conservative said I was supposed to say, I'm just giving you my thoughts. That leads to a more natural and organic conversation. If you are a Black person having a conversation with me, you don't feel like you're talking to a white parrot of a white liberal or a parrot of a white conservative. You're just having a conversation.

HEADLEE: You've said that some of the toughest conversations about race are with white liberals. Why is that?

COLBY: Here's what I would say about white liberals: as a general rule, white liberals are not primarily interested in the subject of race for the liberation of Black people. White liberals are primarily interested in the subject of race to use as a cudgel of moral superiority against white conservatives. The conversation is bad on both of the extreme ends of the spectrum. On the other side, you see this white conservative dogma of affirmative action is bad, be color-blind, all lives matter. It's just talking points. You can pick up that jargon and go out there and expound those talking points and they have nothing to do with your experience or who you are or what you think or what you believe.

Those are very fake, artificial conversations. No Black person wants to have a conversation with you about how much you care about diversity, because it's a phony conversation. You're not talking about yourself. You're not talking about what you actually think.

When I decided to write my book, I wasn't hoping to use the issue of race as a political tool. I was just struck by the fact that all my friends were huge Obama supporters and we didn't have any Black friends. We didn't know any Black people. So I wondered why. I knew nothing about the issue of race and I just wanted to know, What happened here? Why was my high school segregated? Why is my church? I didn't approach race from a political point of view. I just approached it because I wanted to know more.

HEADLEE: I find that when I'm talking with people about how to

have these conversations, they want me to tell them what to say and what not to say. They want a checklist of words to use that will protect them from being called racist. They're often terrified of making a mistake. What do you do when you make a mistake?

COLBY: Empathy is the most important part of having a constructive conversation, and an assumption of good faith. I assume that you are here to have a constructive conversation, even if you make a mistake. And therefore, I am going to enter in this conversation, whether you are a Black Panther or a Trump voter, I'm going to enter the conversation with a base level of empathy for your point of view. I enter with an assumption that you're a good person who just might be confused or might not know the truth.

I think because I wrote that book, whenever I go into a conversation about race, people assume that I've done my homework and that I'm acting in good faith. And so, if I make a mistake or say something they don't agree with, it's not the end of the world. I'm not a typical white person in that way. I get the benefit of the doubt, which someone else might not get.

Mistakes are all about context and intent. I have had literally hundreds of wonderful conversations, one on one. You add four people to that mix and it gets a little iffy because everyone's worried about what everyone else is thinking. You go in front of a classroom with twenty people or make it public in any way and forget about it. It's just not going to happen in any kind of meaningful way.

HEADLEE: So let's say you are talking one-on-one. Are there common mistakes that people can watch out for?

COLBY: Here's one: the whole jargon and vernacular of "wokeness" that's evolved in recent years is terrible. It's one of the worst things to ever happen to constructive conversation. To start these discussions, you have to speak the same language as other people.

If I go into a situation at a school and there's been a racial incident, I don't need to call something a microaggression when I can

just say that it's disrespectful. We start with a common vocabulary to assess the problem. The racial justice movement has been overtaken by jargon as opposed to language. And if you go back and read Martin Luther King or Malcolm X or James Baldwin or any of the great writers, they wrote using language, not jargon. Angela Davis, all of them. They wrote using language that everyone could understand. Today, it's all about privilege, microaggression, diversity, and that's just not how to communicate. All those words should be stripped from the lexicon immediately. If we want to do anything to fix this, we should speak in language that everyone understands. The national conversation about race is a jockeying of political jargon from two different camps. It poisons what should be personal conversations.

Besides the jargon that Tanner Colby says is unhelpful, language can be problematic in other ways, as in the temptation to state opinions as though they are facts. I once overheard two men chatting near me at a gardening center. One of them said, "Well, no one cared about the team's name until recently because Indians never thought the word 'redskin' was offensive until liberals started stirring up trouble."

This is false, yet he said it with total confidence and authority. You might say he probably believed his opinion is true, and you make a good point. Not only do our political beliefs influence what we believe is true, data from the Pew Research Center suggests that Americans struggle to distinguish between a personal belief and a fact. For the Pew survey, people were presented with five factual statements, five opinions, and two that skirted the border between established truth and ideology. For example, one statement claimed that "democracy is the greatest form of government," and about a third of both Democrats and Republicans labeled that as a fact.[7] (It is an opinion.)

Knowing the difference between fact and supposition shouldn't be a political exercise. Some things are provable; some are not. For the sake of conversation, it's best to know when you're stating a personal belief and avoid making it sound as though your opinion is backed up by evidence. Stating opinions as facts is a method of bullying others and manipulating them into agreeing with you.

Plus, there's solid evidence that hedging language—words like "might" or "could" or "may"—is ultimately more persuasive than confident declarations that you're right. Making a declarative statement can be satisfying emotionally, but not effective as a discursive tool. For this reason, it's best to avoid using words like "because" or "therefore" or "actually."

Before we move on from the subject of language, a word about "tone policing," or attacking the *way* someone says something instead of addressing *what* they're saying. In rhetoric, this is a kind of ad hominem fallacy. For example, if I use profanity while complaining about the American criminal justice system, you might respond by saying I shouldn't swear, instead of addressing what I've said about the court system. Tone policing is another form of switch tracking, in that it allows someone to avoid a topic they don't want to talk about and instead flip to a topic they feel confident discussing. In general, I frown on any attempt to change the subject, unless it is mutually agreed to do so.

Words can embrace or exclude, comfort or afflict. I want you to spend time thinking about the way you express yourself. How inclusive is your language? Do your words welcome response or do they shut down debate? Choose your words with care and compassion.

CHAPTER 9

COMMON GROUND AND GOOD QUESTIONS

STEP 7: FIND COMMON GROUND

> Love has within it a redemptive power. And there is a power there that eventually transforms individuals. Just keep being friendly to that person. Just keep loving them, and they can't stand it too long. Oh, they react in many ways in the beginning. They react with guilt feelings, and sometimes they'll hate you a little more at that transition period, but just keep loving them. And by the power of your love they will break down under the load. That's love, you see. It is redemptive.
>
> —MARTIN LUTHER KING JR.

The more passionate you are about issues of race and politics, the more difficult it is to feel you have something in common with those who sit on the opposite side of the ideological spectrum. This is not a new phenomenon. In the 1950s, in a joint report titled "Barriers and Gateways to Communication," the influential psychologist Carl

Rogers and the social scientist F. J. Roethlisberger wrote, "The stronger the feelings, the less likely it is that there will be a mutual element in the communication. There will be just two ideas, two feelings, or two judgments missing each other in the psychological space."[1] In the nearly seventy years since that statement was published, it has simply become more true, as increasing polarization has led to wider ideological gaps and stronger feelings. Rogers and Roethlisberger advocated passionately for the need to listen to others with understanding, to find points of connection even during conflict. Active listening, they wrote, "is the most effective way we've found to alter a person's basic personality structure and to improve the person's relationships and communications with others."[2]

The two men advised that before anyone states their own opinion, they should restate what they heard from the other person, making sure they've articulated their ideas accurately. Doing this in real time can make an interaction seem a little clunky, I admit, yet this exercise slows down the pace of the conversation, making it less likely to escalate into a shouting match.

Consistently, when I ask people to do this during workshops, they are surprised to find they agree on more than they expected. They are forced to see one another as rational, thinking individuals rather than stereotypes of a "white person" or a "person of color." Instead of basing our opinions on assumptions about what we think people mean, this process helps ensure we understand what's actually been said.

I know you may be tired of hearing this advice—to search for common ground, for ways to come together. Maybe you feel there is no common ground, that in the Euler diagram of you and that person who voted for Trump or Clinton or Sanders or Biden or McCain or Bush, two circles just exist alongside each other, never intersecting, sharing no interests or ideas.

But when you begin to see others as more complicated than their

graphic T-shirts and bumper stickers, you may be surprised at how large the common ground really is. When we disagree on consequential issues like white privilege or police brutality, we're inclined to believe we're miles apart on every issue. As rare as it is for two people to agree on everything, its equally uncommon for us to *disagree* on everything.

If you consult opinion polls, you'll identify a long list of issues on which most Americans agree. For example, most people say it's never acceptable for a white person to use the N-word;[3] a majority say Blacks are treated less fairly than whites when dealing with police and the criminal justice system.[4] About two-thirds say people were more likely to say racist things after Donald Trump's election in 2016.[5]

Five minutes of reading through recent opinion polls will produce a substantial list of issues on which most people agree. Once you have a handle on these topics, you can build a respectful conversation on those margins of consensus, no matter how narrow. If you're short on time, here's a quick rundown of a few issues on which most Americans agree:

- More than two-thirds believe we "have more in common with each other than many people think."[6]
- More than 80 percent believe affordable health care is an essential right.[7]
- By nearly a 2-to-1 margin, Americans believe that immigrants make the nation stronger.[8]
- A whopping 92 percent of Americans believe their civil rights are in peril.[9]

You can use these areas of consensus as starting points. For example, perhaps you're having a conversation about the effort to defund police departments in the United States. This is a deeply divisive

issue, partly because there's not broad agreement, even among proponents of the idea, on what it means to defund law enforcement. Instead of arguing about that particular phrase, take a step back and ask, "Would you agree that Blacks are treated less fairly than whites by the criminal justice system?" Chances are better than even that the other person agrees with that statement, so you can follow up with another question: "In what ways do you think they're treated less fairly?" Since most people believe the legacy of slavery still affects the lives of Black Americans, you can ask whether they think that's true and where they see the influence of chattel slavery in modern society.

If you truly cannot find any racial or political issues on which you agree (and this is relatively rare), acknowledge that you may not agree on those topics and try to identify any issue on which you're compatible. It doesn't have to be something significant. Favorite show to binge on Netflix? Dogs or cats? Shower or bath?

When you are really at odds with someone, it can be valuable to simply make an empathic connection, to establish bonds of basic humanity. It's not obligatory to talk about the subject on which you most disagree. Justin Halpern, author of the 2010 book *Sh*t My Dad Says*, reports that his father once advised him, "Don't focus on the one guy who hates you. You don't go to the park and set your picnic down next to the only pile of dog shit."[10] This advice holds true in conversations: if you find that you strongly disagree with someone on something, you don't need to continue talking about that one thing. Talk about something else: food, weather, sports, your kids, books, vacations. It really doesn't matter.

Research has shown that two strangers can form a bond much more quickly than you might imagine, within minutes, while discussing something relatively innocuous or working together to solve a problem. We are so hard-wired to give people the benefit of the doubt, Roderick Kramer of Stanford says, that "trust is our default

position; we trust routinely, reflexively, and somewhat mindlessly across a broad range of social situations."[11]

I'm not suggesting you hold hands with your ideological opposite and sway along to "Kumbaya." (For one thing, that song is rooted in the African American Gullah culture of South Carolina and Georgia; the lyrics are a plea to God for help in the face of violent oppression. "The people who were 'crying, my Lord,'" wrote Samuel G. Freedman of Columbia University, "were Blacks suffering under the Jim Crow regime of lynch mobs and sharecropping."[12] "Kumbaya" is not a refrain born of brotherly love and bliss. But I digress.) The point here is not to force a friendship, but to honestly acknowledge that you disagree on some points and search for an issue (any issue!) on which you see eye-to-eye. Don't mistake this for an excuse not to address race at all, looking the other way when someone says or does something objectionable; to do so would be immoral. In my interview with former white supremacist Derek Black, I asked him what he thought about the idea of avoiding conversations about race with someone who is racist in order to keep the peace. After all, he has been on the other side of such dynamics. He responded, "I cannot possibly imagine a circumstance in which that's okay. To think, 'I'm just going to be nice to them because maybe they'll come around one day.' To never, ever bring up how horrible their beliefs are, how destructive their beliefs are." The purpose of avoiding the topic in the beginning is to create the kind of trust that will allow you to talk about race at some point in the future. It is an incremental strategy.

It's likely that this conversation will involve not a stranger, but someone you know and like or even love, which makes it that much easier to find common ground. Research shows that people today often don't completely trust the news media,[13] nor do they trust officials from the opposing political party to their own. Instead, they trust people they know or people who look like people they know.[14]

It's possible you are more persuasive to your friends and family members than you realize.

That makes it doubly important that you seize any opportunity to speak to your loved ones about issues of race. This is a tenuous moment in history, when political forces have sometimes conspired to blur the line between fact and fantasy. In a 2020 piece for the *Atlantic*, the historian and journalist Anne Applebaum wrote about this phenomenon: "How is it possible to reach people who can't hear you? This is not merely a question of how to convince people, how to use a better argument, or how to change minds. This is a question about how to get people to listen at all. Just shouting about 'facts' will get you nowhere with those who no longer trust the sources that produce them."[15] In these situations, finding common ground is a crucial step to establishing trust, and it is personal trust based on similarities that speaks to those who no longer believe scientists, experts, and media sources.[16]

Commonalities help to build bridges of empathy. Applebaum points out that this strategy is employed in even more challenging circumstances than discussions of race, by people whose job is to deprogram extremists. She interviewed Sasha Havlicek of the Institute for Strategic Dialogue, who recruits former members of extremist groups to work with her, as they are sometimes able to establish connections with current members of those groups. The aim, Applebaum explains, is to locate those individuals "who can offer a crucial form of reassurance: Once you change your vote or your politics, once you break from what everyone around you is doing, 'you won't be alone.'"[17] It can be scary to turn your back on every support system in your world.

The power of establishing common ground cannot be overestimated. It is fundamental to creating lines of communication with those who may never listen to someone who seems to belong to a different or opposing group. When you create a bond based on

similarities, it not only makes someone more likely to trust you but can also allay their fears of abandonment and make them less afraid to alter their beliefs.

The purpose of this, and indeed all the advice in this book, is to increase the number of conversations we have about race, to confront the white supremacist philosophies that are embedded in our government and our education and our commerce. Finding common ground and areas of agreement, no matter how narrow, is a tool for starting these conversations. If you can pin down an issue on which you agree, it can create a foundation on which the rest of the discussion can be built. You begin with agreement and move forward into disagreement.

For more insight on how to find a way into these difficult discussions, I spoke with a scientist who both studies and teaches the art of difficult conversations. Seema Yasmin is an Emmy Award–winning journalist, author, medical doctor, and professor who specializes in science communication. She teaches at Stanford University, and her most recent book is *Viral B.S.: Medical Myths and Why We Fall for Them*.

Not only does Yasmin often find herself countering misinformation on vaccines and disease, but she is a Muslim woman who's experienced racism and sexism throughout her career, so many of her conversations are tough. Much of her work focuses on finding a way to continue a discussion with someone whose beliefs are factually incorrect or openly offensive.

YASMIN: When we're having these conversations, even as antiracists, sometimes our understanding of race might be lacking. I've had conversations with very well-meaning people who just haven't done the reading, haven't examined the social construction of race, or analyzed it from a historical perspective. It's incredibly frustrating and makes me question the value of engaging in conversation

with them, both from the perspective of evaluating what impact that conversation might have, and protecting my sanity and conserving my energy, since I have to deal with racism, Islamophobia, and misogyny daily.

HEADLEE: It is difficult, though, because some of the people whom we most need to reach with these conversations are not going to go to the store and pick up that book and read it.

YASMIN: You know, I teach a class on empathy for medical students because there are high rates of burnout and what we call moral distress among medical workers, and even by their second year, some of my medical students are experiencing empathy fatigue.

I teach them that communication with patients must be centered on empathy. But that can be extremely difficult and even dangerous when it comes to conversations about race. I will not extend empathy to somebody who does not believe that I have a right to exist or live freely in this country as a woman, an immigrant, a person of color, and a Muslim.

HEADLEE: From the research that exists on confirmation bias, empathic bonds are one of the only ways we've found so far that actually changes people's minds.

YASMIN: One of the things I teach is the evidence that shows pouring facts into a conversation about a polarized topic is akin to pouring kerosene onto a fire. It's incendiary. It makes everything go up in flames.

HEADLEE: So we're stuck in this place. There are millions of people in the world who are racist enough that they're endangering the lives of others.

YASMIN: And they are literally endangering the lives of others. I teach anti-racist frameworks to doctors, and some of them argue that medicine is not racist, that it cannot be racist, that medicine is inherently neutral. It's utter codswallop. But a doctor who doesn't understand medical racism, who doesn't comprehend that it results

in Black people's pain being undertreated and underdiagnosed, that doctor is dangerous.

HEADLEE: This leaves us with a dilemma . . .

YASMIN: It's a perfect dilemma because the more intractable this problem seems and the more difficult it seems to talk about it, the more it continues. And that's very comfortable for those in power. We have to admit that racism is really, really good in some ways for some people. Though actually, if we look at it holistically, it is bad for them, too. It's not good for anyone to live in a world that is so unjust.

I have friends who are Black Americans who work in anti-racism and they do this day in, day out. And I'm very worried about their mental health and their blood pressure, among other things. They endure the physical and psychological impacts of confronting anti-Black racism from white people and non-Black people of color in multiple ways.

HEADLEE: What would I have to say to you to convince you to have a few of these conversations, just one out of twenty?

YASMIN: Maybe a reminder that conversations *can* change people or that it won't be as antagonistic as I think, or that it might not take as long as I think. Maybe a simple reminder that I don't have to have *all* of those conversations all of the time, but maybe one or two.

[Laughs] And yet, as I'm saying this, I'm thinking, I need to remember those things but also, can white people do this work, please? Can people of color be relieved of some of the responsibility for these conversations? It's labor.

HEADLEE: So would you say the task of talking racist people out of their racism is a white task?

YASMIN: No, it's not. I can't say that. And I have more to lose, in a way. I have more at stake.

The ironic thing is, and you're going to laugh, is I teach a very complicated set of historical and cultural contexts around anti-science beliefs, and lots of techniques for how to engage with people

who believe, for example, that all vaccines are dangerous. I teach six-hour-long classes on this for our faculty about best practices and evidence-based communications strategies, and then . . . I lose my shit on my family WhatsApp group, because I'm human and flawed, and I do all the things that I teach people not to do, and it has exactly all of the ramifications that I know it will have: it shuts down the conversation, it upsets people, it's not conducive for navigating an impasse, et cetera.

Just this morning, an aunty forwarded a viral video of a British Muslim man saying ridiculous, incorrect things about COVID-19 vaccines. And it got me really riled up. And then I got angry at my family for forwarding the video to our chat group and to others. Bless their hearts. I'm like, you do know that I study health misinformation for a living, right?

HEADLEE: I wonder if I could get you to have really short, low-stakes conversations. Just five minutes. We both know you won't solve racism over the course of a conversation or change anyone's mind.

YASMIN: You're right. And yet my overambitious, epidemiologist self, who likes to think about evaluating interventions and designing metrics for success, wonders how we can wrap this up nicely to have a successful outcome. But I know that's going to take generations. And maybe the only thing I can realistically do is get this one colleague, a white male journalist who tells me it's really hard to be a white man in the profession and it's much easier for me to succeed, to not repeat that poorly considered nonsense in front of his kids. Maybe that's a metric of success in this conversation.

If even a trained investigator and communicator sometimes finds it difficult to say the right thing, then rest assured that the rest of us won't get it right all the time. Even the experts get frustrated and need to take a deep breath before they continue.

During particularly challenging conversations, you might even make a point of enumerating the things you have in common before diving into more fraught waters. I spoke with a very conservative Republican during my last trip to Arkansas, and it was clear almost immediately that we live on opposite sides of the political spectrum.

"Wow," I said. "We disagree on a lot of issues. But I bet I can find something we have in common in three questions or less." It took three questions, and the shared belief was that autumn is the best season of the year.

"I'll bet you a dollar," I said, "that I can find ten more things we have in common."

"You're on!" he answered, laughing.

In about fifteen minutes, we discovered eighteen shared opinions. For example, we both agree that dogs are better than people. He bought me a coffee, and though we didn't speak about race or religion or politics, we made a connection. While not ideal, it's a start. That bond of respect might make him more open to future conversations. He may be less afraid to engage because our interaction didn't result in a fight, and sometimes that's what progress looks like. One step at a time.

STEP 8: ASK GOOD QUESTIONS

> **I beg you, to have patience with everything unresolved in your heart and to try to love the questions themselves as if they were locked rooms or books written in a very foreign language.**
>
> —RAINER MARIA RILKE

If you want to be a great conversationalist, you must be as good at listening as you are at talking. That means you might need to ask a lot of questions. Focusing on questions could necessitate a complete

reevaluation of your approach to social interactions, since so many of us focus on what we're going to say and not what we're going to hear. Julia Galef, a writer and host of the podcast *Rationally Speaking*, describes this as moving from the mindset of a soldier, focused on victory, to that of a scout, focused on exploration.[18]

I'm sure there is some art involved in asking strong questions, but after twenty-two years as a journalist, I'm prepared to assert that it's mostly skill. It's a craft that can be learned, like bike riding or knitting, and every conversation is a chance to practice and improve. For just a moment, let's set aside the issue of race because learning to ask good questions is a worthwhile endeavor on its own. Research shows that when you make a habit of posing questions at least as often as you make statements, you can improve your emotional intelligence, and a higher emotional quotient (EQ) increases the chances that you'll ask better questions. It's a virtuous cycle that can have profound impacts on many aspects of your life.[19]

When it comes to difficult exchanges, like any that are centered on race, making sure your questions are thoughtful and compassionate is imperative. Many of the disrespectful comments that people label as "microaggressions" are bad questions that reflect an ignorance of even the most basic history of racism. For example, "Can I touch your hair?" is inappropriate on several levels, not merely because you're asking to put your hand on someone else's body but also because Blacks have a long history of being subjected to unwanted touches and worse.

"Where are you *really* from?" is an offensive question because it presumes the person you're speaking to is foreign, an outsider. Asking an Asian person, "Why are you so quiet?" can be disparaging, partly because Asians are often stereotyped as being retiring or shy and partly because being outspoken is not a virtue, but a quality. If someone doesn't feel like speaking, it may have nothing to do with

the culture in which they were raised and everything to do with who they are as individuals and how they feel at that moment.

As with anything in personal relationships, your questions must be directed at the individual standing in front of you and not their perceived racial group. Curiosity should drive your queries, not an interest in categorizing or labeling that person. For example, if my rideshare driver has an accent, I'll ask where they grew up, and then follow up by inviting them to tell me about their country of origin: What is the food like? What is the weather like? Did they get snow during childhood winters? Do they ever go back to visit? Do they have family back there?

Because immigration is such a controversial political topic, you must be careful when inquiring about someone's nationality. Stop before you ask and pose this question to yourself: Why do I want to know? Is it so I can judge them or make assumptions, or am I honestly curious and ready to learn something about their place of birth?

How you phrase the question is also important, as an inquiry can be used to interrogate someone as easily as it's used to invite them to share. Make sure you're asking open-ended questions, not the kind that can be answered with a simple yes or no.

Research shows people generally have one of two intentions when they enter a conversation: information exchange or impression management (making a good impression).[20] Asking good questions can accomplish both goals at once, since they help you elicit information efficiently, and people who show interest in others are seen as more likable.

A Harvard analysis of more than three hundred exchanges showed that, while people sometimes hesitate to ask a lot of questions because they're either too focused on what they want to say or they're afraid of coming off as rude and intrusive, asking about another person's

thoughts and opinions is one of the most effective ways to earn their good opinion. The study coauthors wrote that there is a "robust and consistent relationship between question-asking and liking: people who ask more questions, particularly follow-up questions, are better liked by their conversation partners."[21] Follow-up questions are particularly effective, as they demonstrate that you're listening, that you're engaged, and that you're interested in what you're hearing. In other words, so long as you take care to make sure your inquiry is not founded in racist or disrespectful assumptions, it really does not hurt to ask.

Talking about yourself, on the other hand, makes it more likely that others will not want to talk with you. We know from multiple studies over a number of years that we tend to talk about ourselves a lot, especially when meeting new people.[22] And yet, discussing your own experiences, achievements, ideas, and opinions does not lead others to respect you more. In fact, the Harvard researchers cited in the preceding paragraph concluded that "the tendency to focus on the self when trying to impress others is misguided" because others will like you less.[23]

There are four basic principles involved in crafting strong questions: make them open-ended, less is more, one at a time, and follow up.

Open-ended questions invite thoughtful and complicated responses. They require more from the other person than a simple yes or no. They allow the other person to respond as they will, without trying to direct or manipulate their reply. To ask this kind of question, try to avoid starting your questions with verbs, as in "Can you understand what I'm saying?" or "Should you be wearing that?" or "Is this what you wanted?" In most cases, a question that starts with a verb has three possible answers: yes, no, or maybe. Perhaps the person you're speaking with will expand on their answer, but perhaps not.

What's more, yes-or-no questions rarely create an impression

that you're truly interested in the answer. They can come across as passive-aggressive, in the worst cases. Opening with a verb can suggest that you're expecting a particular answer or that the question is rhetorical. If you ask, "Should you be dressed like that?" it's strongly implied that the person you're asking is supposed to say no.

One exception that I use often is "Can you help me?" Asking for help is a powerful trigger for human beings and often elicits a positive response. I will say, "Can you help me understand this?" or "I think I get what you're saying, but can you help me make sure?" In this case, the response you want is one word—yes—but it leads directly to more questions and more discussion.

Open-ended questions often begin with the famous sextet: who, what, where, when, why, and how. These interrogatives nearly always serve you better than verbs. Consider the difference between these questions: "Can you stop saying that word?" versus "Why do you keep saying that word?" Here's another example: "Is there a reason why you're ignoring me?" versus "What do I need to do to get your attention?"

You can even memorize some open-ended openers, or, as negotiators describe them, interrogative-led questions.[24] Some useful phrases are "What happened when . . . ?" or "How did you feel when . . . ?" or "What do you think of . . . ?"

Of course, closed-ended questions are not entirely forbidden. They have important uses, especially to pave the way to more probing material, and for simple information exchange, as in: "Did you vote?" "Yes, did you?" Closed-ended questions are indispensable for discovering what topics are worth exploring. You can ask someone if they've read any James Baldwin. If they say no, you don't attempt to educate them about Baldwin, since people don't like to be lectured to; you simply move on to something else. Have they read *To Kill a Mockingbird*? If yes, then you can talk about the book and the issues it raises.

Whenever you're probing for information, remember that *less is more*. For journalists, the rule of thumb is this: complicated question in, simple answer out. What you want is a thoughtful, nuanced response, so your question should be as simple as possible. The more information you put into the question, the more information the other person leaves out of their answer.

Simplifying your question requires that you leave out unnecessary details, like dates and places and names, but it's also vital that you omit any judgments and opinions. To elicit an honest and respectful response, you must be sincere. Also, avoid aggressive rhetorical questions like "What kind of person would vote for that candidate?"

If I need to state my opinion, I simply articulate my thoughts, then ask the question as blandly as I can. "I don't agree with that at all," I'll say, "but I'm curious about how you came to that perspective. Why do you feel that way?"

Keep in mind that in this book, I am teaching you principles and not rules. Every conversation is as complicated and surprising as every human being, so there are no absolutes, merely fundamentals. In this case, that means you don't have to use only short, open-ended questions, but you should be cautious about how much detail you put into them. Err on the side of simplicity.

John Sawatsky, a longtime investigative journalist for the Canadian Broadcasting Corporation and interview trainer for ESPN, has said the best questions are like clean windows. "A clean window gives a perfect view," he told the *American Journalism Review*. "When we ask a question, we want to get a window into the source. When you put [opinions] into your questions, it's like putting dirt on the window. It obscures the view of the lake beyond."[25] The person you're speaking to shouldn't notice the questions you ask; they should look through them to the more expansive thought or idea behind them, the "lake" beyond the window.

We're grappling here with the difference between outputting and inputting. "Outputting," in a conversation, describes any instance in which you make a statement, voice an opinion, or place a judgment on something you've heard. "Inputting" refers to something you say that spurs further response or propels the conversation forward, by inviting the other person to add their thoughts. You will often output in your discussion, so the questions should be all about input.

If you're interested in seeing a demonstration of this principle, read through the *Report on the Investigation into Russian Interference in the 2016 Presidential Election*—that is, the report written by the special counsel Robert Mueller.[26] Leave politics aside, if you can, and take a moment to appreciate how good the questions are. Investigators who submitted queries to the president were very careful with their wording to make sure they invited as thorough a response as possible, and they didn't lead the witness by using loaded words like "exploit" or "propaganda." Most of the questions in the report begin with "what" or "how." The team avoided "why" as much as possible, it seems, and for good reason. Questions that begin with "why" can come across as judgmental, as in "Why do you think that?" There are also very few questions that begin with "where" or "when," most likely because inquiries that begin with those words often seek basic information and surface-level responses. "Where did you grow up?" is a perfectly fine opener in a conversation, as long as you follow up with questions about what the neighborhood looked like or when the person you're speaking with first learned about racism.

Another detail you may notice in the Mueller report: the investigators ask *one question at a time*, which is the next principle of good questions. It's common for people to string several questions together, as in, "Why do you believe Black people are more likely to be poor? Did you grow up in a poor neighborhood? Do you

believe poor people are less moral than everyone else?" Unfortunately, when you ask multiple questions at the same time, you've left open an escape route. You allow the other person to choose which question they want to answer. That means one of the most famous questions in history—"What did the president know and when did he know it?"—was strong as a headline and weak as an actual question.

Finally, use your inquiries to *follow up*. Research has shown that follow-up questions have a unique power to demonstrate that you're engaged in the discussion, and to convey to the other person that they are truly being heard. They also can make you seem more likable, possibly because you're giving the other person the freedom to talk about whatever they choose, rather than trying to dominate and steer the exchange. You are following their lead. Studies have also shown that when someone is asked a lot of follow-up questions, they are more likely to say they felt respected during the exchange.[27] Experts might tell you that for every question you ask, you should ask five follow-ups. It's not usually possible to regiment yourself like that in real-world discussions, but the underlying message here is that most of your questions should be follow-ups.

There is one particular follow-up that works well in many situations: "How do you know?" If someone says Native Americans are "spiritual people," you can ask how they know that. Create chains of questions in order to dig deeply into someone else's thought process or background, and to nudge someone to give you specifics about a claim they've made.

Here's an example:

PERSON 1: People in the South are racist.
PERSON 2: How do you know?
PERSON 1: Well, they oppress all the Blacks who live in the South.

PERSON 2: You're right that Blacks face more obstacles in the United States than whites do, but I saw a lot of racism when I lived in Michigan, too, and California, and Washington. How do you know it's worse in the South?

All four of these tactics—make it open-ended, less is more, one at a time, and follow up—are designed to help you ask questions out of a sincere interest in what the other person has to say. No amount of advice I can give will help if you're asking questions because it's what you're supposed to do, and not because you're invested in having a productive conversation.

If you struggle to think of questions to ask, it may be because you've haven't fully accepted that the other person has interesting things to say, or that you can learn from them. Perhaps the exercise of inquiry is performative, something you do in order to *appear* engaged in order to mask your real intention, which is to tell them what you think and what you believe. These strategies will not help you, if that's the case.

Always begin with curiosity. Take the time to consider what you might want to know about the other person. If you truly don't know what to ask, fall back on TED: tell, explain, describe. Encourage them to *tell* you more, to *explain* what they mean, or to *describe* what a particular experience was like. TED phrases are not questions per se, but inputting statements that urge someone to keep talking. They're versatile, and they often elicit enthusiastic responses. The legendary interviewer Terry Gross, host of NPR's *Fresh Air*, told the *New York Times* that the only ice breaker you should memorize is "Tell me about yourself."[28]

If coming up with simple, strong, open-ended questions is a challenge for you, rely on TED. The goal is to urge the other person to share and divulge information and then listen carefully to what they

say. I firmly believe that if you are listening attentively, you won't have to scramble to come up with follow-up questions; they will come to mind organically.

Your work is not over once you've asked your question, of course. The second half of the inquiry process is listening. You ask, they respond, you listen. If you are listening actively—not worrying about what you'll say in response, but focused on the words they use and their underlying meaning—you may find you don't have to work very hard at asking more questions.

CHAPTER 10

KEEP IT PERSONAL AND DON'T RUSH

STEP 9: KEEP IT PERSONAL

> Could a greater miracle take place than for us to look through each other's eyes for an instant? We should live in all the ages of the world in an hour; ay, in all the worlds of the ages.
>
> —HENRY DAVID THOREAU

I remember watching the live presidential debate on September 29, 2020. The broadcast was ninety minutes long, divided into fifteen-minute segments focused on specific topics like "the economy" and "the Supreme Court," and was moderated by Chris Wallace of Fox News. One segment was dedicated to the topic "race and violence in our cities," with Wallace asking the candidates—Donald Trump and Joe Biden—questions about racism in America.

We know all too well the disastrous exchange that followed. Not only were fundamental debate protocols ignored—there were no demonstrations of mutual respect, no turn-taking, no acknowledgment that differing opinions can be equally valid—but, also, the

candidates' remarks were vapid. Viewers were presented with nothing new, nor did they gain a clear understanding of the candidates' perspectives on race. Perhaps the discussion was doomed before it began, as linking violence to anti-racism protests is problematic at best. At worst, it is stereotyping based on historical falsehoods.

The biggest hurdle in that setting, though, was that both candidates were white men being asked to speak about race and oppression in the broadest possible terms. They weren't talking about individuals, really; they were talking about all Black Americans, all Latinx people, all Native Americans. That is a well-nigh impossible task.

The few times race has been addressed successfully on the public stage have almost always involved someone sharing a personal story. For example, during one of the earliest debates of the 2019 presidential primaries, the issue of segregation came up. In a moment that might seem somewhat ironic now, since Joe Biden is president and Kamala Harris vice president, Harris attacked Biden over his opposition to busing programs in the 1970s by sharing her personal experience with the issue. She began by saying that she didn't believe Biden was racist but that his stance on busing allowed individual municipalities to segregate their schools. "There was a little girl in California who was part of the second class to integrate her public schools, and she was bused to school every day," Harris said. "That little girl was me."[1] It was a powerful moment during a mostly chaotic and frustrating evening of argument and snide remarks.

Years earlier, when then president Barack Obama stepped to the podium in the White House Briefing Room in July 2013, he initially made some predictable comments about the Trayvon Martin case, in which a Florida man was charged with murdering an unarmed Black teenager in 2012. The reason people remember that speech is that, a few minutes in, the president said something unpredictable: "You know, when Trayvon Martin was first shot, I said that this

could have been my son. Another way of saying that is Trayvon Martin could have been me thirty-five years ago."[2] Watching the president of the United States draw parallels between himself and an average Black kid, I struggled not to cry. It felt like he'd made an emotional connection with me, echoing thoughts I'd had and feelings I'd experienced when I heard about young Trayvon Martin, who would never see his eighteenth birthday.

Perhaps one of the most important lessons to learn in talking about race is this: it is always personal. It's always about individual lives and pain. Don't worry about the view from fifty thousand feet; tell us what's happening here on the ground. Whenever you can, restrict your comments to what you know personally, what you've seen, what your family has experienced. If you do this, you will never make the mistake of saying "you people," because you won't make comments about others, only yourself. What prevents so many of us from having these difficult conversations is the fear of saying something wrong, but if you are talking about only personal perspectives and experiences and inviting others to do the same, the odds of making an egregious error decrease significantly.

Instead of claiming that whites face racism and discrimination in the United States (something that more than 55 percent of white people believe), for example, share a story about a time you were discriminated against because of your race. In a 2017 interview with NPR, a sixty-eight-year-old white man from the Midwest told the political correspondent Don Gonyea, "If you apply for a job, they seem to give the blacks the first crack at it and basically, you know, if you want any help from the government, if you're white, you don't get it. If you're black, you get it."[3] Factually, this man was incorrect. Unemployment among African Americans is consistently higher than it is for whites, and far more white people have received support from federal welfare programs than Blacks have, taken in total. I suspect, however, that he was extrapolating from personal

experience. Perhaps he had endured a long and painful period of unemployment, or perhaps he saw some Black people in his town get hired for jobs he wanted. If he'd shared his story, without adding the racist assumptions, he might have connected with listeners instead of sounding like a bigot.

Unfortunately, this tendency to project our individual experience as universal is common. Many people talk about race *only* in such generalities. Instead of bolstering their views with personal anecdotes, they simply repeat ideas or "facts" they've heard from others.

Reciting stereotypes is one thing, but what about when the facts are on your side? Even then, I suggest anchoring a conversation in personal experience. You stand the best chance of breaking through to someone else by appealing to your common humanity, by reminding them that you struggle and strive and sometimes fail, just like them. Telling a personal story doesn't mean recounting a traumatic experience in order to enlighten someone else; it means keeping your conversation grounded in what you've seen and what you've experienced, rather than talking about history or racism writ large. While those topics are worthy of discussion, you'll find they rarely reach those who disagree on history or racism. Politics are always personal, people say, and so is racism.

Talking about the persecution of millions of people will rarely carry the same weight as talking about one person in particular. There's a reason why Black Lives Matter activists insist that we say the names of Black people who've been shot down by police officers—because those individual stories can have a more profound emotional impact than talking about victims of police brutality in the aggregate.

I remember having a conversation years ago with a white colleague who admitted she hadn't truly understood the reality of police brutality until she watched an interview with the actor LeVar Burton on CNN. In the 2013 conversation with the host Don

Lemon and a panel of other guests, Burton described the ritual he follows every time he is stopped by a police officer while driving. "I taught this to my son, who is now thirty-three, as part of my duty as a father to ensure that he knows the kind of world in which he is growing up," Burton said. "When I get stopped by the police, I take my hat off and my sunglasses off, I put them on the passenger's side, I roll down my window, I take my hands, I stick them outside the window and on the door of the driver's side because I want that officer to be as relaxed as possible when he approaches my vehicle. And I do that because I live in America."[4]

Burton is wealthy and successful, and has one of the most recognizable faces of our generation. My colleague in Georgia couldn't believe the man who played Geordi La Forge in *Star Trek: The Next Generation* had to go through such an elaborate routine in order to feel safe during a traffic stop. "I don't do any of that," she told me. "I'm usually irritated about being pulled over, and once or twice I've given the officer a piece of my mind." It was Burton's personal story that resonated with her.

Human beings have always learned through stories. For most of our 300,000 years on this planet, we've preserved history and information through oral narratives, songs, and verse. Printed books, like the one you're reading, are a relatively new development. The psychologist Jerome Bruner, known for his research on the cognitive development of children, estimated that humans are twenty-two times more likely to remember a fact if it's delivered through a narrative.[5] Perhaps you've never thought of conversations as mutual storytelling, but good conversations are linear. They have a beginning, a middle, and an end, and they move in only one direction: forward. They don't jump around, as can happen when you're skimming a newspaper or scrolling through social media.

But stories have an even more consequential value than helping us to retain new information; they stir our emotions. Stories have

been shown, through decades of research, to have a direct connection to empathy. The German scholar Fritz Breithaupt, author of *The Dark Sides of Empathy*, has written, "Empathy intensifies our experiences and widens the scope of our perceptions. We feel more than we could without it, and it enables us to participate more fully in the lives of others."[6]

In one study from the 1960s, scientists split a group of white second graders into two groups. One group heard stories featuring white characters only, while the teacher read to the other group from a multiethnic reader featuring characters from several racial groups. The kids in the second group ultimately had more positive views of Black people than the kids in the control group, and they were more likely to include Black kids in their play groups.[7]

Equally important is that when you narrow your side of the discussion to what you know personally, you avoid drawing conclusions about a large group of people based on racist rhetoric. The same goes for your response to what others say to you: try to listen to their experience without adding the emotional baggage of what you've heard others say. After all, grappling with centuries of racist history and the sins of our ancestors is simply too much weight for two people to carry. You can't hold any one individual accountable for the legacy of slavery, but you might ask why they have a Confederate flag sticker on their car.

I realize these suggestions are a tall order and often easier said than done. If someone votes for a racist candidate, for example, don't we know their views on race already? In late 2020, I saw an exchange on social media in which one person urged people to purposely reach out to people who supported a different candidate. Another person responded: "I'm not considering reaching across any aisles until the other side believes every one of my friends and family have a right to exist and love who they please."

This perspective is neither wrong nor unexpected. Mutual respect

is mandatory in civil discourse, and if someone tells you that they don't believe in your fundamental rights, I will never counsel you to continue speaking with them. But, as tempting as it is to believe that someone's vote reflects their personal beliefs, political opinions are influenced by an incredible number of forces. Their support doesn't really tell you what they think; you'll have to ask, if you want to know.

My suggestion is this: don't talk to "sides"; talk to people. You can certainly stand on principle and refuse to speak with anyone whose vote contributed to the success of a racist candidate, but ostracizing large numbers of people will ultimately lead to more polarization, more hatred, more entrenched belief. No person is a "side," and by treating someone as a symbolic representation of an entire group, you are also denying their right to be seen as an individual.

I'm asking you to see people, really see them, and to hear their personal experiences. As the comedian Dave Chappelle said in his opening monologue for *Saturday Night Live* on November 7, 2020, we all must find a way to understand what others are going through, knowing that we've all suffered, that the conversation about race is personal to all of us. "Remember," Chappelle said, "that for the first time in the history of America, the life expectancy of white people is dropping because of heroin, because of suicide. All these white people out there that feel that anguish and pain, that [are] mad because they think nobody cares. . . . Let me tell you something, I know how that feels. . . . Everyone knows how that feels."[8]

I'd like to share one last anecdote about the value of keeping the conversation personal and specific rather than broad and all-encompassing. After the 2020 presidential election, one of my neighbors was bemoaning the fact that Donald Trump had lost. I asked him, "Why do you think nearly all Black people voted against him?"

He said, "I think Black people have been duped for a long time into believing that Republicans are racist."

"I strongly disagree with that, and I'm interested to know why you believe it," I responded. "How many Black people do you know well? Well enough to invite to your birthday party?"

He thought for a moment, looking off over his left shoulder, and then said, "I think you're the only one I know well."

There are many things I could have said in response, notably that we are not actually close or that neither of us would ever invite the other to a party at our homes or, if invited, attend. Saying that, though, might have led to an argument over a hypothetical situation, which is an argument that cannot be settled. Instead, I asked, "So you believe that I've been duped?"

He was quick to say no, that he thinks I'm smart and knowledgeable about political issues. I told him I was confused because he implied that Blacks vote a certain way because they're ignorant of the truth, but he only knows one Black person and doesn't think that person is ignorant.

"I'm just talking in general," he said.

"When you speak in general," I answered, "there's a real danger of generalizing about people, and those generalizations can easily become stereotypes. Imagine for a moment that I know a lot about political issues and chose not to support Trump anyway. Why do you think I voted the way that I did?"

I was asking him to put himself in my shoes, to imagine that he was a Black Jewish female, and consider the issues of the election from my perspective, assuming that I'm as smart as he is, as reasonable as he is, and as invested in the outcome as he is.

To his credit, he spent several minutes listing all the reasons he thought I might not vote for a Republican right now. "I see what you're saying," he told me, although I hadn't spoken for several minutes. "I see why you might think Republicans aren't on your side."

At that point, my dog lunged at a squirrel and I made a stupid joke about how short the Dog Party platform would be, with strong

stances on treats, belly scratches, naps, and squirrels. He gave me a courtesy laugh, and we both walked away.

I didn't change his mind, of course, but I think I forced him to see me as an individual. Racism is a tool for dehumanizing people, for stripping away their individuality and treating them as a separate species. Anti-racism demands that we break down these stereotypes into their component pieces and relate to one another as unique human beings, each with our own ideas, perspectives, and experiences. To make it personal is to recognize the person in front of you.

Don't give a speech on race. Don't hold forth or orate or deliver a brilliant treatise on the roots of systemic oppression. Tell a story. Tell *your* story.

STEP 10: DON'T RUSH IT

> One of the most effective means for working with that moment when we see the gathering storm of our habitual tendencies is the practice of pausing or creating a gap. We can stop and take three conscious breaths and the world has a chance to open up to us in that gap. We can allow space into our state of mind.
>
> —PEMA CHÖDRÖN

Racism has blighted society for centuries; there's no need to rush through your discussion of it now. It's said that anything worth doing is worth doing well, and a conversation about oppression and prejudice is worth the time it takes to make it good. It's okay to feel passionate. It's okay to be sick of waiting for progress. When it comes to enacting real reform and substantive changes, it's long past too late for too many people. I've always been struck by James Baldwin's comments in the *American Masters* episode "James Baldwin: The Price of the Ticket": "I was born here almost sixty years

ago. I'm not going to live another sixty years. You always told me it takes time. It's taken my father's time, my mother's time, my uncle's time, my brothers' and my sisters' time, my nieces' and my nephews' time. How much time do you want for your progress?"[9]

Looking back through my own family history, to my great-great-grandmother saying goodbye to her children as they were sold and my great-grandmother staging Shakespeare plays to raise money for a library that Blacks in Arkansas could use, I'm impatient, too. How many more generations will be told to wait, wait, wait?

Playing in the background of every conversation I have about race is that insistent drumbeat, the sound of marching telling me we've waited too long already. Yet I remind myself repeatedly to keep that beat at a remove and focus my attention on the person in front of me.

Of all the advice you'll find in this book, this is perhaps the most achievable and the most effective: slow down. I was struck in 2020 while reading social media posts from Nate Nichols, the founder and creative director of the marketing agency Palette Group in Brooklyn. He's also the cofounder of Allyship and Action, an organization focused on uniting the advertising industry to fight for anti-racist reform. Nate often shares stories about conversations he's had with strangers about race, and it's clear he has committed a great deal of his time to having these discussions.

HEADLEE: Tell me about a time when you've had an authentic conversation about race.
NICHOLS: I have so many stories! A couple years ago during a trip to L.A., I was taking an Uber ride and the driver kept stereotyping me. He said all Black people look the same, then he asked what kind of music I listen to, and automatically turned on the hip-hop station. And I was thinking, "No way. This is impossible. This is not

happening right now." I was in L.A. for a client project and I was going from the east side of L.A. to the west side, near Venice.

HEADLEE: Oh, that's a long drive.

NICHOLS: Yeah, it's a forty-five-minute trip, and I was thinking, "Oh, this is going to be interesting." He says, "What's your name? Is it Jamal?" I didn't say anything. I didn't really engage because I was trying to figure out the best way to handle it, since I was going to be in this man's car for some time.

Finally, I decided to address his comments. I said, "I can't tell if you're not in on your own jokes or you're being serious, but it's your responsibility to make me feel comfortable on this car ride. I don't feel comfortable here."

He freaked out. He looked in the rearview mirror and said, "Okay, man, I thought you were cool, but you want to get out of the car? We can take this outside." I said, "What are you talking about? We're on the highway."

HEADLEE: He wanted to fight you?

NICHOLS: He just immediately went into fight mode. And then he melted down. He said, "I'm so sorry. Listen, my wife is Black and, you know, I have friends who I crack these jokes with all the time. And this is my livelihood; I need this job to make ends meet." I told him, "Listen, your role is to get me from point A to point B safely, and right now I don't feel comfortable on this ride. I'm not going to report you," I said. "I'm just letting you know that I'm not comfortable and you're causing that. Maybe you know people who allow you to belittle their culture and they laugh about it. That's okay for them, but it's not okay for me."

I asked him, "What's your story? What's your heritage?" He said, "I'm Jewish," and I said, "Okay, then, what if I came in here shooting off 'Heil, Hitlers' and talking stuff about the Jewish community, dropping Nazi jokes?" He said, "I'd be so angry." And I

said, "Right. That's how I feel right now. So who gave you the right and the license to say things you think are funny and cool to some stranger?" That was the start of the conversation, then we got to know each other. He's a great dude.

HEADLEE: What was going through your mind when you decided how to respond to him?

NICHOLS: I'm always trying to find an angle of vulnerability that I can tap into. My hope, and this is a risk, is that if I can find a place of vulnerability within this person's life experience, I can also find empathy there. If I can identify what activates their empathy, maybe we can align on seeing each other equitably and with fairness.

HEADLEE: You're talking about finding common ground. But that's difficult when you're talking about race. Can you give me some examples? Some signs of empathy that you've found.

NICHOLS: I think if people can see you in your sadness and be with you in your sadness, they can make a connection. As a Black man talking with someone who isn't Black, it's my right to allow a certain amount of grace. It's up to me to identify the amount of grace I want to extend. And with grace comes responsibility and accountability.

It's hard, in the moment, to know if they're genuine and they can understand the grieving and the sadness of the oppressed. But the conversation is still significant to me as a life experience, whether I have a relationship with that person or I'm never going to see them again. In my journey as a Black person, it's powerful and hopeful to just . . . stand. Take a stand for myself and my identity and my allies. So, while it may not change that person, it changed me. It allowed me to open up to provide more grace.

HEADLEE: There are plenty of people of color who find it hard to extend that grace. Perhaps they feel they're too often pressured to extend it. Maybe they're angry. What would you say to someone like that?

NICHOLS: We all have our own experience, and some people don't

like when people touch their fucking hair. For them, that's like an atrocity and they have traumatic experiences correlated with that. My lived experience is one of lots and lots and lots of trauma, and that informs my ability to have more grace.

No one else has had the Nate Nichols experience. I was born and immediately put into foster care; my mom was put into a psych ward. I was raised by my foster mother for two years. I loved my foster mother so much, so much so that I could memorize how to get back to her home, the foster house, even as a three-year-old. And I hated my mother growing up. We did not like each other.

Later, we reunited. And I grew to learn, she was dealing with challenges that were rooted in her heritage and culture from growing up in Jamaica. I had to start a journey to understand that my mother's lived experience of being a Black woman in America and in Jamaica is one that is riddled with oppression. Not like what I experienced in dealing with our relationship, but one that's far greater. And I was able to embrace my mother and love her.

If I can restore my relationship with a human being who was supposed to love me unconditionally, with whom I've had such a distasteful, terrible relationship . . . who am I not to look across a racial boundary and extend a bit of grace?

HEADLEE: Has it ever gone wrong?

NICHOLS: No, not yet.

Nate's experience validates the idea that conversations on race shouldn't be rushed. If you have five minutes to talk, then you probably have ten, and a rushed exchange that happens while you're headed somewhere else to do something else will likely benefit no one. Take a breath.

The great Buddhist spiritual leader Pema Chödrön recommends "pause practice,"[10] and I suggest you try it the next time you're in the middle of a difficult discussion. It's simple: Take three conscious

breaths. Breathe in and pay attention to the breath as it fills your lungs; then breathe out and watch the changes in your body as the breath leaves your chest and passes through your lips. Repeat that process twice more and you're done.

I just did a pause practice while I was writing and it took about thirty-three seconds (the third breath is generally longer and deeper than the first one). If you're in the middle of an intense discussion, perhaps you'll only have time for one breath. Even so, take the breath and pause for just a moment.

Often, arguments occur because we're in such a hurry to respond to what someone else has said that we consider neither what we've heard nor what we plan to say before the words leave our mouths. It's like a choir that keeps speeding up as they get more and more excited by the music. The tempo accelerates until it's impossible to make out the lyrics. When we rush, we escalate. When you're in a hurry, your contemplative mind doesn't get a chance to weigh in. It's your reactive, fear-driven mind that does all the talking, and that's a recipe for disaster. Time pressure moves our thought processes from the more mature outer layers of our brains and buries them deep into our amygdala, where responses are often based in fear.

One common habit that tends to increase the pace of our discussions is listening only until we hear a phrase or word that we find offensive and then preparing a response while the other person is still speaking. Perhaps they say, "I read the book *White Fragility*," and you hear nothing else because you're simply waiting, like a high-strung horse at the starting gate, to express your view of that book.

If you do this often—listen only until you hear something you disagree with—this habit will inevitably push your conversations forward at an unhealthy pace. You hear ten seconds of the other person's comments, then spend a minute waiting for them to take a breath so you can jump in with your rejoinder, and they do the same. Eventually, you'll be talking on top of each other.

Force yourself to decelerate and hear every word, all the way to the end of their final sentence. Then say, "Okay," to signal that you want to respond. Take a breath so you have time to consider, and only then begin speaking. If things grow heated, take a break. You can say, "I'm starting to get worked up, so give me just a moment to think through what I want to say." Then take your three conscious breaths for thirty seconds and return to the discussion.

Experts in public speaking have long suggested a variety of ways to slow down your speaking pace as well. For example, you can ask someone to tell you when you're speaking too quickly, you can take a sip of water occasionally, or you can learn to take a short pause every time you make an important point.

If you're speaking at a breakneck speed, it's common for people to tune you out, as the effort to understand what you're saying is unreasonable. Accelerated speech can also lead quite easily to a loss of clarity.

To understand what someone tells us, especially on a complicated subject like race, we must absorb not just their words but also their tone of voice, their body language, and their breathing. If you speak too quickly, people might focus all their attention on the words and lose the nuance you're conveying nonverbally.

Fast talkers can, in some situations, be more persuasive, but the psychologist Jeremy Dean, founder of *PsyBlog*, points to research showing that a quick pace doesn't aid in comprehension. In fact, he says, "it seems the fast pace is distracting and we may find it difficult to pick out the argument's flaws."[11]

Matching paces with an auctioneer can give our listeners the impression that we're packing a lot of information into a short window of time, but when researchers analyze what's said, they find that fast talkers use simpler words and ideas.[12] So, all things considered, someone speaking at 195 words per minute doesn't convey any more information than a person who speaks at a more leisurely pace.

In truth, the ruler by which to measure pace in your conversation shouldn't be information conveyed; it should be information understood. If you wait to speak until you comprehend what someone has said, and they wait to respond until they're confident they know what you mean, your conversation will naturally slow down.

Let the discussion breathe. However long it takes to make yourself clear, it's worth the time.

CHAPTER 11

I SCREWED UP. WHAT NOW?

> When we think about the many barriers to personal communication, particularly those due to differences in background, experience, and motivation, it seems extraordinary that any two people can ever understand each other.
>
> —F. J. ROETHLISBERGER

There are two kinds of people in this world: those who *have* said the wrong thing about race and those who *will*. Even if you were unaware of it at the time, it's likely you've already said something that was insensitive. If you plan to have more conversations about race, and I dearly hope you do, it is inevitable that, at some point, you'll mess up.

How do you know you messed up? Perhaps it's a subtle shift in the atmosphere that you're not able to articulate but that alerts you something has changed, and not for the better. Human communication is so sophisticated that we don't fully understand the signals our brains receive from others. Maybe it's a hitch in their breath, a twitch in their facial muscles, a minor tilt of the head, a lift in the eyebrows or a new heaviness in their tone.

I would tell you to focus on people's body language and facial

expressions so you can detect these nuances, but research shows that even when we pick up on such cues, most of us aren't very good at interpreting them. We tend to be overconfident in our ability to understand what a grimace means, or a smile, and we are quite prone to making mistakes when we try to read other people.

In one study, scientists found that a person's beliefs and experience can shape the way they interpret facial expressions. Our interpretation of emotions and the meaning of what someone is saying is significantly influenced by the race of the speaker.[1] Also, people sometimes use nonverbal expressions to mask their true feelings.[2] A 2008 experiment found that people were mostly successful when asked to conceal their reactions to images of strong emotion and were quite convincing when prompted to pretend they felt happiness.[3]

The social psychologist Michael Kraus also studies human expression and communication and says vocal cues are ultimately more important than body language when it comes to identifying another person's emotional state. "Facial expressions," Kraus writes, "can sometimes be inconsistent with internal states or used to actively dissemble."[4] That means the voice is the most accurate tool we have for correctly identifying someone's reaction to what we've said.

What's more, the research on facial expressions may not be capturing the full picture. For one thing, most research subjects are quite similar: they are mostly white, relatively young, and middle class or higher on the income scale.[5] We know that facial recognition gets more difficult when we're analyzing faces of people from a different race from our own,[6] and it makes sense that would hold true when it comes to recognizing the difference between anger and disgust.

For example, perhaps you tell someone that you didn't really like the movie *Black Panther*, and you see them frown a little while their eyebrows contract. You think, "They're upset that I don't like the

movie. I'd better explain that I didn't like the plot, and it had nothing to do with race at all. They're making a face, so I need to clarify that I'm not racist." What you may not realize is that when you mentioned *Black Panther*, they briefly remembered the night they went to see the film, when they locked their keys in their car and had to stand outside for a couple of hours waiting for help to arrive. That memory made them grimace, and your sudden protestations that you're not racist and you don't hate movies with Black people in them were overly defensive.

That's why it's important not to rely solely on your powers of observation, but to ask the other person to tell you if you've said something wrong. Keep in mind that people readily respond to requests for help and phrase it this way: "Can you help me with something? I'm trying to get better at communicating on racial issues and I would very much appreciate it if you let me know if I say something insensitive."

This strategy is excellent if your goal is to build your communication skills and avoid saying the wrong thing. Instead of pretending you know everything you need to know and that a mistake is tantamount to an admission of racism, you can accept that mistakes are inevitable, not catastrophic, and are golden opportunities to learn.

On the flip side, of course, this only works if you are as forgiving of others' mistakes as you ask them to be of yours. To be perfectly clear, I'm talking about mistakes someone may make over the course of your conversation, not forgiving something they may have done or said in the past. If you sit down to talk with a co-worker who's been racially insensitive, there should be no promise or expectation of forgiveness. That would require an acknowledgment of harm on their part and a commitment to change in the future.

However, the two of you can mutually agree to take note of the mistakes you might make while in discussion and give each other the benefit of the doubt. Essentially, you agree that you're both

entering the conversation in good faith, that you have a shared goal of increased understanding, and this mutual trust endures throughout the conversation and not necessarily beyond.

This is the kind of détente negotiators reach when they mediate a conversation between two warring parties, for example, attempting to establish a cease-fire. Creating an atmosphere in which both parties allow each other the benefit of the doubt is essential in order to defuse tensions and calm fears.

I have suggested this approach while advising people on discussions of race and have been told it's "impossible" because the other person has caused too much harm, is too stubborn, or would never agree to those terms. Yet, when they sat down together, both parties consented to set aside past differences at least for the duration of the conversation, and the discussions proceeded respectfully. Sometimes the story we tell ourselves in our heads is based on fear and not reality.

Obviously, if you point out that someone has said something insensitive and they respond negatively or defensively, it's okay to end the conversation. Mutual consideration is demonstrated by concern for the feelings of the other person. If they don't care about your feelings, if they have no concern for your reaction to what they say, there's not much point in prolonging the discussion.

The first step is to set an intention to react gracefully should someone make a mistake. Once you've done that, you can mentally prepare yourself to react in a healthy way should you mess up. Whether it's right or wrong, it's quite likely you'll say something at some point that the other person doesn't like. Perhaps you'll be tempted to lecture them and explain why they shouldn't be upset by what you've said. That's the wrong approach, as no one gets to decide what upsets someone else. As discussed earlier, you must accept what others tell you about their emotions and thoughts, resisting the impulse to judge those reactions.

You have a few options when you've said the wrong thing: keep talking, become defensive, or ask the other person to explain why they're upset so you can better understand how your comments have hurt them. I'm sure you can guess which option I suggest you choose. Only the latter allows you to continue the conversation, demonstrate consideration for the other person, and allow for the possibility of growth all at once.

The most crucial component of your response is immediate acknowledgment of the mistake. Even if they phrase their objection poorly—"That's racist!" or "You're a bully!"—deal with the complaint first before you take on the issue of how it was raised. If they were offended by something you said, apologize immediately and without excuses.

I talked in chapter 7 about switch tracking. It's the tendency to respond to a complaint by bringing up another, and it's a common method used to circumvent the need to apologize. I once heard the couple sitting behind me on a plane discussing their recent visit with family. The wife said, "I was so embarrassed when you told my brother-in-law how articulate he is. Don't you know that's racist when you say it to a Black person?"

The husband, instead of responding to her very specific (and accurate) point, said, "Well, you called my dad fat at dinner." She may have said that, but it's a distraction from the subject at hand: the husband's use of a word evoking the racial stereotype that Black people are less intelligent and so it's somehow surprising when they're smart and well-spoken.

It is not enjoyable when someone points out our flaws, but it's important to handle that feedback with maturity and grace. Keep in mind that, no matter how it's phrased, a correction can help you avoid making that mistake in the future. Own up to it. I've used many words in the past that I later discovered were inappropriate and possibly offensive, words like "gyp" (derived from "Gypsy,"

itself a pejorative for the Romani people), "Eskimo" (a word imposed on Native peoples of Alaska and other arctic regions), and "peanut gallery" (which originally referred to people, mostly Black, who sat in the cheap seats in a theater). It's humbling to be called out for using a racist term, but it's also far better to know that it's racist than to continue using it, unbeknownst. Whether you meant to hurt them or not, whether you realized you were saying something inappropriate or you didn't, it's best to accept responsibility for the error without excuses.

When someone points out that you've said something offensive, they are often saying that your remark has caused them pain. Blanket denial—"That wasn't racist"—is not a productive way to respond. Imagine you've accidentally kicked someone as you walked by. They say to you, "You kicked me." Would you respond by saying, "No, I didn't!" or "You shouldn't have been hurt by that. I barely touched you." Of course not (I hope). Most likely, even if you didn't realize that you did it, you would apologize. Saying you're sorry requires little effort and is the best way to handle accusations of racist language or phrasing. What does the apology cost you, anyway?

You can reflect on the exchange later. What was it, specifically, that caused the other person to react the way they did? Why are you still using terms like "colored" or "Eskimo"? Perhaps it would be just as easy to stop using them and avoid giving offense. It's also helpful to think carefully about the terms that people use that bother you.

We're all sensitive to something, and those sensitivities are unique to us, reflective of our experiences, our struggles, and our insecurities. Perhaps you don't mind comments about your weight but are irritated when someone uses the term "snowflake." Perhaps you found it offensive when Hillary Clinton referred to Trump supporters as "deplorables." If you know what it feels like to become angry or upset because someone used a racially or politically charged

term, then you can understand how others feel, even if you don't react negatively to the same things.

A few years back, I used the term "paddy wagon" in conversation at a conference in Massachusetts. One man in the group said, "That's actually a racist phrase and you might want to stop using it." I assure you that my first instinct was to say, "I wasn't using it in a racist way!" Instead, I paused for a moment to allow myself time to think and then thanked him.

I said I had no idea that phrase was offensive, asked him some questions, and learned that "paddy" is a slur once used to describe people from Ireland. Police vehicles were often called paddy wagons because of a widespread stereotype that Irish people were likely to be either criminals or policemen. It was an enlightening history lesson.

I talked about the challenge of recovering from error with Beverly Daniel Tatum, a psychologist, author, administrator, and race relations expert. She was the president of Spelman College from 2002 to 2015 and has moderated dozens of dialogues about bias and discrimination.

HEADLEE: What should someone do if they make a mistake during a conversation about race?
TATUM: It's okay to make a mistake. We all get misinformation, whether we want to or not. It's part of growing up. Any one of us can make a mistake, and knowing that levels the playing field.
HEADLEE: So how do we get through this minefield without blowing up?
TATUM: When I run workshops on race, I establish guidelines at the very beginning. One is that we're there to listen. Everyone must share the airtime, and no one should dominate without allowing space for others to talk. Two, there's a teacher and a learner in every seat. We can all learn from each other.

So if someone says something wrong, you can say you have a concern about what they said. Allow people to make mistakes, but also allow space for people to say they've been hurt by those mistakes. Errors are inevitable, so you have to have a plan for when they happen.

HEADLEE: Are there people who simply can't be reasoned with?

TATUM: Sometimes you get to that place, but you shouldn't start there. There may be people—you've been patient with them, you've really tried—but you just can't bear to listen to another minute of what comes out of their mouth. Maybe they use offensive language at the dinner table when your kids are around. It may come to that at some point, but your first reaction to an offensive comment shouldn't be to throw up your hands. People can make an informed choice about how to manage that situation if it persists.

HEADLEE: Can you give me an example of how you suggest I handle a conversation with someone I care about who says something offensive?

TATUM: Okay, let's say Susan has been isolating [because of concerns about COVID-19] all summer and now she's getting together with her family. The subject of Black Lives Matter protests comes up, and someone asks her why she would ever choose to join those marches.

Let's say Susan is talking to Uncle Joe. Uncle Joe is a Fox News watcher and is expressing all the things he's heard on Fox News, with which Susan disagrees. But this is her favorite uncle and she's loved him her whole life. So she says to him, "You know, there was a time I thought that, too. But I found out something new. I heard this new information." Or she might mention that she went to a protest and it was peaceful. "Now," Susan says, "I feel it's important to speak up when people use the language you just used, so I hope you can appreciate when I ask you not to use that language in front of my kids."

These conversations work best this way, when you can share a common identity. Then you can say, "I also grew up thinking that was okay and so I can understand where you're coming from."

I remember having that conversation with a man in one of my workshops who was using homophobic language. I told him . . . "When I was growing up I heard a lot of people saying things like that. I thought it was okay to say them, but then I found out that about twenty percent of people fall outside of the heterosexual norm. So we don't know who is gay and who isn't, even in our families. A lot of young people struggle with sexual identity, and I would never want to say or do something that might hurt one of my kids, not knowing what their orientation would be. I know you're a dad with kids. I found out this information and I decided it was important to model welcoming and inclusive language, to make people feel comfortable." He said, "I never thought about it like that," and he stopped the behavior.

You should never say "You're stupid" or "You're wrong." If one person wants to persuade the other person that their point of view is correct and so their portion of the discussion boils down to "You're wrong and here's why," that leads to defensiveness.

Instead, you want to tell them, "I have something in common with you." Now, you might eventually conclude that this is a topic best avoided with this person. But you don't have to start by writing them off. Or you might say, "I read this article that really changed my perspective, would you be willing to read it?"

HEADLEE: What would you say to encourage someone to try? To tell them to at least attempt to have the conversation about race?

TATUM: We spend a lot of our time learning not to talk about what's right in front of us. If you're encouraged not to discuss it, it takes a lot of energy to suppress your thoughts about those issues. So it can be freeing to discuss them. You can't solve a problem you can't talk about.

I can disagree with you in a civil way. I don't have to insult your personhood.

Often, acknowledging your error and saying you're sorry is as far as this exercise must go. Most of the time, the mistakes we make in conversation are minor and easily remedied. However, sometimes the harm is more significant and possibly lasting. Perhaps you made a comment that triggered memories of trauma or that belittled and disempowered a co-worker.

If you have caused damage with your words, you must apologize in a more meaningful way. Obviously, in moments such as these, it's imperative that you get it right. Fortunately, scientific research can help point us in the right direction. Extensive study has demonstrated that there are six main components to an effective apology[7]:

1. Expression of regret
2. Explanation of what went wrong
3. Acknowledgment of responsibility
4. Declaration of repentance
5. Offer of repair
6. Request for forgiveness

I have read many, many statements of apology issued by business leaders and public figures after they've said or done the wrong thing. Nearly all have included an expression of regret—"I feel terrible about this thing that I've done"—and a statement of repentance—"I know I was in the wrong and I won't ever do that again." There is almost always a request for forgiveness as well—"I hope you can pardon me so we can move forward with mutual respect."

Sadly, that's as far as most public apologies go. It's especially unfortunate because research shows these three components are the

least impactful of the six. In fact, when researchers have measured the effectiveness of these statements, the least important of all is the request for forgiveness. Why? Because you're asking something of the person you hurt. For that request to be heard as sincere, it needs to follow a full acknowledgment of responsibility in which you take the blame on your own shoulders and do not imply the victim was at fault in any way.

Acknowledgment of responsibility is the most important component of any apology, followed by an offer of repair. To mend the damage, you should be specific in describing what actions you'll take, instead of merely saying "I'll be better in the future." What, specifically, will you do? If the offer of repair is not precise, it is not measurable. And if it can't be measured or tracked, there is no way to hold you accountable for accomplishing it.

Often, when investigation reveals patterns of racial discrimination, companies issue statements like "We will make diversity a priority." What does that mean? How would we know if they achieve that? That kind of promise is empty and useless. It doesn't commit the company to any course of action, and the same is true of any apology that makes no specific guarantee of change or reparation.

A strong apology would sound something like this:

I'm very sorry that I called you angry and told the group you complain too much [expression of regret]. I understand now that saying these things about a woman of color not only plays into racial stereotypes but also encourages others to downplay your concerns [explanation of what went wrong]. It was a disrespectful and racist thing to say, and you were right to call me out [acknowledgment of responsibility]. I am sorry that I've hurt you, and I assure you that I will never say such things again [declaration of repentance]. I would also like to invite you to join me at the next senior managers'

meeting, if you're interested, so we can talk about the issues you've raised and discuss the right strategies for addressing them [offer of repair]. I value you as a colleague and hope you can pardon my mistake [request for forgiveness].

Once, when I had belittled a colleague during a news meeting, I wrote out my apology in advance, invited that person to lunch in order to discuss the incident, and then asked if I could read the apology to them. Apologizing in person is the most effective method, if your goal is to settle the issue and repair the relationship.

Many people like to apologize over email, but digital communication doesn't often lead to forgiveness because it doesn't stimulate the part of the brain associated with empathy and compassion. We default to email because it's easy and convenient and allows you to avoid speaking directly to the other person, yet it's the difficulty involved in an apology that gives it value. Use email or texting to set up a meeting or call, if necessary, but deliver your apology in person or on the phone. Allow the other person to hear the regret in your voice.

Up to now, we've talked about expressing regret because of something you've said that was offensive or hurtful. It's an entirely different matter, and much more serious, if you are accused of discriminatory *acts*, meaning that you have directly injured another person because of your prejudice. If, as a result of unconscious bias, you harmed someone unknowingly, you must apologize and attempt to make amends. It may take education and deep introspection, combined with establishing new protocols, to prevent you from making a similar error in the future.

However, if you knowingly discriminated against someone, or have discriminated in the past and failed to take substantive action to change your ways, you should be removed from power because you can't be trusted not to abuse that power. There is no way to

sugarcoat this: Discrimination is an abuse of power and it is disqualifying for leadership. What's more, while everyone should be afforded the right to employment, positions of power are a privilege. Attaining a high-level job doesn't entitle you to a similar rank for the rest of your life.

If an employee embezzles money and is fired, it's unlikely another employer will give them a job that involves oversight of finances. They've proven they cannot be trusted, and there is a real risk they'll again unlawfully mishandle their employer's money.

How ludicrous would it be, for example, for a bank to hire someone who's been convicted of embezzlement and promote them to customer account supervisor? Yet this is essentially the decision many corporations make when a leader has a history of discrimination and prejudice and is allowed to continue in their managerial position or is given yet another executive role.

When someone abuses power in a way that damages others, they have demonstrated they cannot be trusted with power over others. Their next job should be one in which they are supervised and not supervising, in which they are managed and not managing. They should not be placed in a position in which they again are able to make decisions that affect people, since they've proven they are willing to make those decisions based on personal biases.

If they embark on a journey of change, it should be possible for them to prove they are trustworthy and therefore deserve another chance at leadership. But remember, no one is entitled to a position of power. If you lose your job as a senator, you are perfectly welcome to take another job in another industry. If you lose your lucrative film deal or TV contract, you can earn a living just as the rest of us do, by applying for another position and proving you deserve the benefit of the doubt.

We should never hesitate to remove someone from power, especially political power, if they've proven they are willing to abuse

that power for racist (or sexist, ableist, ageist, etc.) reasons. I don't know about you, but I've lost jobs for far less serious reasons, and I was the only one worried about how I might support myself.

Apologies are important, but they cannot fix racism. Sometimes, an apology is not enough.

CHAPTER 12

TALKING ABOUT RACISM IN THE WORKPLACE

> Corporate diversity shouldn't be a goal. It should be the outcome of a fundamental shift in the DNA of a company.
>
> —TRAVIS MONTAQUE

When you move a conversation about race from a one-on-one setting into a group setting, the problems inherent in maintaining honest, open, and respectful lines of communication intensify. The stakes are higher, as social standing is at risk, and in some situations employment status may be on the line as well. The temptation to behave performatively, overly cognizant of the audience around you, can impair the ability to communicate authentically.

More important, there is an imperative involved in many group conversations about race. Whether they take place at a university, in a parent-teacher organization, or in the workplace, conversations like this are often a response to an unfortunate incident or an attempt to address racial inequalities within a group. These conversations are about problem-solving. That's both a blessing and a curse.

Problem-solving is difficult, no doubt, especially when the issue at hand is as personal and fraught as racial identity and inequality.

However, human beings are more likely to cooperate if they are solving a problem together. There is ample research to show that presenting two people with a puzzle is an effective strategy for encouraging teamwork.[1]

This is where group discussions must start: with a clear articulation of the problem at hand and a stated goal of finding solutions, not just airing grievances. Time and time again, I find that the most common responses to allegations of racism or discrimination is to ask people to attend an educational lecture or to schedule a listening session, during which people are encouraged to share their stories of disrespect and prejudice while leaders nod their heads with furrowed brows.

Research seems to indicate that watching videos doesn't accomplish much. After evaluating the effectiveness of this kind of training, a task force at the U.S. Equal Employment Opportunity Commission concluded that it's unlikely these programs, unless combined with other interventions, "will have a significant impact on changing employees' attitudes, and they may sometimes have the opposite effect."[2]

As to the listening sessions that seek to bring to light past injuries, these types of gatherings can be cathartic, under the right circumstances, but are generally counterproductive. Unless real changes are made as a result of what's said during the meeting, these discussions can increase cynicism and decrease morale. Many employees have told me, for example, that their managers force them to attend meetings like this so that leadership can "pretend to listen."

Race is difficult to talk about, and telling others about trauma you've experienced can be re-traumatizing. What's more, there's a fair amount of research on the psychological effects of venting, and the bottom line is that it doesn't unburden the mind, as we have long assumed it does.[3] Instead, a number of studies have found that complaining makes us feel worse, not better. One study from 2015 found

that complaining not only depressed people's mood in the short term but also increased the chances that they'd feel bad the next day and made it more difficult for people to put negative events behind them.[4]

In contrast, having positive, constructive conversations doesn't just make people feel better; it also makes their brains work better. One researcher has found that asking people to think about a happy moment in their lives increased their accuracy on cognitive tests.[5] And, according to Stanford professor of psychiatry Vinod Menon, having a positive attitude toward learning "results in enhanced memory and more efficient engagement of the brain's problem-solving capacities."[6]

Venting sessions may feel good for a fleeting moment, as though you are letting off steam, but that feeling doesn't last. We know that temporary mollification doesn't create real opportunities for change. If you plan to ask people to take a risk and discuss race and oppression in a group setting, you must have a clear goal. You must offer something in return. Often leaders will view the opportunity to talk about inequality as a benefit in and of itself, as though they're doing people a favor by allowing them to discuss racism. The truth is quite the opposite: You are asking people to do *you* the favor of articulating their experiences of mistreatment and prejudice. They are giving you the gift of their honesty, and it's only fair you repay their trust with serious consideration and follow-up action.

Inclusivity seems like a value and an action that should come to us naturally, but accepting people who are not like us is a learned behavior. This is because humans are inherently tribal; we naturally seek to engage with people who are similar to ourselves in both appearance and behavior. For most of our lives, we've been taught to exclude: to assign ranks and exact a price for those who do not fit into a previously established culture. We have been taught that the way things are is the way they should be, and those who don't accept and adopt existing norms are wrong.

Companies and institutions often say they value diversity and inclusion, but their actions rarely substantiate their stated values. That's at least partly because before an organization becomes inclusive, it must initiate a disruptive revision of the organization's culture, and that sparks a lot of difficult conversations about how many norms are based on the desire for a homogenous workplace identity. As the cognitive psychologist Art Markman wrote in 2019, "People must be able to bring their authentic selves to work. That doesn't mean they need to feel comfortable in their work at all times, but their discomfort shouldn't stem from who they are."[7]

To gain more insight into why so many companies struggle to diversify their workforces and retain BIPOC talent, I spoke with Cindy Gallop. Cindy is a business consultant and career coach. She is the founder of two tech companies, IfWeRanTheWorld and MakeLoveNotPorn, and she is often called in to advise leaders on issues of diversity and, as she puts it, redesign company processes "to integrate equality, diversity and inclusion as key drivers of growth, profitability and better business outcomes."

HEADLEE: Why is it so difficult for corporate leaders to have authentic conversations about diversity with their staffs?

GALLOP: Part of it is that they're still talking about diversity and inclusion. There shouldn't be DNI [diversity and inclusion] departments or DNI initiatives.* Those values need to be baked into the DNA of an organization. It's ridiculous to pretend that diversity is

* There are a number of acronyms used to describe initiatives focused on antiracism. DNI translates to "Diversity and Inclusion." DEI stands for Diversity, Equity, and Inclusion. Some choose to use the term "DEAI", which stands for Diversity, Equity, Access, and Inclusion.

something we do during a workshop and then we get back to our regular business.

I recommend companies stop talking about diversity altogether. That's because research has shown that it's fundamental human nature to believe that when you do good in one area, it's fine to do bad in another. The everyday example is "I had a Diet Coke, so now I can eat a bag of chips." When people think they're doing something good for diversity in a training session or a retreat or something, they're then protected from accusations of racism. "Oh, we've got diversity taken care of over there, so I can carry on behaving just as I always have."

Diversity is not something you talk about; it's something that happens because you've taken the right steps when you hire people and promote them. Inclusion happens because you've created a culture at your company that is welcoming to all kinds of people and that embraces differences.

HEADLEE: Is that why you say that companies should stop hiring people of color to run their DEI [diversity, equity, and inclusion] programs?

GALLOP: Listen, a Black person will take that job if that's all you're offering. But they'd much rather be the CFO or the CEO. It's so predictable that you'll look at the leadership of a company and see that it's all white people, mostly men, and they have one Black person on the leadership team and he or she is the chief diversity officer.

HEADLEE: I can imagine someone saying that it's problematic to hire a white person to oversee diversity at a company.

GALLOP: It is problematic because you shouldn't need a chief diversity officer at all. If you need someone in that position, you've failed to create a business where women and people of color are valued. But also, it's about time that white people step up and do the work on racism that they've left to Black people for so long.

Black people are sick to death of having to educate white people about how hard it is to survive in a racist system. White people should be talking about this all the time. It should be discussed at every board meeting, at every conference, at every business lunch. And at home, too! White people should be talking about racism all the time and talking very specifically about what they're doing to end it. Stop trying to figure out how to talk to Black people about race and start talking to your own friends and family. Black people are tired of talking about it.

HEADLEE: You are half Chinese. Have you had difficult conversations about your own race?

GALLOP: Conversations about race don't have to be difficult. And I also think it's my responsibility to talk about this whenever I can. Every non-Black person should be focused on ending racism. You know, leaders sometimes create space for employees to discuss racial issues and then they go on with their lives the next day. You can't just discuss discrimination without also talking about what you're going to do—you, specifically—to help combat it.

Don't start that conversation with your team until you've done some of the work, until you've redesigned your hiring system to attract women and people of color, until you've redesigned your promotional system to make sure you're putting Black people into executive roles. It's not enough to say that you value diversity and you're not racist. You need to be anti-racist.

HEADLEE: But there are people who are upset by discussions about diversity and who think that it's threatening to them. They feel angry, or that people of color are demanding jobs, demanding promotions.

GALLOP: I've had enough of that line of bullshit. It's just nonsense. People who think that valuing the talent of Black people equals their losing power should be invited to leave the organization. Everyone has to be focused on creating an anti-racist organization, because it

requires that kind of focus and energy. Our entire society is built on racism and prejudice. It's everywhere, in the very fabric of our society. It will require a massive effort from all sides to break it down. That's what is needed.

As Cindy Gallop says, an organization that hopes to be truly inclusive must link inclusivity to specific policies. Leaders must recognize the inherent hypocrisy in issuing statements of support for diversity measures while maintaining a board that is largely white, or in touting diversity numbers but failing to mention that most of the workers of color occupy positions of limited power and influence. These issues are often "unspoken" in institutions, meaning people are speaking about them frequently but not publicly.

It's critical that group conversations about race take place only when there is a sincere organizational appetite for reform. It's not acceptable to make people endure what can be an upsetting exercise for no reason. Conversation in group settings is rarely therapeutic, unless it's led by a trained therapist under controlled circumstances. Your goal in these situations is problem-solving, so stating the problem is the first challenge and must be accomplished before the group conversation begins.

As you prepare for such a discussion, I want you to reconsider the nature of diversity, framing it more as a skill than a value. Learning to embrace diversity is about learning to value difference as an asset and to work alongside others without conflict or prejudice. It's about creating a team in which everyone is supported, heard, and afforded the same opportunities for success and growth. Designing a healthy environment for everyone, regardless of color, religion, sexual orientation, gender identity, or ability, is at heart about fostering an environment for healthy teamwork.

Please note that embracing diversity has nothing to do with enjoyment. You don't have to like people who are different from you

in order to include them; you simply must respect them and not obstruct them. Research shows no real correlation between whether people like each other and the collective intelligence of a group.[8]

There are some hard truths to face over the course of this work. We naturally prefer to be members of a group of people who resemble us, with similar backgrounds and interests and abilities. We like it when people agree with us (yet we do better work when they don't). A team that is relatively homogenous will likely feel relaxed, but reams of research show a team that's chummy is probably less efficient than a heterogeneous team that isn't so cozy. The people who are most like you don't usually expose you to new ideas because they have the same basic experiences you do. Comfort is the enemy of innovation, and that's especially true when it comes to team problem-solving. Remember the study mentioned in chapter 3, in which teams were asked to solve murder mysteries, and the resulting experiment demonstrated the value of diversity within a group? That and other research suggests a simple conclusion: pairing with people who are different from ourselves can lead us to work more carefully and creatively, partly because when we are paired with people who are similar to us, we assume we all have the same information and perspective. We may not enjoy diversity, but it makes us better.

For years, the prevailing assumption was that when team members get along, when they share interests and enjoy hanging out together, they are more productive and creative, but the truth is often the opposite. In fact, research shows that too much cohesiveness, too much unity, within a group leads to the suppression of dissent.[9] People are wary of voicing objections because they don't want to cause conflict and disturb the friendly atmosphere of the team.

This is likely why centuries of study have conclusively proven that diverse groups of people are generally smarter than even the smartest expert. Heterogeneous groups are more accurate, less error-

prone, and more creative than experienced, intelligent specialists.[10] But that kind of environment is less comfortable and less pleasant, so in order to make it work, it's crucial that team members are highly skilled in communication and in talking through differences in a productive way.

We have handled our conversations about diversity badly in the past. We've structured them under the assumption that resistance to diversity is a knowledge problem, that we can educate people so they better understand the harm caused by racism and sexism, and that understanding will change their behavior. But that's not how change works.

There simply isn't much evidence that standard training in diversity and inclusion is effective in changing someone's core values or influencing their future decisions. (Although these programs aren't cheap. In 2015 alone, Google committed to spending $150 million on diversity programs,[11] and the most recent estimate available suggests that American companies spend at least $8 billion a year on diversity, equity, and inclusion training.[12]) The attorney Cyrus Mehri, who helped the NFL craft the Rooney Rule, which requires teams to include non-whites among candidates for coaching jobs, says, "Everybody is quick to do unconscious bias training and not interventions. When you keep choosing the options on the menu that don't create change, you're purposely not creating change."[13]

The psychologist Elizabeth Levy Paluck and the political scientist Donald Green carried out a rigorous review of nearly a thousand studies of diversity and inclusion initiatives. They found little evidence that these programs reduce prejudice. In fact, they found that many types of training programs—morality-based, cultural competency, and others—have never been tested to determine whether they're effective or not.[14]

In some instances, standard diversity training makes people *more* prone to behave in a discriminatory way, partly because they think

the training has inoculated them from allegations of racism. In fact, an analysis of more than eight hundred companies showed that firms that used traditional methods to increase diversity—training programs, performance ratings, grievance systems—saw a *drop* in the percentage of BIPOC in management roles.[15] Instead of creating substantial change in the systems that prevent people of color from succeeding, many diversity initiatives are designed to protect companies from liability in legal action.

The tactics that have been proven to be effective—targeted recruiting, robust mentoring programs, and empowered task forces—are focused on reforming policies and practices, rather than simply relaying information. We don't need to give people more information; we need to train them in new skills. As Iris Bohnet wrote in her 2016 book, *What Works: Gender Equality by Design*, "Maybe the pathway to behavioral change is not a change in individual beliefs but instead a change in the socially shared definitions of appropriate behavior."[16] Organizations that want to build an inclusive environment must define the change they want, implement new policies designed to bring that change about, and then objectively evaluate the results to ensure that the reforms are accomplishing what they're intended to accomplish.

We have known for a very long time, by the way, that the solution to racism was not more information. In June 1935, W. E. B. Du Bois wrote this: "For many years it was the theory of most Negro leaders . . . that white America did not know of or realize the continuing plight of the Negro. Accordingly, for the last two decades, we have striven by book and periodical, by speech and appeal, by various methods of agitation, to put the essential facts before the American people. Today there can be no doubt that Americans know the facts; and yet they remain for the most part indifferent and unmoved."[17]

This point was frequently hammered home by the educator Jane Elliott, made famous by her "blue eyes/brown eyes" experiment,

carried out in her third-grade classroom beginning in April 1968, the day after Martin Luther King Jr. was assassinated. Elliott divided her students into groups according to eye color and then told them brown-eyed people are smarter and nicer than blue-eyed. Kids with dark eyes were allowed to spend more time at recess and were put ahead of the others in the lunch line. On the second day of her experiment, Elliott reversed the roles: blue-eyed children were praised and given preferential treatment while the brown-eyed kids were purposely made to feel inferior. She was astonished by how well her manipulation worked. Whichever group was in favor began to treat the other children cruelly and to discriminate against those whose eyes were a different color.

In a speech she delivered in the 1990s to a largely white audience, Elliott asked people to stand if they wanted to be treated the same way that Black people are treated in society. When no one stands, Elliott says, "That says very plainly that you know what's happening, you know you don't want it for you. I want to know why you are so willing to accept it or allow it to happen for others."[18]

Even if an organization publicly sets an agenda committed to diversity and expresses its intent to enforce that agenda, it may be nearly impossible for people to comply. That's because most of the time, people base their actions more on instinct than on thought. While they may consciously agree that racial preferences are wrong, many of their choices are based on long-held, subconscious beliefs. As mentioned earlier, most of our thoughts are not within conscious control.

Therefore, if our goal is better, more equitable decisions, we must enter the decision timeline not at the moment when a thought arises, but when that thought is expressed as action. If you change the policies that govern work relationships, change the consequences for racist actions, then you need never concern yourself with core values. For example, most workplace policies about issues like

attendance or dress code are changed without much explanation or discussions of values. I suppose you could invite an expert to explain the history of the business suit and why it's traditionally the most appropriate attire for a law firm, but we don't bother doing it because it doesn't really matter what your opinion is on the matter. The dress code is the dress code. Somehow, regardless of their core beliefs, people generally comply. While issues of equity and bias are far more complicated than issues of clothing, the same principle can be true of policies on racism.

To change behavior and ultimately change the conversation about race, we must design new "cognitive software," new processes drawn from current research in behavioral science. First, increase observation and situational awareness in the workplace. Look around you and take note of the atmosphere, of how people feel, of the level of tension during meetings. Talk with colleagues about their perceptions of the organization's culture. According to research, there are three indicators that can point to a toxic workplace:

1. People feel pressured to "cover" aspects of their personality in order to fit in.
2. Hypercompetitiveness is tolerated or even rewarded, while burnout is common.
3. People are pressured to work long hours.

If any of these three forces are present in your organization, you have a good place to start your discussion, focused on the goal of solving that specific problem. Over the course of the ensuing discussion, people may share stories that are critical of leadership, but keep in mind that honesty is a gift, not a punishment.

Your aim is to structure conversations so that you can create a set of rules that allows the same latitude and support to all members. The idea is not to create consensus, but to encourage people

to maintain their individuality while embracing difference. This sounds simple, but it is quite difficult to achieve. It's not surprising that we don't play well together, in general. During all the years of our schooling, we are conditioned to go it alone, to work alone, to be graded and rewarded alone. In a system focused on individual success, we have little training in group work.

Do you remember being forced to work on a joint project with a classmate? I'm not sure how that went for you, but I dreaded those assignments. Maybe you were like me and you simply did the project by yourself and let the other kid share in your A grade. Even in college, we are educated as individuals, and then we're dumped into the workplace, where we're immediately supposed to know how to function in a team. That's simply not fair. It takes education and practice to work with others successfully, and most of us don't get adequate preparation.

Therefore, the next skill necessary in an inclusive organization is collaborative problem-solving. Here again, many adults are not naturally gifted. In fact, the product designer Peter Skillman has noted that kindergarten graduates generally outperform MBAs on what he calls the Design Challenge, or the Spaghetti Tower, in which teams must use dry spaghetti, tape, and string to build the tallest structure possible that will support a marshmallow on top. Kids are used to playing together; adults are not.[19]

We tend to want to do things ourselves; we don't trust other people. Culturally, we idolize solitary geniuses. We often prefer to work alone, but that's not the best way to work. So we must learn how to function together. Instead of emphasizing individual achievement, we must create structures and systems that force people to rely on one another and reward high-functioning teams. To encourage healthy conversation across racial boundaries, organizations should train members in transactivity.

The word "transactive" comes from the same root as "transaction."

It means an exchange of information and tasks: I receive from you at the same time that I'm giving to you. Transactivity within teams is the ultimate predictor of success, even if the teams are diverse. Transactive memory, for example, occurs when we disperse information across a group of people, rather than expecting everyone to know everything. It's incredibly inefficient to ask that every member of a team memorize the same set of facts or be able to carry out the same tasks. Through transactive memory, we can store information in other people or other things.

We all move up and down a spectrum of memory, between internally and externally stored knowledge. It's natural to think of externally stored knowledge as the information we keep in a spreadsheet or a book, but it can also live inside someone else's mind. In fact, when we make use of transactive memory, it pushes people to have more conversations in order to consult one another's internally stored knowledge. Perhaps one person knows how to reorder coffee beans for the breakroom. If you want more coffee, you simply speak with that person, eliminating the need to dedicate any cognitive space to storing that information yourself.

Our educational system is biased toward people who store a lot of knowledge internally and can therefore perform well on a closed test like the SAT. Yet, in a group environment, like a standard workplace, the transactive group will win. Most work is a team sport, so systems that lighten the cognitive load on individuals by encouraging transactive memory create a larger library of shared knowledge.

Essentially, the key to improving conversations within groups is to make those conversations mandatory. If cooperation is obligatory to accomplish a job, people will become better collaborators. This is true within individual teams, and equally true throughout the organization. People will look past their differences in order to succeed within the group.

To embed diversity into a group's culture, organizations must dis-

courage tribalism and isolation whenever possible. Therefore, the next skill to teach people is cross-silo communication and collaboration. Each department or team within an organization is a silo. Often, the groups within those silos try to become as self-sufficient as possible in order to avoid having to deal with other departments. Yet research shows that companies that encourage workers to venture outside their silos see higher margins and more customer loyalty. At one pharmaceutical company, sales increased by 10 percent when interactions among co-workers on other teams rose by 10 percent.[20]

Tribalism within an organization can often lead to an increase in racism or discrimination. Yet separating "us" from "them" is quite natural. Research shows that all of us tend to believe we've struggled more and come up against more obstacles than others have.[21] We can readily remember hardships we've endured but find it difficult to think of what others have gone through.

In workplaces, for example, we are generally aware of information technology problems we're experiencing, but unaware of tech problems plaguing other departments. The same goes for scheduling issues, resources, and many other things. As a result, we think carrying out basic duties is harder for us than it is for others. To break through that bias, we must remind ourselves regularly that things are probably as tough for our co-workers as they are for us. That's easier to do if you listen to others talk about how they go about their jobs.

Therefore, try making exploration a component of every worker's job description. For example, how much do people know about the capabilities of other teams? What are their goals and what special expertise do their team members have? Perhaps one team includes an expert on social media who can spend a small amount of time working with other teams, instead of having each department hire their own expert. Instead of creating tiny, self-sufficient kingdoms, leaders should encourage colleagues to tear down the walls.

Create opportunities for teams to share space, equipment, talent, and resources.

Analysis of behavior at corporations, schools, and hospitals has generated a short list of strategic actions that encourage horizontal rather than vertical teamwork. The first is to hire and develop people who are good at bridging divides. Recruiting for these people relieves a great deal of pressure on leadership, as they will be less wary of difficult conversations and more willing to discuss sensitive subjects without prompting. Second, create a culture of asking questions. It's common for leaders to view pushback on policies and procedures as criticism and then respond defensively. This will ultimately shut down communication, making it less likely that people will bring new ideas and critical analysis to the table. Instead, make pushback a normal part of business, setting aside time and even soliciting critique from team members.[22]

It's quite common for managers to *state* that they want to receive feedback from workers, but much less common for that feedback to be seriously considered or respected. In fact, negative feedback is often handled in such a way as to discourage people from reporting on problems within the organization. This is often known as "organizational silence," and it can be detrimental to a team's morale.

One last strategy for encouraging conversation and collaboration across boundaries is to force people to consider ideas from outside their silos. This simply means that, when brainstorming, groups should not just bring their own suggestions to the table but also solicit ideas from people outside the department and even outside the organization.

Of course, encouraging teamwork and cross-boundary collaboration will not, on its own, make an organization fair and inclusive. This work always brings us back to honest and productive conversation and, to foster that kind of communication, it's crucial that leaders open the floor to all topics without, through explicit instruction

or implication, labeling some issues as too sensitive to discuss. I'm not referring to people's personal lives, of course, but workplace-related topics that people whisper about on coffee breaks.

In other words, leaders should root out any "undiscussables." When reporting and feedback are discouraged through behavior, if not stated policy, you can end up with a long list of undiscussables. Researchers at the IMD Business School say, "Undiscussables exist because they help people avoid short-term conflicts, threats, and embarrassment. But they also short-circuit the inquiries and challenges essential to both improving performance and promoting team learning."[23]

If there are issues with inequality and racial harassment within an organization, it's likely they are on the undiscussable list. Keep in mind that while issues like this may not be discussed openly, people are still talking about them. The conversations are happening, and it's more beneficial for everyone in an organization to make space for them and bring them out into the open rather than let them fester and slowly spread.

The mere fact that undiscussables exist at an organization is a red flag, as it means there are significant matters people are simply too afraid to share publicly. Often, managers overestimate the risk involved in talking about issues of inequity, toxic culture, preferential treatment, or discrimination. Perhaps they mistakenly believe public discussion will increase resentment and lower morale, but the impact of these discussions is generally positive, if they're structured in the right way.

When researchers force workers to discuss the undiscussables, there is often a sense of shared relief. Having a forum in which to share one's experience without fear of retribution tends to boost energy levels. One method for sparking these kinds of conversations is to ask people to fill in the blanks in the following sentence: "We say we want to _____, but we actually _____." Or simply ask,

"In what ways are we living up to our values? In what ways are we falling short?"

The way that leaders respond to feedback predicts how honest and valuable future feedback will be. I've often seen managers make the mistake of receiving valuable feedback and choosing to ignore it. In one instance, I wanted to communicate to my CEO that a particular manager was not well-suited for their position. I spent two weeks collecting evaluations of that manager from various members of the team and then created a report that I presented to the CEO. She told me that I wasn't seeing the full picture, asked if my objections might be rooted in personal dislike, and then thanked me for my time and sent me on my way. Not only did that response discourage me from offering feedback in the future, but it also sent a clear message that workers' opinions were neither valued nor welcome. Yet this was a CEO who prided herself on having an open-door policy. The door to her office may have remained open, but access to influence was not.

Discouraging communication between leaders and team members can have terrible consequences. Think of all the headline-grabbing stories about racism at large corporations. What if leaders at those companies had encouraged workers to report such issues and took the reports seriously? I often wonder how leaders can be surprised when rampant discrimination is made public at their institution; were they not encouraging people to report such incidents, or were they not listening?

Ultimately, there should be no unwritten rules within any organization. Team members should be encouraged to articulate what they feel are the rules and the undiscussables. What are the norms within the group? What do people believe is the best way to be promoted, for example, or the surest path to termination or expulsion? Until there is agreement on what the rules are, it's impossible to change them.

It's also important to consider the environment in which these conversations—both formal and informal—take place. Research shows that workplaces where people naturally interact with one another—passing co-workers in hallways or standing together at the coffee machine or copier—see increases in performance. Some years ago, researchers at MIT had the workers at a software company wear electronic sensors for weeks.[24] These sensors allowed them to track communication patterns by recording interactions, tone of voice, and even body language.

While leaders at the company thought they could encourage social exchanges by hosting cocktail parties and other social events, the collected data showed that "these events had little or no effect." Instead, a much simpler change brought better results: adding longer lunch tables to the cafeteria so that workers were forced to sit together.

In another, similar study, one company expanded its cafeteria and removed the coffee machines from individual departments so that people were forced to meet one another when they sought caffeination. As a result, sales rose by 20 percent.[25] That company, Boehringer Ingelheim, also launched a lunch roulette program in which workers were randomly paired to have lunch together.

Working environments have undergone radical changes in recent years, with a move toward fewer traditional offices and more shared spaces. Often, these changes are implemented in order to encourage conversation and collaboration that could, in turn, make offices more friendly and welcoming to all employees.

As offices have evolved, co-working has become a popular research subject in recent years. The findings, so far, make a compelling case for abandoning the old structures of the workplace. In one study, fifteen hundred people from fifty-two different countries were surveyed before and after switching to a co-working environment. In organizations where co-working was not just encouraged

but also systematized, productivity increased by 75 percent and perceived isolation fell by 83 percent.

Diversity is a skill that can be taught and learned, and a crucial component of that training is increasing the chances that informal but essential conversations—ones that encourage diverse groups of employees to connect with one another—will occur. Designing an environment that creates collisions and community and discourages isolation is one way to do this, though the potency of the environment doesn't end with its architecture. For any workplace to encourage such communication, it must also foster a safe and respectful culture.

It should be said that these conversations are not easy; at times, they might even be painful. For generations, people of color have suppressed their thoughts and instinctive reactions in order to keep the peace, keep their jobs, and avoid conflicts in which they usually have more to lose than others do. If white people are truly invested in having these conversations and becoming anti-racist, they will ultimately have to carry some of the emotional burden that people of color have carried for so long. Making the world a safe and comfortable place for white people is how we got to the place we're in now, surrounded by racial inequity, hatred, and violence. As painful as it is, this work must be done.

IN CLOSING: GOOD LUCK

> Prejudice is a mist, which in our journey through the world often dims the brightest and obscures the best of all the good and glorious objects that meet us on our way.
>
> —ANTHONY ASHLEY COOPER, THIRD EARL OF SHAFTESBURY

Racism is a form of binary thinking: this group is good, beautiful, smart, and deserving while this other group is bad, ugly, stupid, and lazy. You can discern the difference, racism tells us, by the color of the skin: the darker the skin, the more bestial the creature. Binary thinking also helps establish a world order in which some are disadvantaged from birth. The French philosopher Hélène Cixous is one of many who argue that binary thinking leads inevitably to discrimination, as establishing polar opposites invariably places one above the other.[1] Whether intentionally or not, binary thinking creates a dominant side and a submissive one, a privileged and a disadvantaged.

Because it simplifies what is complex and appears to make clear what is murky, binary thinking is seductive. We cheer when the movie hero punches a Nazi because there is no gray area there: punching a Nazi is always a good choice. Separating people into good and bad makes it easy to know whom to support, whom to

revile. We search for dichotomies in everything, even our diet, yearning to be told what food is healthy and what is not, becoming frustrated when doctors tell us that nothing is either good or bad. "All things in moderation" is not a particularly exciting motto.

In recent years, we have become even more enamored of our black-and-white fantasy world. We now try to fit everything and everyone into an us-versus-them narrative. One of my favorite authors, N. K. Jemisin, was musing about this trend on Twitter, saying there is now "a kind of rigidity that's become more widespread."[2]

She cited the Perry scheme, an outline of how students evolve to understand knowledge, moving from a stage in which they believe what they're told by trusted authority figures, through a period in which they come to accept that everyone has a right to their own opinions, eventually coming to realize that, while they have their own values, they are open to learning from others.

Many of us are not at that stage, however. We are attached to the belief that people are good or bad, racist or not, worth speaking to or not worthy of acknowledging. "Moral relativism," the idea that moral judgments are neither absolute nor universal, is a foul term, and even a hint of it will earn vilification on social media. As a global society, we can't seem to break away from the idea that flaws are intolerable. Jemisin called it "arrested development on a societal level."[3]

Binary thinking in relation to human beings can only persist in the absence of knowledge. In other words, if you get to know someone, it becomes impossible to see them as either hero or villain. As we learn about people, we understand them as nuanced and complicated and flawed. Connection is the antidote to binary thinking.

At this moment in our society, "racist" has become synonymous with "sociopath." If you are racist, you cannot possibly do or say anything good. But history debunks that theory. There are many examples of people who were racist or sexist and yet produced

admirable work or contributed to the progress of humankind in other ways.

Again, I am not justifying racism or sexism or making excuses for people who harbor bigotry in any form. I am simply saying that being racist does not make you inhuman. Sadly, racism is all *too* human, and that's a much more difficult truth to swallow than to believe that all racists are monsters.

No one is free from the stain of racism; we are all subject to the systemic discrimination that's embedded in our governments and schools and workplaces. We absorb racism through our pores, inhale it into our lungs, and swallow it with our water. Discrimination based on skin color is the standard and has been for centuries. And we cannot see the full picture of racism's deadly impact without including the view from the other side. We are all, at times, victims or heritors; some are perpetrators in one space and targets in another.

We must talk to one another if we are to have any prayer of ending this hatred. We can't change anything without naming it, without acknowledging it. It is not too dangerous to talk about race; it *is* too dangerous to remain quiet on the subject.

In some cases, your conversation about race will amount to two minutes of chat with a neighbor, or a few sentences exchanged over the dinner table with your aunt. You probably think a few words about oppression won't change the world, and you're right. But we cannot bring about big change without small change. Revolutions begin when individuals make new choices. Your conversations don't have to be life-altering; they can be mundane and even boring. In the end, anti-racism is not overly complicated. As the tech CEO Travis Montaque said, "Black people just want to be equal and normal. I want to be equal and normal."[4]

The Chinese philosopher Lao Tzu tells us that a journey of a thousand miles starts beneath one's feet or, as the saying often goes, with a single step (another erroneously attributed saying, commonly

ascribed to Confucius). This is particularly true of conversations about race. One discussion may not change anyone's mind, but a series of honest encounters might, and that series must begin somewhere.

One benefit of looking the way I do is that people are unsure what my background is but are usually willing to assume I'm part of their clan. They therefore feel comfortable telling me things they wouldn't if they knew I'm Black and Jewish. Ironically, this is also a major drawback to looking the way I do. While I hear many things that are upsetting and hurtful, I also have a solid understanding of other people's views on race, since they so often feel safe expressing those views in my presence.

If your goal is real change and tangible progress, you must prepare yourself to hear uncomfortable things. If that is too painful for you, it's possible that substantive discussions on this subject will be beyond your endurance.

"Why are you engaging in this conversation about race?" asks Bayard Love, formerly of the International Civil Rights Center & Museum, in Greensboro, North Carolina. "If it's just curiosity, a pet project, a desire to 'fit in' or not look silly, or to feel less guilty, you might want to reconsider. If you are ready to be part of change, and you want to understand racism better so that you can be a part of that change, then come on!"[5] Many people say you must "lean into the discomfort." That often means letting go of ego and making yourself vulnerable to distress.

Conversations about race are only easy when you're talking to someone who agrees with you on just about everything. Those kinds of discussions are important. They can serve as a release valve, an opportunity to express frustration or hope or confusion and receive only support and understanding in return. But while they might make you feel better, they won't teach you anything.

I have traveled all around the country and spoken about issues

of race and inequity with hundreds of people from all walks of life, various backgrounds, widely divergent philosophies. I can assure you that having the conversation with someone who disagrees is more than possible. It's also rewarding, and it's necessary.

Our democracy teeters on a knife's edge. For centuries, we have chosen to avoid conflict by not engaging with issues of race, by walking away from discussions when disagreements arise, by shouting down opposition and shaming those who have arrived at different answers to life's important questions. The divisions that have plagued this nation since its inception have been undiscussable for far too long.

I hope we can recognize that elections don't solve this problem. The same divisions that led to record polarization endure after elections are over. We will have to learn to talk with one another. We will have to learn to stop isolating ourselves, hoping to be protected from opinions that are opposed to our own. We have reached a critical moment in our history.

I believe that recent protests could be a catalyst for real change. But we must be careful about what kind of change we get. If we continue to barricade ourselves behind walls, gathering our likeminded clan around us, and throwing rocks at everyone else, then the change will be toward further divisiveness, increased anger, and the breakdown of our social systems.

But if we can find empathy, if we can understand one another better, this could be a positive turning point for us. It could be the beginning of a new era. Many people are searching for hope, and I assure you, you will find that hope in other human beings. People are better than you assume. They are more than stereotypes. You will rediscover inspiration and optimism and confidence in other people, but you must see them as people, and you must hear them out.

The author Ijeoma Oluo told NPR in a 2020 interview: "I really wish that my white friends would sit down with their white parents

and all of their white community members and start talking about the real power that they have as individuals in their communities, in their workplaces, in their stores and say, 'I think we all want a world where black people feel safe. Where they have just as much access to opportunity. So, what can we do together?'"[6]

Perhaps we can at least all agree that people should feel safe while going about their daily lives and then begin the discussion on how to achieve that. The discussion will not progress, though, until we learn how to talk about race honestly and with empathy even for those who are wrong.

In 2020, I was asked to participate in a project called Artists-in-Presidents led by artist Constance Hockaday, in partnership with UCLA's Center for the Art of Performance. The goal was to embrace Franklin Delano Roosevelt's tradition of the fireside chat and to update it using a broad array of voices.

Here, in its entirety, is my submission. This is my message not just to Americans but to all citizens of the world:

My fellow citizens, my friends, I know we're having trouble talking with each other. I know we don't like each other. I know we don't trust each other.

I want to tell you about a conversation I had with a friend recently. My friend told me that he may have to cut ties with two of his buddies. He said their views on the Black Lives Matter movement are wrong and you can't compromise when it comes to civil rights.

He said, When I watched George Floyd die right after seeing Ahmaud Arbery get murdered in the street, something snapped inside of me. I suddenly realized that I had been looking and not seeing the world around me. Like when you're pregnant and you suddenly see babies everywhere. At that moment, I felt I finally understood oppression and all at once, I saw it everywhere. My two

buddies don't get that at all, so I might have to let those friendships go.

And I said, You know, I wasn't raised to be an activist either. I hated politics as a young person. I don't even remember what it was that opened my eyes, but there came a time when I, too, had an aha moment. I was struck with radical understanding. I had seen through a glass darkly, but suddenly, face-to-face.

Everything changed for me, much like it did for you. It could well be that your friends haven't had their moment yet. They are still looking through that dark glass and everything is distorted and unclear. If you walk away, if you isolate them and leave them to talk only with others who are looking through that same smudged glass, they may come to believe that view is normal.

They and the people around them will simply think the world looks muddy and partially obscured, and scary and dark.

Or they could spend time with you, with someone whose window is so clean that the glass disappears, and you see the mountains beyond. They'll say the whole world is shadowed and scary. You'll say, But I see sunlight and meadows and trees. They may want a peek out of your window.

The truth is, none of your arguments or statistics or data will change their mind, however well-articulated they are, but the beautiful view out of your window is so much more tempting. It was not a compelling piece of evidence that opened my eyes, but the distillation of years of observation and experience that coalesced into one moment of clarity.

It's true that some people will never change. But so many others are just waiting for their moment. You might want to hang around so you can be there when the moment arrives. You don't have to support their worldview. You can actively work against it. But you don't have to abandon them to darkness.

Thank you, and good luck.[7]

So many speeches end with that simple blessing—good luck. The phrase doesn't just convey hopes for success. It also has a more informal meaning, a slightly sarcastic one in which someone acknowledges how difficult the task is that you face, and by wishing you good fortune, clearly conveys that the odds are stacked against you.

What you're trying to do isn't easy; it may be one of the most difficult tasks you will ever take on. But the fate of society rests in our collective hands. We can choose whether to embrace honesty and authenticity, whether to face the ugliness of our history, or to turn away, as we've done for centuries.

Don't be afraid! These conversations can be wonderful and enlightening, as they are a very real statement of optimism. To talk about race in a productive and constructive way is to hold tight to a belief that racism can be faced and defeated. We can do this, one conversation at a time.

I wish you patience and joy in discovery. Good luck.

ACKNOWLEDGMENTS

What do you call a fish wearing a tux?
SoFISHticated.

Most people don't read the acknowledgments, and I understand why. It's like watching the Oscars and tuning out while an emotional actor lists off the names of twenty-five people he wants to thank. You don't know them, and you don't really care.

But if you enjoyed this book, it's partly because of the brilliance and effort of a whole bunch of people. So, I'm going to borrow a strategy from the Marvel movies and sprinkle Easter eggs throughout the acknowledgments, as an incentive to keep you reading. My eggs will take the form of horrible Dad jokes.

What did the ocean say to the beach?
Nothing. It just waved.

First and foremost, I'm grateful to my editor, Julie Will, for taking another chance on me. Her work is so incisive and insightful. It's a joy to work with Julie because I know, at every step, that she's making the book better. Next, a big thanks to my agent, Heather Jackson, who is a dear friend and supportive no matter how many stupid jokes I make.

My PR rep is Ashley Sandberg and I recommend her to anyone because she makes me feel like I'm her only client. She is so smart, so talented, so grounded, and takes incredible photographs.

What do sprinters eat before a big race?
Nothing, they fast!

I was lucky to be surrounded, during the pandemic, by some of the best people in the world, friends and neighbors whom I love and admire: Mike Canino, Lisa Cunningham, Gus Umanzor, Laura Romano, and Susan Green. The Rock Creek Pod forever. Much love to Maura, too, even though she fled cicada-covered Maryland for the wilds of Seattle.

A huge thanks to those who gave me the gift of their insight and experience through interviews for the book: Beverly Daniel Tatum, Karen Tamerius, Tori Williams Douglass, Mitch Landrieu, Xuan Zhao, Cindy Gallop, Chenjerai Kumanyika, Tanner Colby, Seema Yasmin, John Biewen, Farai Chideya, Hugh Breakey, Nate Nichols, and Derek Black. It's hard to write a book about conversation if people aren't willing to talk to you.

Why do melons have weddings?
Because they cantaloupe!

I want to express my appreciation for the entire team at Harper Collins: Emma Kupor, Yelena Nesbit, and Laura Cole. Thank goodness for the people who love books and dedicate their lives to selling books and supporting authors.

Thanks to my team as well: Cynthia Sjoberg, both my manager and a friend for nearly twenty years, and Alexis Richardson, who is an underappreciated gem.

Did you hear about the kidnapping at the elementary school?
Don't worry. The kid woke up.

Thank you to the incredible journalists and public radio employees who have shared their stories and ideas for the past year, and helped build a new company focused on bringing anti-racist reforms to our industry.

Thank you, as always, to my best friend and soul sister, Theresa. And to my son, Grant: you're a dork, but I love you anyway.

There are two sausages in a frying pan. One of them says, "Man, it's hot in here." The other one says, "Aaaaaaah! It's a talking sausage!"

READING LIST

If you truly want to have insightful and productive conversations about race, you'll probably have to do a little homework. It's not fair to ask others to educate you about the history of race, so I recommend you dig into the research on your own. Plus, there are dozens of engaging and fascinating books on the subject of race, each one unique in perspective and tone. This is by no means a comprehensive list, simply a starting point that will hopefully lead you to yet more books, more resources, more insight.

HOW TO GROW YOUR SKILLS

The Black Friend, Frederick Joseph
The Person You Mean to Be, Dolly Chugh
Race Talk and the Conspiracy of Silence, Derald Wing Sue

WHAT WE SAY ABOUT RACE
Conversations About Our Original Sin

Race, Studs Terkel
Two-Faced Racism, Leslie Houts Picca and Joe R. Feagin

LOOKING BACK TO LOOK FORWARD
The History of Race and Racism

Stamped from the Beginning, Ibram X. Kendi
Race, Reform, and Rebellion, Manning Marable

Caste, Isabel Wilkerson
The New Jim Crow, Michelle Alexander
White Rage, Carol Anderson
The Condemnation of Blackness, Khalil Gibran Muhammad

CURRENT EVENTS
Examining Racism in the Modern World
We Too Sing America, Deepa Iyer
Racism Without Racists, Eduardo Bonilla-Silva
Dying of Whiteness, Jonathan M. Metzl
The Short and Tragic Life of Robert Peace, Jeff Hobbs

WHY ARE WE LIKE THIS?
Understanding Our Biases
Blindspot: Hidden Biases of Good People, Mahzarin R. Banaji and Anthony G. Greenwald
Everyday Bias, Howard J. Ross
Biased: Uncovering the Hidden Prejudice That Shapes What We See, Think, and Do, Jennifer L. Eberhardt, PhD

THE MUST-READS
The Books That Have Endured for Good Reason
The Souls of Black Folk, W. E. B. Du Bois
The Fire Next Time, James Baldwin
Letter to My Daughter, Maya Angelou
Native Son, Richard Wright
Black Skin, White Masks, Frantz Fanon
Why Are All the Black Kids Sitting Together in the Cafeteria?, Beverly Daniel Tatum, PhD
Crusade for Justice, Ida B. Wells
Montage of a Dream Deferred, Langston Hughes

POWERFUL WRITING

Memoir and Essay and Novel

The Fire This Time, Jesmyn Ward

Between the World and Me, Ta-Nehisi Coates

Killing Rage: Ending Racism, bell hooks

Minor Feelings, Cathy Park Hong

The Good Immigrant: 26 Writers Reflect on America, edited by Nikesh Shukla and Chimene Suleyman

Sister Outsider, Audre Lorde

Homegoing, Yaa Gyasi

Their Eyes Were Watching God, Zora Neale Hurston

There is a wealth of material available for those who want to learn more about race and bias. Here are a few other options you can consult if you're looking for something other than a book:

PODCASTS

Code Switch from NPR: https://www.npr.org/2020/06/09/873054935/want-to-have-better-conversations-about-racism-with-your-parents-heres-how

Seeing White from Duke's Center for Documentary Studies: https://www.sceneonradio.org/seeing-white/

Intersectionality Matters! from the African American Policy Forum: https://www.aapf.org/intersectionality-matters

1619 from the *New York Times*: https://www.nytimes.com/2020/01/23/podcasts/1619-podcast.html

FILMS

Eyes on the Prize, a series from PBS

Black America Since MLK: And Still I Rise, a four-part series from PBS

I Am Not Your Negro, a documentary about writer James Baldwin
Quest: A Portrait of an American Family
The Central Park Five, from Ken Burns
The Talk: Race in America, from the *New York Times*

ACTIVITIES

Me and White Supremacy workbook: http://www.co.umatilla.or.us/bcc/agendas/SaadWorkbook.pdf

Take the Implicit Association Test: https://implicit.harvard.edu/implicit/takeatest.html

Take the Hidden Tribes Quiz: https://hiddentribes.us/quiz/

Take the Perception Gap Quiz: https://perceptiongap.us/

NOTES

INTRODUCTION

1. Eddie L. Hoover, "There Is No Scientific Rationale for Race-Based Research," *Journal of the National Medical Association* 99, no. 6 (2007): 690–92.
2. Jack Herrera, "DNA Tests Can't Tell You Your Race," *Popular Science*, December 27, 2019, https://www.popsci.com/story/science/dna-tests-myth-ancestry-race.
3. Vivian Chou, "How Science and Genetics Are Reshaping the Race Debate of the 21st Century," *Science in the News*, Harvard University, February 27, 2019, sitn.hms.harvard.edu/flash/2017/science-genetics-reshaping-race-debate-21st-century/.
4. Quoted in *American Masters*, season 4, episode 4, "James Baldwin: The Price of the Ticket," directed by Karen Thorsen (PBS, aired August 14, 1989).
5. Jeremy A. Frimer, Linda J. Skitka, and Matt Motyl, "Liberals and Conservatives Are Similarly Motivated to Avoid Exposure to One Another's Opinions," *Journal of Experimental Social Psychology* 72 (September 2017): 1–12, https://doi.org/10.1016/j.jesp.2017.04.003.
6. Peter H. Ditto et al., "At Least Bias Is Bipartisan: A Meta-analytic Comparison of Partisan Bias in Liberals and Conservatives," *Perspectives on Psychological Science* 14, no. 2 (May 31, 2018): 273–91, https://doi.org/10.1177/1745691617746796.
7. Judith E. Glaser, "Your Brain Is Hooked on Being Right," *Harvard Business Review*, February 28, 2013, https://hbr.org/2013/02/break-your-addiction-to-being.
8. Catharine A. Winstanley, Paul J. Cocker, and Robert D. Rogers, "Dopamine Modulates Reward Expectancy During Performance of a Slot Machine Task in Rats: Evidence for a 'Near-Miss' Effect," *Neuropsychopharmacology* 36, no. 5 (April 2011): 913–25, https://doi.org/10.1038/npp.2010.230.
9. Craig A. Foster and Steven M. Samuels, "Psychology, Skepticism, and Confronting Racism," *Skeptical Inquirer* 42, no. 1 (January/February 2018), https://skepticalinquirer.org/2018/01/psychology-skepticism-and-confronting-racism.
10. Bethany Mandel, "We Need to Start Befriending Neo Nazis," *Forward*, August 24, 2017, https://forward.com/opinion/380510/we-need-to-start-befriending-neo-nazis.
11. Quoted in Zaid Jilani, "How to Save Thanksgiving from Political Arguments," *Greater Good Magazine*, November 20, 2018, https://greatergood.berkeley.edu/article/item/how_to_save_thanksgiving_from_political_arguments.
12. Michael W. Kraus, "How Fair Is American Society?" *Yale Insights*, September 18, 2017, https://insights.som.yale.edu/insights/how-fair-is-american-society.
13. Thomas Jefferson Foundation, "Monticello Affirms Thomas Jefferson Fathered Children with Sally Hemings," Monticello, accessed March 16, 2021, https://www.monticello.org/thomas-jefferson/jefferson-slavery/thomas-jefferson-and-sally-hemings

-a-brief-account/monticello-affirms-thomas-jefferson-fathered-children-with-sally-hemings.
14. Phil Haslanger, "White or Black? The Children of Thomas Jefferson and Sally Hemings Wrestle with Racial Identity," Nehemiah Center for Urban Leadership Development, October 13, 2017, https://nehemiah.org/nehemiah-blog/white-or-black-the-children-of-thomas-jefferson-and-sally-hemings-wrestle-with-racial-identity.
15. Thomas Dixon Jr., *The Leopard's Spots: A Romance of the White Man's Burden, 1865–1900* (New York: Doubleday, 1902), 242.
16. Adam Rutherford, *How to Argue with a Racist: What Our Genes Do (and Don't) Say About Human Difference* (New York: The Experiment, 2020), 121.
17. Ibid., 89.
18. Craig White, "John Ross / *Guwisguwi* (1790–1866)," Craig White's Literature Courses: Historical Backgrounds (University of Houston–Clear Lake), accessed March 16, 2021, https://drwhitelitr.net/xhist/TrailTears.htm.
19. Walter White, "'I Learn What I Am,' from *A Man Called White*," in *Georgia Voices*, vol. 2: *Nonfiction*, ed. Hugh Ruppersburg (Athens: University of Georgia Press, 1994), 11.
20. Henry Louis Gates Jr., "White Like Me," *New Yorker*, June 10, 1996, https://www.newyorker.com/magazine/1996/06/17/white-like-me.
21. Douglas Stone and Sheila Heen, *Thanks for the Feedback: The Science and Art of Receiving Feedback Well (Even When It Is Off-Base, Unfair, Poorly Delivered, and Frankly, You're Not in the Mood)* (London: Portfolio Penguin, 2015), 46.
22. Quoted in Studs Terkel, *Race: How Blacks and Whites Think and Feel About the American Obsession*, 20th anniversary ed. (New York: New Press, 2012), 277.
23. "On Views of Race and Inequality, Blacks and Whites Are Worlds Apart," Pew Research Center, June 27, 2016, https://www.pewresearch.org/social-trends/wp-content/uploads/sites/3/2016/06/ST_2016.06.27_Race-Inequality-Final.pdf.
24. Michael W. Kraus, Julian M. Rucker, and Jennifer A. Richeson, "Americans Misperceive Racial Economic Equality," *Proceedings of the National Academy of Sciences* 114, no. 39 (September 18, 2017): 10324–31, https://doi.org/10.1073/pnas.1707719114.
25. Ibram X. Kendi, *How to Be an Antiracist* (New York: One World, 2019), 235.
26. Quoted in Terkel, *Race*, 275.
27. Beverly Daniel Tatum, *"Why Are All the Black Kids Sitting Together in the Cafeteria?": And Other Conversations About Race*, 20th anniversary ed. (New York: Basic Books, 2017), 86.

CHAPTER 1: WHO IS RACIST?
1. Angela C. Bell, Melissa Burkley, and Jarrod Bock, "Examining the Asymmetry in Judgments of Racism in Self and Others," *Journal of Social Psychology* 159, no. 5 (2019): 611–27, https://doi.org/10.1080/00224545.2018.1538930.
2. Quoted in Studs Terkel, *Race: How Blacks and Whites Think and Feel About the American Obsession*, 20th anniversary ed. (New York: New Press, 2012), 65.
3. Quoted in ibid., 76.
4. Quoted in ibid., 143.
5. Adam Gorlick, "Backing Obama Gives Some Voters License to Favor Whites over Blacks, Study Shows," Stanford University, March 2, 2009, https://news.stanford.edu/news/2009/march4/obama-moral-credentials-favor-whites-030409.html.
6. John Blake, "'Am I Racist?' You May Not Like the Answer," CNN, June 20, 2020, https://www.cnn.com/2020/06/20/us/racist-google-question-blake/index.html.
7. Daniel A. Effron, Jessica S. Cameron, and Benoît Monin, "Endorsing Obama Licenses Favoring Whites," *Journal of Experimental Social Psychology* 45, no. 3 (May 2009): 590–93, https://doi.org/10.1016/j.jesp.2009.02.001.

8. Quoted in Jen Graves, "Deeply Embarrassed White People Talk Awkwardly About Race," *Stranger*, August 31, 2011, https://www.thestranger.com/seattle/deeply-embarrassed-white-people-talk-awkwardly-about-race/Content?oid=9747101.
9. Helen Barrington, in discussion with the author, August 18, 2020.
10. Ibid.
11. George Wallace Jr., "George Wallace Jr. to Oprah: 'Selma' Portrayal of My Father Is 'Pure, Unadulterated Fiction,'" *AL.com*, January 13, 2015, https://www.al.com/opinion/2015/01/george_wallace_jr_defies_movie.html#incart_river.
12. Quoted in *American Experience*, season 12, episodes 12–13, "George Wallace: Settin' the Woods on Fire, Parts I and II," directed by Daniel McCabe and Paul Stekler (PBS, aired April 24 and 25, 2000).
13. Celeste Headlee, "Opera Tells Saga of 'Margaret Garner,'" NPR, May 7, 2005, https://www.npr.org/templates/story/story.php?storyId=4633538.
14. Isabel Wilkerson, *Caste: The Origins of Our Discontents* (New York: Random House, 2020), 89.
15. Ibid., 68–69.
16. Kendi, *How to Be an Antiracist*, 9.
17. "Full Text: Obama's Remarks on Fatal Shooting in Charleston, S.C.," *Washington Post*, June 18, 2015, https://www.washingtonpost.com/news/post-politics/wp/2015/06/18/full-text-obamas-remarks-on-fatal-shooting-in-charleston-s-c/.
18. Leila McNeill, "How a Psychologist's Work on Race Identity Helped Overturn School Segregation in 1950s America," *Smithsonian Magazine*, October 26, 2017, https://www.smithsonianmag.com/science-nature/psychologist-work-racial-identity-helped-overturn-school-segregation-180966934.
19. Interview with Dr. Kenneth Clark, conducted by Blackside, Inc., on November 4, 1985, for *Eyes on the Prize: America's Civil Rights Years (1954–1965)*, Washington University Libraries, Film and Media Archive, Henry Hampton Collection, http://repository.wustl.edu/downloads/f4752j543.
20. Quoted in John J. DiIulio Jr., "My Black Crime Problem, and Ours," in *Race, Crime, and Justice: A Reader*, ed. Shaun L. Gabbidon and Helen Taylor Greene (New York, Routledge, 2005), 84.
21. bell hooks, *Ain't I a Woman: Black Women and Feminism* (London, Pluto Press, 1982), 157.
22. Dolly Chugh, *The Person You Mean to Be: How Good People Fight Bias* (New York: HarperCollins, 2018), 123.

CHAPTER 2: THE SCIENCE
1. Quoted in Iris Bohnet, *What Works: Gender Equality by Design* (Cambridge, MA: Harvard University Press, 2016), 40.
2. Quoted in Daphne White, "Berkeley Author George Lakoff Says, 'Don't Underestimate Trump,'" *Berkeleyside*, May 2, 2017, https://www.berkeleyside.com/2017/05/02/berkeley-author-george-lakoff-says-dont-underestimate-trump.
3. George Lakoff and Mark Johnson, *Philosophy in the Flesh: The Embodied Mind and Its Challenge to Western Thought* (New York: Basic Books, 1999), 478.
4. Richard F. West, Russell J. Meserve, and Keith E. Stanovich, "Cognitive Sophistication Does Not Attenuate the Bias Blind Spot," *Journal of Personality and Social Psychology* 103, no. 3 (September 2012): 506–19, https://doi.org/10.1037/a0028857.
5. Betsy Mason, "Curbing Implicit Bias: What Works and What Doesn't," *Knowable Magazine*, June 4, 2020, https://doi.org/10.1146/knowable-060320-1.
6. Daniel Kahneman, *Thinking, Fast and Slow*. (New York: Farrar, Straus and Giroux, 2011), 24.

7. Kevin Boyle, *Arc of Justice: A Saga of Race, Civil Rights, and Murder in the Jazz Age* (New York: Henry Holt, 2005).
8. Clarence S. Darrow, *The Story of My Life* (New York: Hachette, 1932), chapter 34.
9. Douglas Linder, "Closing Argument of CLARENCE DARROW in the Case of PEOPLE v. OSSIAN SWEET ET AL.," Famous Trials (website posted by Douglas O. Linder), November 24 and 25, 1925, 2015, https://www.famous-trials.com/sweet/123-darrowargument.
10. Ibid.
11. Quoted in Leah Donnella, "Does It Matter When a White CEO Says 'Black Lives Matter'?," Delaware Public Media, November 10, 2016, https://www.delawarepublic.org/post/does-it-matter-when-white-ceo-says-black-lives-matter.
12. Marte Otten et al., "No Laughing Matter: How the Presence of Laughing Witnesses Changes the Perception of Insults," *Social Neuroscience* 12, no. 2 (2017): 182–93, https://doi.org/10.1080/17470919.2016.1162194
13. Brian Resnick, "A New Brain Study Sheds Light on Why It Can Be So Hard to Change Someone's Political Beliefs," *Vox*, December 28, 2016, https://www.vox.com/science-and-health/2016/12/28/14088992/brain-study-change-minds.
14. Quoted in ibid.
15. Randi Gunther, "Emotional Reactivity—the Bane of Intimate Communication," *Psychology Today*, October 18, 2013, https://www.psychologytoday.com/us/blog/rediscovering-love/201310/emotional-reactivity-the-bane-intimate-communication.
16. Quoted in Douglas Stone and Sheila Heen, *Thanks for the Feedback: The Science and Art of Receiving Feedback Well (Even When It Is Off-Base, Unfair, Poorly Delivered, and Frankly, You're Not in the Mood)* (London: Portfolio Penguin, 2015), 153.
17. Rachel Ruttan and Loran F. Nordgren, "The Strength to Face the Facts: Self-Regulation Defends Against Defensive Information Processing," *Academy of Management Proceedings* 2015, no. 1 (January 2015): 18548, https://doi.org/10.5465/ambpp.2015.216.

CHAPTER 3: THE STAKES
1. See Brett McKay and Kate McKay, "Manvotional: Self-Made Men by Frederick Douglass," The Art of Manliness, July 12, 2009 (updated September 18, 2020), https://www.artofmanliness.com/articles/manvotional-self-made-men-by-frederick-douglass.
2. Eboni K. Williams, "Yes, You Must Talk About Race at Work: 3 Ways to Get Started," *Forbes*, June 16, 2020, https://www.forbes.com/sites/ebonikwilliams/2020/06/16/yes-you-must-talk-about-race-at-work-3-ways-to-get-started/?sh=3637d79b3985.
3. Katherine Phillips, "How Diversity Makes Us Smarter," *Greater Good Magazine* (University of California Berkeley, September 2017), https://greatergood.berkeley.edu/article/item/how_diversity_makes_us_smarter.
4. James Surowiecki, *The Wisdom of Crowds: Why the Many Are Smarter Than the Few and How Collective Wisdom Shapes Business, Economies, Societies and Nations* (New York: Anchor Books, 2005), xix.
5. Stephen Hawkins et al., *Hidden Tribes: A Study of America's Polarized Landscape*, (New York: More in Common, 2018), 4, https://hiddentribes.us/media/qfpekz4g/hidden_tribes_report.pdf.
6. Ibid., 137.
7. "Extremism," Anti-Defamation League Glossary, accessed March 15, 2021, https://www.adl.org/resources/glossary-terms/extremism.
8. Karin Tamerius, "Traumatized by Trump? Try This," *Medium*, October 16, 2020, https://medium.com/progressively-speaking/i-cured-my-trump-derangement-syndrome-so-i-could-make-a-difference-b37678f43663.

9. Quaoted in Emily Kasriel, "Deep Listening: To Understand a Different Perspective," *Social Business Hub* (London School of Economics blog), June 25, 2020, https://blogs.lse.ac.uk/socialbusinesshub/2020/06/25/deep-listening-to-understand-a-different-perspective.
10. Michael W. Kraus, "How Fair Is American Society?," *Yale Insights*, September 18, 2017, https://insights.som.yale.edu/insights/how-fair-is-american-society.
11. Israel Zangwill, *The Melting-Pot: Drama in Four Acts*, rev. ed. (New York: Macmillan, 1920), 33.

CHAPTER 4: WHEN IT HAS WORKED

1. "Homeland Threat Assessment: October 2020," U.S. Department of Homeland Security, October 2020, https://www.dhs.gov/sites/default/files/publications/2020_10_06_homeland-threat-assessment.pdf.
2. Quoted in Studs Terkel, *American Dreams: Lost and Found* (1980; repr. New York: New Press, 2005), 199.
3. Osha Gray Davidson, *The Best of Enemies: Race and Redemption in the New South* (Chapel Hill: University of North Carolina Press, 2007).
4. Jeffrey A. Hall, "How Many Hours Does It Take to Make a Friend?," *Journal of Social and Personal Relationships* 36, no. 4 (March 15, 2018): 1278–96, https://doi.org/10.1177/0265407518761225.
5. Quoted in Rebecca Savastio, "KKK Member Walks Up to Black Musician in Bar—but It's Not a Joke, and What Happens Next Will Astound You," *Guardian Liberty Voice*, November 21, 2013, https://guardianlv.com/2013/11/kkk-member-walks-up-to-black-musician-in-bar-but-its-not-a-joke-and-what-happens-next-will-astound-you.
6. Daryl Davis, "Why I, as a Black Man, Attend KKK Rallies," TEDxNaperville video posted on YouTube, December 8, 2017, https://www.youtube.com/watch?v=ORp3q1Oaezw.
7. Quoted in Conor Friedersdorf, "Talking About Race with the KKK," *Atlantic*, March 27, 2015, https://www.theatlantic.com/politics/archive/2015/03/the-audacity-of-talking-about-race-with-the-klu-klux-klan/388733.
8. Nick van der Kolk, Jessi Carrier, and Steven Jackson, "How to Argue," *Love + Radio* (podcast), February 11, 2017, http://loveandradio.org/2017/02/how-to-argue.
9. Lisa Provence, "Preston's Plea: Imperial Wizard Says No Contest to Firing Gun," *C-VILLE Weekly*, May 9, 2018, https://www.c-ville.com/prestons-plea-imperial-wizard-says-no-contest-firing-gun/#.W32CNy2ZNUM.
10. Mallory Simon, "Why a KKK Wizard Went to the Crucible of Black History," CNN, August 10, 2018, https://www.cnn.com/2018/08/10/us/kkk-imperial-wizard-charlottesville/index.html.
11. Mark Potok, "The Curious Case of Daryl Davis, the Black Man Befriending Members of the KKK," *Daily Beast*, September 2, 2018, https://www.thedailybeast.com/the-curious-case-of-daryl-davis-the-black-man-befriending-members-of-the-kkk.
12. Christian Picciolini, "My Descent into America's Neo-Nazi Movement—and How I Got Out," TEDx talk, November 2017, https://www.ted.com/talks/christian_picciolini_my_descent_into_america_s_neo_nazi_movement_and_how_i_got_out?language=en.
13. Quoted in Clemence Michallon, "Sarah Silverman Argues That 'Path to Redemption' Is Needed in 'Cancel Culture' Moments," *Independent*, October 26, 2020, https://www.independent.co.uk/arts-entertainment/tv/news/sarah-silverman-cancel-culture-blackface-white-supremacy-b1351777.html.
14. Picciolini, "My Descent into America's Neo-Nazi Movement."
15. Davis, "Why I, as a Black Man, Attend KKK Rallies."

CHAPTER 5: FIRST, GET YOUR HEAD STRAIGHT

1. "Geneva Conventions and Their Additional Protocols," Cornell Law School Legal Information Institute, 2017, https://www.law.cornell.edu/wex/geneva_conventions_and_their_additional_protocols.
2. Max Rollwage, Raymond J. Dolan, and Stephen M. Fleming, "Metacognitive Failure as a Feature of Those Holding Radical Beliefs," *Current Biology* 28, no. 24 (December 17, 2018): 4014–21, https://doi.org/10.1016/j.cub.2018.10.053.
3. Quoted in Kat Eschner, "People with Extreme Political Views Have Trouble Thinking About Their Own Thinking," *Popular Science*, December 18, 2018, https://www.popsci.com/radical-politics-metacognition/.
4. Juliana Menasce Horowitz, Anna Brown, and Kiana Cox, "Race in America 2019," Pew Research Center, Social & Demographic Trends, April 9, 2019, https://www.pewresearch.org/social-trends/2019/04/09/race-in-america-2019/.
5. Michael W. Kraus, Julian M. Rucker, and Jennifer A. Richeson, "Americans Misperceive Racial Economic Equality," *Proceedings of the National Academy of Sciences* 114, no. 39 (September 18, 2017): 10324–31, https://doi.org/10.1073/pnas.1707719114.
6. Shunryū Suzuki, *Zen Mind, Beginner's Mind: Informal Talks on Zen Meditation and Practice*, 50th anniversary ed., ed. Trudy Dixon (Boulder, CO: Shambhala, 2020), 2.
7. Chris Argyris, "Teaching Smart People How to Learn," *Harvard Business Review*, May 1991, https://hbr.org/1991/05/teaching-smart-people-how-to-learn.
8. Ibid.
9. Muqtafi Akhmad, Shuang Chang, and Hiroshi Deguchi, "Closed-Mindedness and Insulation in Groupthink: Their Effects and the Devil's Advocacy as a Preventive Measure," *Journal of Computational Social Science*, September 18, 2020, https://doi.org/10.1007/s42001-020-00083-8.
10. Ronit Roth-Hanania, Maayan Davidov, and Carolyn Zahn-Waxler, "Empathy Development from 8 to 16 Months: Early Signs of Concern for Others," *Infant Behavior and Development* 34, no. 3 (June 2011): 447–58, https://doi.org/10.1016/j.infbeh.2011.04.007.
11. Dylan Scott, "The Data Is Clear: Nobody Actually Fights About Politics at Thanksgiving Dinner (Well, Almost Nobody)," *Vox*, November 21, 2018, https://www.vox.com/policy-and-politics/2018/11/21/18106469/thanksgiving-dinner-politics-debate-fake-news.

CHAPTER 6: RESPECT AND ACCEPTANCE

1. Tom Junod, "Can You Say . . . Hero?: Fred Rogers Has Been Doing the Same Small Good Thing for a Very Long Time," *Esquire*, November 1998, https://www.esquire.com/entertainment/tv/a27134/can-you-say-hero-esq1198/.
2. Tom Junod, "Mister Rogers's Enduring Wisdom," *Atlantic*, November 7, 2019, https://www.theatlantic.com/magazine/archive/2019/12/what-would-mister-rogers-do/600772/.
3. Quoted in Karen Grigsby Bates, "When Civility Is Used as a Cudgel Against People of Color," NPR, March 14, 2019, https://www.npr.org/sections/codeswitch/2019/03/14/700897826/when-civility-is-used-as-a-cudgel-against-people-of-color.
4. "Studs Terkel in Conversation with Sydney Lewis: Interviewing the World's Greatest Interviewer," *Transom*, August 1, 2001, https://transom.org/2001/studs-terkel-in-conversation.
5. Reni Eddo-Lodge, *Why I'm No Longer Talking to White People About Race* (New York: Bloomsbury Publishing, 2019), xiii.
6. Friedrich Nietzsche, *The Complete Works of Friedrich Nietzsche*, vol. 8: *Beyond Good and Evil / On the Genealogy of Morality*, trans. Adrian Del Caro (Stanford, CA: Stanford University Press, 2014), 74.

7. Ayaz Virji, with Alan Eisenstock, *Love Thy Neighbor: A Muslim Doctor's Struggle for Home in Rural America* (New York: Convergent, 2019).
8. Quoted in Kaomi Lee, "Why This Muslim Doctor Is Taking a Break from Rural America," *Twin Cities PBS Originals*, September 21, 2020, https://www.tptoriginals.org/why-this-muslim-doctor-is-taking-a-break-from-rural-america.
9. Quoted in Kaomi Lee, "Muslim Doctor Finds Purpose and Pushback in Rural Town," *Twin Cities PBS Originals*, February 12, 2018, https://www.tptoriginals.org/muslim-doctor-finds-purpose-pushback-rural-town.
10. Quoted in Stephanie McCrummen, "In a Midwestern Town That Went for Trump, a Muslim Doctor Tries to Understand His Neighbors," *Washington Post*, July 1, 2017, https://www.washingtonpost.com/national/in-a-midwestern-town-that-went-for-trump-a-muslim-doctor-tries-to-understand-his-neighbors/2017/07/01/0ada50c4-5c48-11e7-9fc6-c7ef4bc58d13_story.html.
11. Quoted in ibid.
12. Quoted in Lee, "Why This Muslim Doctor Is Taking a Break from Rural America."
13. Quoted in Lonnie G Bunch, "Jackie Robinson's Legacy in a Changing America," *Washington Post*, April 19, 2013, https://www.washingtonpost.com/blogs/therootdc/post/jackie-robinsons-legacy-in-a-changing-america/2013/04/19/863693ac-a92f-11e2-b029-8fb7e977ef71_blog.html.
14. Erica J. Boothby and Vanessa K. Bohns, "Why a Simple Act of Kindness Is Not as Simple as It Seems: Underestimating the Positive Impact of Our Compliments on Others," *Personality and Social Psychology Bulletin*, 47, no. 5 (May 2021): 826–40, https://doi.org/10.1177/0146167220949003.
15. David K. Sherman and Geoffrey L. Cohen, "Accepting Threatening Information: Self-Affirmation and the Reduction of Defensive Biases," *Current Directions in Psychological Science* 11, no. 4 (August 2002): 119–23, https://doi.org/10.1111/1467-8721.00182.
16. Quoted in Studs Terkel, *Race: How Blacks and Whites Think and Feel About the American Obsession*, 20th anniversary ed. (New York: New Press, 2012), 128.
17. Mark Goulston, *Just Listen: Discover the Secret to Getting Through to Absolutely Anyone* (New York: American Management Association, 2009), 74.
18. Rick Hanson, "Accept Them as They Are," *Psychology Today*, October 13, 2014, https://www.psychologytoday.com/us/blog/your-wise-brain/201410/accept-them-they-are.
19. "Rate of Fatal Police Shootings in the United States from 2015 to March 2021, by Ethnicity," Statista, March 1, 2021, https://www.statista.com/statistics/1123070/police-shootings-rate-ethnicity-us.
20. Lincoln Quillian and Devah Pager, "Black Neighbors, Higher Crime? The Role of Racial Stereotypes in Evaluations of Neighborhood Crime," *American Journal of Sociology* 107, no. 3 (2001): 717–67, https://doi.org/10.1086/338938.

CHAPTER 7: TAKE TURNS AND BE SPECIFIC
1. Erica J. Boothby et al., "The Liking Gap in Conversations: Do People Like Us More Than We Think?," *Psychological Science* 29, no. 11 (November 2018): 1742–56, https://doi.org/10.1177/0956797618783714.
2. Eddie Wrenn, "The Great Gender Debate: Men Will Dominate 75% of the Conversation During Conference Meetings, Study Suggests," *Mail Online*, September 19, 2012, https://www.dailymail.co.uk/sciencetech/article-2205502/The-great-gender-debate-Men-dominate-75-conversation-conference-meetings-study-suggests.html.
3. Shari Kendall and Deborah Tannen, "Gender and Language in the Workplace," in *Gender and Discourse*, ed. Ruth Wodak (London: Sage, 1997), 81–105, https://time.com/wp-content/uploads/2017/06/d3375-genderandlanguageintheworkplace.pdf.

4. Susan C. Herring, "Gender and Participation in Computer-Mediated Linguistic Discourse," paper presented at the Annual Meeting of the Linguistic Society of America, Philadelphia, PA, January 9–12, 1992.
5. Alisha Haridasani Gupta, "It's Not Just You: In Online Meetings, Many Women Can't Get a Word In," *New York Times*, April 14, 2020, https://www.nytimes.com/2020/04/14/us/zoom-meetings-gender.html.
6. Jason Fried, "The Basecamp Guide to Internal Communication," Basecamp, accessed March 15, 2021, https://basecamp.com/guides/how-we-communicate.
7. Woman Interrupted, accessed March 15, 2021, http://www.womaninterruptedapp.com/en.
8. Amber Burton, "Women of Color: Invisible, Excluded and Constantly On Guard,'" *Wall Street Journal*, October 15, 2019, https://www.wsj.com/articles/women-of-color-invisible-excluded-and-constantly-on-guard-11571112060.
9. Leda Fisher, "Should White Boys Still Be Allowed to Talk?," *Dickinsonian*, February 7, 2019, https://thedickinsonian.com/opinion/2019/02/07/should-white-boys-still-be-allowed-to-talk.
10. Quoteinvestigator.com. Accessed April 28, 2021. https://quoteinvestigator.com/2014/11/18/great-minds/.
11. Douglas Stone and Sheila Heen, *Thanks for the Feedback: The Science and Art of Receiving Feedback Well (Even When It Is Off-Base, Unfair, Poorly Delivered, and Frankly, You're Not in the Mood)* (London: Portfolio Penguin, 2015), 21.
12. Sameer Rao, "'SNL's' Michael Che Tackles 'All Lives Matter,' Police Violence in New Stand-up Special Trailer," www.colorlines.com, November 15, 2016, https://www.colorlines.com/articles/snls-michael-che-tackles-all-lives-matter-police-violence-new-stand-special-trailer.
13. Max Fisher, "A Fascinating Map of the World's Most and Least Racially Tolerant Countries," *Washington Post*, May 15, 2013, https://www.washingtonpost.com/news/worldviews/wp/2013/05/15/a-fascinating-map-of-the-worlds-most-and-least-racially-tolerant-countries/.
14. "Overview," Project Implicit, Harvard University, 2011, https://implicit.harvard.edu/implicit/education.html.
15. B. Keith Payne et al., "Affect Misattribution Procedure," *PsycTESTS Dataset*, 2005, https://doi.org/10.1037/t04568-000.
16. Christina Wilkie, "Trump Tells Suburban Voters They Will 'No Longer Be Bothered' by Low-Income Housing," CNBC, July 29, 2020, https://www.cnbc.com/2020/07/29/trump-suburban-voters-will-no-longer-be-bothered-by-low-income-housing.html.
17. Joint Economic Committee of the U.S. Congress, "The Economic State of Black America in 2020," *Joint Economic Committee*, February 14, 2020, https://www.jec.senate.gov/public/_cache/files/ccf4dbe2-810a-44f8-b3e7-14f7e5143ba6/economic-state-of-black-america-2020.pdf.
18. Jessica Semega et al., "Income and Poverty in the United States: 2019," U.S. Census Bureau, September 2020, https://www.census.gov/content/dam/Census/library/publications/2020/demo/p60-270.pdf.
19. Quoted in Rick Perlstein, "Exclusive: Lee Atwater's Infamous 1981 Interview on the Southern Strategy," *Nation*, November 13, 2012, https://www.thenation.com/article/archive/exclusive-lee-atwaters-infamous-1981-interview-southern-strategy.

CHAPTER 8: LOCATION AND LANGUAGE
1. Quoted in Alexandra Petri, "Starbucks CEO Has a Terrible Idea to Fix Race Relations," *Washington Post*, March 17, 2015, https://www.washingtonpost.com/blogs/compost/wp/2015/03/17/starbucks-ceo-has-a-terrible-idea-to-fix-race-relations.

2. April Reign, tweet @ReignOfApril, Twitter, March 17, 2015, 7:59 a.m., https://twitter.com/ReignOfApril/status/577801460026613760.
3. Holly B. Shakya and Nicholas A. Christakis, "A New, More Rigorous Study Confirms: The More You Use Facebook, the Worse You Feel," *Harvard Business Review*, August 21, 2017, https://hbr.org/2017/04/a-new-more-rigorous-study-confirms-the-more-you-use-facebook-the-worse-you-feel.
4. Harriet A. Jacobs, *Incidents in the Life of a Slave Girl: Written by Herself*, ed. Jennifer Fleischner (1861; repr. Boston: Bedford/St. Martin's, 2010).
5. Rachel Ruttan and Loran F. Nordgren, "The Strength to Face the Facts: Self-Regulation Defends Against Defensive Information Processing," *Academy of Management Proceedings* 2015, no. 1 (January 2015): 18548, https://doi.org/10.5465/ambpp.2015.216.
6. Shai Danziger, Jonathan Levav, and Liora Avnaim-Pesso, "Extraneous Factors in Judicial Decisions," *Proceedings of the National Academy of Sciences* 108, no. 17 (April 11, 2011): 6889–92, https://doi.org/10.1073/pnas.1018033108.
7. Amy Mitchell et al., "Distinguishing Between Factual and Opinion Statements in the News," Pew Research Center, June 18, 2018, https://www.journalism.org/2018/06/18/distinguishing-between-factual-and-opinion-statements-in-the-news/.

CHAPTER 9: COMMON GROUND AND GOOD QUESTIONS

1. Carl R. Rogers and F. J. Roethlisberger, "Barriers and Gateways to Communication," *Harvard Business Review* 30, no. 4 (July–August 1952): 46–52, repr. November–December 1991, https://hbr.org/1991/11/barriers-and-gateways-to-communication.
2. Ibid.
3. Michael Tesler, "Democrats and Republicans Used to Agree About the N-Word. Now They Don't," *Washington Post*, August 20, 2018, https://www.washingtonpost.com/news/monkey-cage/wp/2018/08/30/democrats-and-republicans-didnt-use-to-disagree-about-the-n-word-now-they-do/.
4. Juliana Menasce Horowitz, Anna Brown, and Kiana Cox, "Race in America 2019," Pew Research Center, Social & Demographic Trends, April 9, 2019, https://www.pewresearch.org/social-trends/2019/04/09/race-in-america-2019.
5. Ibid.
6. John Shattuck and Mathias Risse, "Reimagining Rights and Responsibilities in the United States: Toward a More Equal Liberty," Carr Center for Human Rights Policy, Harvard Kennedy School, October 8, 2020, 3, https://carrcenter.hks.harvard.edu/files/cchr/files/201007_rr-executive-summary.pdf?m=1611693383.
7. Ibid.
8. "Polling Update: American Attitudes on Immigration Steady, but Showing More Partisan Divides," National Immigration Forum, April 17, 2019, https://immigrationforum.org/article/american-attitudes-on-immigration-steady-but-showing-more-partisan-divides.
9. Joshua Bote, "92% of Americans Think Their Basic Rights Are Being Threatened, New Poll Shows," *USA Today*, December 16, 2019, https://www.usatoday.com/story/news/nation/2019/12/16/most-americans-think-their-basic-rights-threatened-new-poll-shows/4385967002.
10. Justin Halpern, tweet @shitmydadsays, Twitter, June 28, 2010, 12:41 p.m., https://twitter.com/shitmydadsays/status/17263814629.
11. Roderick M. Kramer, "Rethinking Trust," *Harvard Business Review*, June 2009, https://hbr.org/2009/06/rethinking-trust.
12. Samuel G. Freedman, "A Long Road from 'Come by Here' to 'Kumbaya,'" *New York Times*, November 19, 2010, sec. U.S., https://www.nytimes.com/2010/11/20/us/20religion.html.

13. Mathew Ingram, "Most Americans Say They Have Lost Trust in the Media," *Columbia Journalism Review*, September 12, 2018, https://www.cjr.org/the_media_today/trust-in-media-down.php.
14. Kramer, "Rethinking Trust."
15. Anne Applebaum, "The Facts Just Aren't Getting Through," *Atlantic*, August 10, 2020, https://www.theatlantic.com/ideas/archive/2020/08/how-beat-populists-when-facts-dont-matter/615082/.
16. "'Who Shared It?' How Americans Decide What News to Trust on Social Media," Media Insight Project (an initiative of the American Press Institute and the Associated Press–NORC Center for Public Affairs Research), March 20, 2017, https://www.americanpressinstitute.org/publications/reports/survey-research/trust-social-media.
17. Applebaum, "The Facts Just Aren't Getting Through."
18. Julia Galef, "Why You Think You're Right—Even If You're Wrong," TED talk, February 2016, https://www.ted.com/talks/julia_galef_why_you_think_you_re_right_even_if_you_re_wrong?language=en.
19. Alison Wood Brooks and Leslie K. John, "How to Ask Great Questions," *Harvard Business Review*, May 2018, https://hbr.org/2018/05/the-surprising-power-of-questions.
20. Ibid.
21. Karen Huang et al., "It Doesn't Hurt to Ask: Question-Asking Increases Liking," *Journal of Personality and Social Psychology* 113, no. 3 (September 2017): 430–52, https://doi.org/10.1037/pspi0000097.
22. Adrian F. Ward, "The Neuroscience of Everybody's Favorite Topic," *Scientific American*, July 16, 2013, https://www.scientificamerican.com/article/the-neuroscience-of-everybody-favorite-topic-themselves.
23. Huang et al., "It Doesn't Hurt to Ask," 431.
24. Jim Camp, "The Science of Asking Great Questions," American Management Association, January 24, 2019), https://bit.ly/38Jg03O.
25. Quoted in Susan Paterno, "The Question Man," *American Journalism Review*, October 2000, https://ajrarchive.org/Article.asp?id=676.
26. Robert S. Mueller III, *Report on the Investigation into Russian Interference in the 2016 Presidential Election* (Washington, DC: U.S. Department of Justice, March 2019), https://www.justice.gov/archives/sco/file/1373816/download.
27. Brooks and John, "How to Ask Great Questions."
28. Quoted in Jolie Kerr, "How to Talk to People, According to Terry Gross," *New York Times*, November 17, 2018, https://www.nytimes.com/2018/11/17/style/self-care/terry-gross-conversation-advice.html.

CHAPTER 10: KEEP IT PERSONAL AND DON'T RUSH
1. Quoted in Edith Honan, "'That Little Girl Was Me': Kamala Harris, Joe Biden Spar over Desegregation at Democratic Debate," ABC News, June 27, 2019, https://abcnews.go.com/Politics/girl-senator-harris-vice-president-biden-spar-desegregation/story?id=64007842.
2. Barack Obama, "Remarks by the President on Trayvon Martin," White House website, August 21, 2013, https://obamawhitehouse.archives.gov/the-press-office/2013/07/19/remarks-president-trayvon-martin.
3. Don Gonyea, "Majority of White Americans Say They Believe Whites Face Discrimination," NPR, October 24, 2017, https://www.npr.org/2017/10/24/559604836/majority-of-white-americans-think-theyre-discriminated-against.
4. "Burton: I Put Hands Outside Car When Pulled Over," CNN video posted on YouTube, July 1, 2013, https://www.youtube.com/watch?v=M-ckDJ3xTaE.

Notes 255

5. Kate Harrison, "A Good Presentation Is About Data and Story," *Forbes*, January 20, 2015, https://bit.ly/3rSKasD.
6. Fritz Breithaupt, *The Dark Sides of Empathy*, trans. Andrew B. B. Hamilton (Ithaca, NY: Cornell University Press 2019), 221.
7. John H. Litcher and David W. Johnson, "Changes in Attitudes Toward Negroes of White Elementary School Students After Use of Multiethnic Readers," *Journal of Educational Psychology* 60, no. 2 (1969): 148–52, https://doi.org/10.1037/h0027081.
8. "Dave Chappelle Stand-up Monologue," *Saturday Night Live* video posted on YouTube, November 7, 2020, https://www.youtube.com/watch?v=Un_VvR_WqNs.
9. Quoted in *American Masters*, season 4, episode 4, "James Baldwin: The Price of the Ticket," directed by Karen Thorsen (PBS, aired August 14, 1989).
10. Pema Chödrön, "Take Three Conscious Breaths," *Lion's Roar*, April 2, 2017, https://www.lionsroar.com/take-three-conscious-breaths.
11. Jeremy Dean, "Are Fast Talkers More Persuasive?," *PsyBlog*, November 24, 2010, https://www.spring.org.uk/2010/11/are-fast-talkers-more-persuasive.php.
12. Uriel Cohen Priva, "Not So Fast: Fast Speech Correlates with Lower Lexical and Structural Information," *Cognition* 160 (March 2017): 27–34, https://doi.org/10.1016/j.cognition.2016.12.002.

CHAPTER 11: I SCREWED UP. WHAT NOW?

1. Monica D. Weathers, Elaine M. Frank, and Leigh Ann Spell, "Differences in the Communication of Affect: Members of the Same Race Versus Members of a Different Race," *Journal of Black Psychology* 28, no. 1 (February 2002): 66–77, https://doi.org/10.1177/0095798402028001005.
2. Stephen Porter and Leanne ten Brinke, "Reading Between the Lies," *Psychological Science* 19, no. 5 (May 2008): 508–14, https://doi.org/10.1111/j.1467-9280.2008.02116.x.
3. Michael W. Kraus, "Voice-Only Communication Enhances Empathic Accuracy," *American Psychologist*, 72, no. 7 (2017): 644–54, https://doi.org/10.1037/amp0000147.
4. Ibid., 652.
5. Natalie Jacewicz, "Why Are Health Studies so White?," The Atlantic, June 16, 2016, https://www.theatlantic.com/health/archive/2016/06/why-are-health-studies-so-white/487046/.
6. Davide Castelvecchi, "Is Facial Recognition Too Biased to Be Let Loose?," *Nature* 587, no. 7834 (November 18, 2020): 347–49, https://doi.org/10.1038/d41586-020-03186-4.
7. Roy J. Lewicki, Beth Polin, and Robert B. Lount, "An Exploration of the Structure of Effective Apologies," *Negotiation and Conflict Management Research* 9, no. 2 (April 6, 2016): 177–96, https://doi.org/10.1111/ncmr.12073.

CHAPTER 12: TALKING ABOUT RACISM IN THE WORKPLACE

1. Vera Hagemann and Annette Kluge, "Complex Problem Solving in Teams: The Impact of Collective Orientation on Team Process Demands," *Frontiers in Psychology* 8 (September 29, 2017): 1–17, https://doi.org/10.3389/fpsyg.2017.01730.
2. Chai R. Feldblum and Victoria A. Lipnic, "Select Task Force on the Study of Harassment in the Workplace," U.S. Equal Employment Opportunity Commission, June 2016, https://www.eeoc.gov/select-task-force-study-harassment-workplace#_Toc453686310.
3. Michael D. Baer et al., "Pacification or Aggravation? The Effects of Talking About Supervisor Unfairness," *Academy of Management Journal* 61, no. 5 (October 2018): 1764–88, https://doi.org/10.5465/amj.2016.0630.

4. Evangelia Demerouti and Russell Cropanzano, "The Buffering Role of Sportsmanship on the Effects of Daily Negative Events," *European Journal of Work and Organizational Psychology* 26, no. 2 (December 5, 2016): 263–74, https://doi.org/10.1080/1359432x.2016.1257610.

5. Barbara L. Fredrickson, "The Role of Positive Emotions in Positive Psychology: The Broaden-and-Build Theory of Positive Emotions," *American Psychologist* 56, no. 3 (March 2001): 218–26, https://doi.org/10.1037//0003-066x.56.3.218.

6. Quoted in Erin Digitale, "Positive Attitude Toward Math Predicts Math Achievement in Kids," Stanford Medicine News Center, January 24, 2018, http://med.stanford.edu/news/all-news/2018/01/positive-attitude-toward-math-predicts-math-achievement-in-kids.html.

7. Arthur B. Markman, *Bring Your Brain to Work: Using Cognitive Science to Get a Job, Do It Well, and Advance Your Career* (Boston, Massachusetts: Harvard Business Review Press, 2019), 146.

8. Roy Baumeister, in discussion with the author, May 18, 2018.

9. Sean Wise, "Can a Team Have Too Much Cohesion? The Dark Side to Network Density," *European Management Journal* 32, no. 5 (October 2014): 703–11, https://doi.org/10.1016/j.emj.2013.12.005.

10. James Surowiecki, *The Wisdom of Crowds: Why the Many Are Smarter Than the Few and How Collective Wisdom Shapes Business, Economies, Societies and Nations* (New York: Anchor Books, 2005).

11. Heather Kelly, "Google Commits $150 Million to Diversity," CNNMoney, May 6, 2015, https://money.cnn.com/2015/05/06/technology/google-diversity-plan.

12. Pamela Newkirk, "Diversity Has Become a Booming Business. So Where Are the Results?," *Time*, October 10, 2019, https://time.com/5696943/diversity-business.

13. Quoted in ibid.

14. Elizabeth Levy Paluck and Donald P. Green, "Prejudice Reduction: What Works? A Review and Assessment of Research and Practice," *Annual Review of Psychology* 60, no. 1 (January 2009): 339–67, https://doi.org/10.1146/annurev.psych.60.110707.163607.

15. Frank Dobbin and Alexandra Kalev, "Why Diversity Programs Fail," *Harvard Business Review*, November 6, 2018, https://hbr.org/2016/07/why-diversity-programs-fail.

16. Iris Bohnet, *What Works: Gender Equality by Design* (Cambridge, MA: Harvard University Press, 2016), 58.

17. Quoted in Gary D. Wintz, ed., *African American Political Thought, 1890–1930: Washington, Du Bois, Garvey, and Randolph* (New York: Routledge, 2015), 161.

18. *Blue Eyed*, directed by Bertram Verhaag (Denkmal Film, 1996).

19. Peter Skillman, "The Design Challenge (Also Called Spaghetti Tower)," *Medium*, April 14, 2019, https://medium.com/@peterskillman/the-design-challenge-also-called-spaghetti-tower-cda62685e15b.

20. Ben Waber, Jennifer Magnolfi, and Greg Lindsay, "Workspaces That Move People," *Harvard Business Review*, October 2014, https://hbr.org/2014/10/workspaces-that-move-people.

21. Ira Hyman, "Doing the Dishes: A Who-Done-It Mystery Story," *Psychology Today*, January 23, 2010, https://www.psychologytoday.com/us/blog/mental-mishaps/201001/doing-the-dishes-who-done-it-mystery-story.

22. Tiziana Casciaro, Amy C. Edmondson, and Sujin Jang, "What Cross-Silo Leadership Looks Like," *Harvard Business Review*, April 16, 2019, https://hbr.org/2019/05/cross-silo-leadership.

23. Jean-Louis Barsoux and Ginka Toegel, "It's Time to Tackle Your Team's Undiscussables," *MIT Sloan Management Review*, September 10, 2019, https://sloanreview.mit.edu/article/its-time-to-tackle-your-teams-undiscussables.

24. Alex Pentland, "The New Science of Building Great Teams," *Harvard Business Review*, July 15, 2015, https://hbr.org/2012/04/the-new-science-of-building-great-teams.
25. Waber, Magnolfi, and Lindsay, "Workspaces That Move People."

IN CLOSING: GOOD LUCK

1. Nasrullah Mambrol, "Helene Cixous and Poststructuralist Feminist Theory," *Literary Theory and Criticism*, December 15, 2018, https://literariness.org/2016/12/20/helene-cixous-and-poststructuralist-feminist-theory.
2. N. K. Jemison, tweet @nkjemisen, Twitter, December 17, 2020, 2:36 p.m., https://twitter.com/nkjemisin/status/1339655845274120194.
3. Ibid.
4. Travis Montaque, "I'm a Black Tech CEO. Diversity Shouldn't Be Our End Goal; Ending the Current Corporate Culture Should," *Fortune*, June 10, 2020, https://fortune.com/2020/06/10/black-ceo-corporate-diversity-inclusion.
5. Quoted in Dwight Smith, "The 10 R's of Talking About Race: How to Have Meaningful Conversations," *Net Impact* (blog), June 18, 2015, https://www.netimpact.org/blog/talking-about-race.
6. Quoted in Sarah McCammon, "Want to Have Better Conversations About Racism with Your Parents? Here's How: Life Kit," NPR, June 15, 2020, https://www.npr.org/2020/06/09/873054935/want-to-have-better-conversations-about-racism-with-your-parents-heres-how.
7. Celeste Headlee, "Fireside Chat," Artists-in-Presidents, 2020, https://artistsinpresidents.com/celesteheadlee.

ABOUT THE AUTHOR

CELESTE HEADLEE is an award-winning journalist, a professional speaker, and the author of *We Need to Talk: How to Have Conversations That Matter* and *Do Nothing: How to Break Away from Overworking, Overdoing, and Underliving*. An expert in conversation, human nature, reclaiming our common humanity and finding well-being, Celeste frequently provides insight on what is good for all humans and what is bad for us, focusing on the best research in neurology and social science to increase understanding of how we relate with one another and can work together in beneficial ways in our workplaces, neighborhoods, communities, and homes. She is a regular guest host on NPR and American Public Media and a highly sought consultant, advising companies around the world on conversations about race, diversity and inclusion. Her TEDx Talk sharing ten ways to have a better conversation has over 23 million total views, and she serves as an advisory board member for ProCon.org and The Listen First Project. Celeste is the recipient of the 2019 Media Changemaker Award. She is the proud granddaughter of composer William Grant Still, the dean of African American Composers.